THE ART OF

NAUGHTY DOG

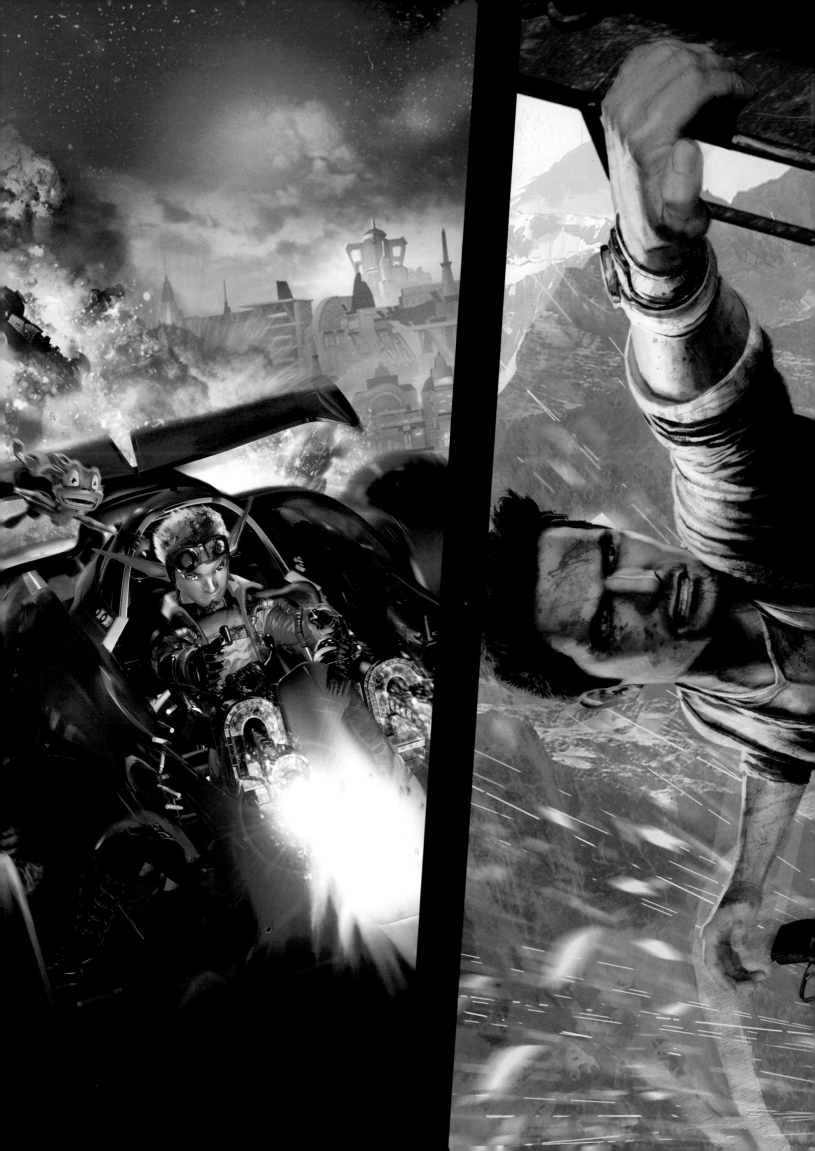

THE ART OF
NAUGHTY DOG

FOREWORD

EVAN WELLS

CHRISTOPHE BALESTRA

CAPTIONS

VIC HARRIS

ARNE MEYER

ERIC MONACELLI

JUSTIN MONAST

ERICK PANGILINAN

BRYAN PARDILLA

ROBH RUPPEL

REUBEN SHAH

SAM THOMPSON

DARK HORSE BOOKS

Digital Production
CHRIS HORN

Designer
JUSTIN COUCH

Assistant Editor
IAN TUCKER

Editor
BRENDAN WRIGHT

President and Publisher
MIKE RICHARDSON

Special Thanks
ERIC MONACELLI, ARNE MEYER, and **LILY NISHITA** at Naughty Dog,
and **NICK McWHORTER, ANDREA SANDERS**, and **JIMMY PRESLER** at Dark Horse Comics

And to
**BOB RAFEI, ERICK PANGILINAN, JUSTIN MONAST, ERIC IWASAKI, ROB TITUS, REUBEN SHAH,
MARK KOERNER, HUGO MARTIN, EDWIN ROSELL, SHADDY SAFADI, ROBH RUPPEL, HONG LY,
ANDREW KIM, BRIAN YAM, EYTAN ZANA, HYOUNG TAEK NAM, AARON LIMONICK, JOHN SWEENEY,
MACIEJ KUCIARA, KORY HEINZEN, ERWIN MADRID, FELIX YOON, PHU GIANG, JAMES PAICK,
POLINA HRISTOVA, MICHAEL YAMADA, CHRISTIAN SCHEURER, DAVID KRENTZ, STEPHAN MARTINIERE**,
and anyone who contributed to our art we may have forgotten.

Published by Dark Horse Books, a division of Dark Horse Comics, Inc.
10956 SE Main Street, Milwaukie, OR 97222

DarkHorse.com

To find a comics shop in your area, call the Comic Shop Locator Service
toll-free at (888) 266-4226. International Licensing: (503) 905-2377.

First edition: October 2014
ISBN 978-1-61655-477-4

Limited Edition: October 2014
ISBN 978-1-61655-725-6

10 9 8 7 6 5 4 3 2 1
Printed in China

THE ART OF NAUGHTY DOG

CONTENTS

FOREWORD

BY EVAN WELLS AND CHRISTOPHE BALESTRA

Getting the chance to make a book collecting artwork from the thirty-year history of Naughty Dog has been a nostalgia-filled journey. Thirty years is a long time for any company to be in business, but in the video game industry it's almost unheard of, as commercial video games have existed maybe only fifteen years longer than that. Of course, many people have come and gone from Naughty Dog over these three decades. Every one of them has contributed in some way to make the studio what it is and played a role in the success we've been fortunate enough to have had along the way. So right off the bat, we want to thank each and every one of the former and current Dogs for allowing us to celebrate our thirtieth anniversary this year. Thank you.

Digging through our archives to find artwork from the earliest years proved to be challenging. This was before we had digital cameras, scanners, or the Internet, so records for the art, and often the art itself, were difficult to locate. But thanks to some of the old Dogs, we've unearthed some pretty amazing stuff that shows you not only how far Naughty Dog has come as a developer, but how far the industry has come in advancing interactive entertainment. Comparing the games from thirty years ago to games of today, you can barely recognize them as the same category of product.

Obviously, everything we've done at Naughty Dog would not have been possible without the original Dogs, cofounders Jason Rubin and Andy Gavin. We personally owe a debt of gratitude to these two for not only starting the studio that has given so much to its employees, the industry, and gamers around the world, but also for defining the culture and attitude that fuel the spirit of development here.

Via the creation of this art book, we were fortunate enough to work with them again to help us cover the history of the company that Jason and Andy originally launched as JAM Software. Additionally, we teamed up with Naughty Dog's first art director (and the first official employee), Bob Rafei, to provide invaluable insights for the introduction and captions of our *Crash Bandicoot* and *Jak and Daxter* years. As we get into our more contemporary work, our current team of directors pick things up and share our latest stories.

Throughout Naughty Dog's history, our success has been predicated on our hallmark ability to tell powerful stories while creating best-in-class art and technology to move it all along. While it's impossible to encapsulate our entire thirty-year history in just under two hundred pages, this book is the best look we can provide at how we accomplish what we have done and what we will continue to do here.

We hope you appreciate this walk down memory lane and step towards our future as much as we do. Enjoy.

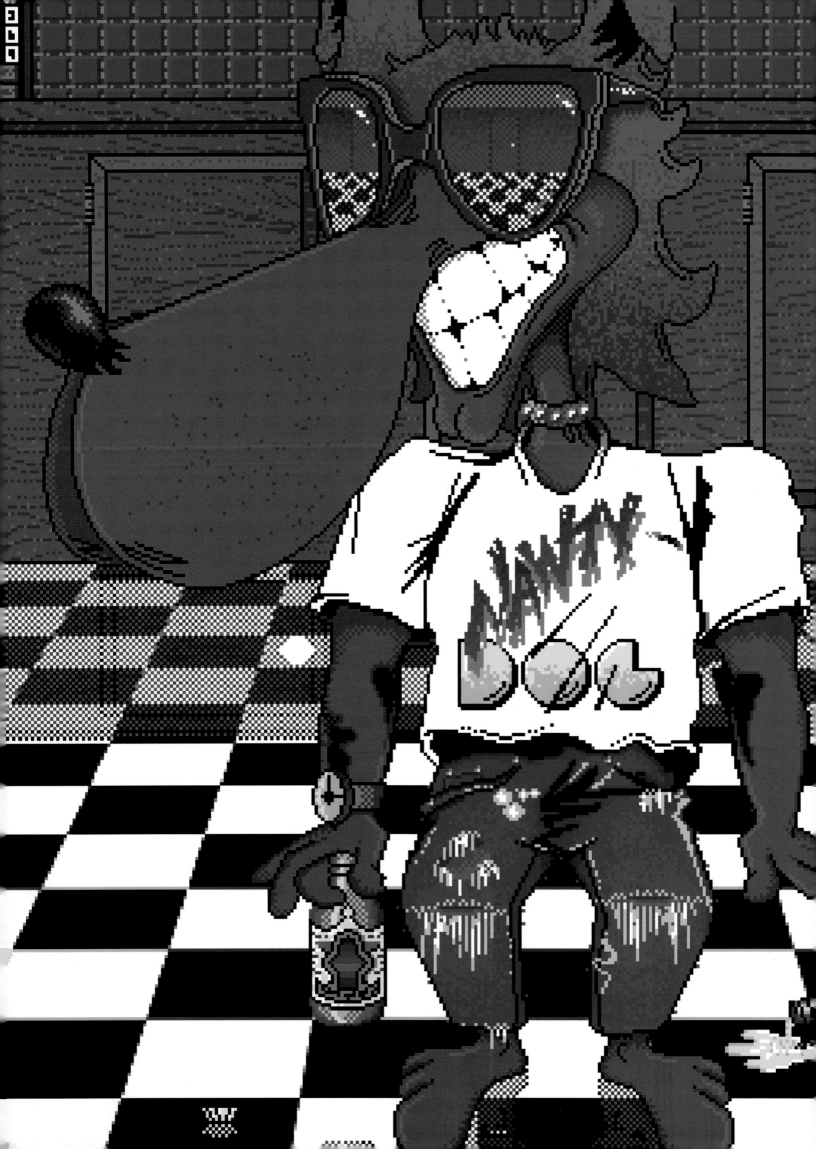

THE EARLY YEARS

1984–1996

Andrew Gavin and Jason Rubin, Naughty Dog's founding fathers, began working together in 1984 and departed Naughty Dog in 2001. The following essays take a look at video game development during their tenure. Learn how Naughty Dog started, our foundation, and where our benchmarks for making best-in-class games arose.

BUILDING THE KENNEL

BY JASON RUBIN

Hang loose—California had its own influence over Jason Rubin as his software development business grew.

Naughty Dog literally formed in Andy's basement.

It's hard to convey how unlikely, and truly uncool, it was for Andy and me to be making games back in 1983. When news of my hobby broke, I found myself hung from a hook in the junior high locker room, dangling by tighty-whitey elastic. Once free, I was determined to switch to boxers, but hobbled home undaunted to work on my latest game.

Slowly and surely, the solo experimentation became fruitful as Andy and I began collaborating. I wasn't born with the blood of a true coder, and Andy's art has always been "placeholder." Together we were a formidable, if awkward, early teen coding force.

Our first title, *Ski Crazed*, was published a year later. Within the next two years we published the adventure game *Dream Zone* and signed a contract to develop *Keef the Thief* for Electronic Arts. Then we graduated from high school.

During the eighties, most people considered video games to be childish toys (Nintendo famously shipped the NES with a robot to convince Toys "R" Us to stock it). But Andy and I always believed games were an entertainment medium equal to TV, movies, or music. We took games seriously, even if our early offerings were tongue in cheek.

As the eighties gave way to the nineties, Naughty Dog switched from computer to console games, developing *Rings of Power* for the Genesis and an over-the-top 3DO fighting game called *Way of the Warrior*.

My grandmother never really understood what I did, but as our generation grew from teens to young adults, we all kept playing. Games catered to the maturing audience. Once *Doom* and *Quake* were released, even the bullies that had hung us from hooks started playing—and we fragged their noob asses.

It was inevitable that Hollywood would take notice, both of the unsullied emerging game market and of independent talent. They offered us offices on Universal Studios' backlot, a real budget, and employees. Two human (and one canine)

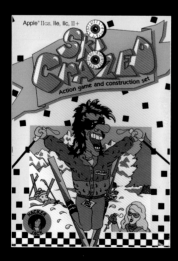

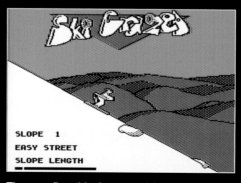

The very first title Jason and Andy developed together was *Ski Crazed*. It came out in 1986, when entertainment based around skiing was at its peak in popularity.

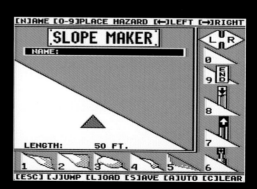

Level editor for *Ski Crazed*. It seems rudimentary nowadays but encouraging this amount of player agency on an Apple II computer was remarkable for its time.

Naughty Dogs piled in our tiny car and drove west.

The cross-country move marked the end of Naughty Dog's basement decade. We had sold fewer than 300,000 copies of all our games to date.

During our three-day journey, we planned out our next game. Racing and fighting games had gone 3-D, and we wanted to do the same for another genre. Our favorite was character action, but there were design challenges, control issues, and technical hurdles. We code named our idea "Sonic's Ass" because turning the level ninety degrees into the screen would leave the player staring at the hero's backside. As a security blanket, we planned to keep time-tested side-scrolling levels. And maybe running toward the screen would work too?

We hired a talented team—Dave Baggett, Bob Rafei, Taylor Kurosaki, Justin Monast, and Charlotte Francis—and set to work making the game that would become *Crash Bandicoot*. Our Universal Studios producer, Mark Cerny, was also instrumental. This book is a tribute to him as much as it is to Naughty Dog.

Naughty Dog took advantage of Universal's connections to enlist two amazing cartoon designers. Charles Zembillas and Joe Pearson, whose work you will see in the next chapter, gave *Crash* the visual edge and professional design that set it above its peers.

Sony's PlayStation announcement presented an unmistakable opportunity. Nintendo had Mario, and Sega had Sonic, but PlayStation had no mascot. We decided to fix that problem.

I have no idea what made Naughty Dog and the (admittedly more seasoned) Mark Cerny believe we could go head to head with two of the most accomplished game creators on the planet. Nor can I explain our unshakable confidence

As his Q Score rose, Crash became a de facto mascot with universal appeal and presence.

that PlayStation would eventually publish our product. But against all odds the plan came together.

Crash became the de facto PlayStation mascot. Naughty Dog's four *Crash* titles sold over thirty million copies. One in twenty PS one titles sold was a *Crash* title. *Crash 3* became the highest-selling foreign-developed game in Japanese history. Crash Bandicoot's image was on the TGV; Crash sold Pizza Hut pizza; Crash taught Australian beach safety. And at the height of his popularity, Crash had a higher Q Score than Superman.

I confidently switched to boxer briefs.

As Crash grew, so did Naughty Dog. One by one, Andy built a world-class coding team and I filled the art room with people far more talented than I was. We added dedicated sound talent, writers, designers, testers, and everything else required to make bigger and better games. I wish I had space to call them all out by name.

We didn't succeed at everything we set out to do. The team had wanted *Crash Bandicoot* to have story interwoven with action. But budgets and technology of the time didn't

Dream Zone was a text adventure game published in 1987 in which the player becomes trapped in their own dream after consuming a scientist's rotten elixir. It's a world full of strange, wonderful creatures and magic.

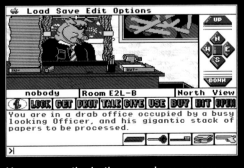
Here we see the bothersome bureaucracy that was part of the dreamscape in the game. Pigs in suits were one of the tamer dream creations.

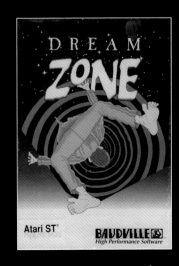

support it. By the end of the series we barely managed a rudimentary plot.

As our contract with Universal came to an end, we seized the opportunity to launch a new franchise, rewrite the rules, and push our dream of integrated story and gameplay forward. We gave the hero a sidekick, so dialogue could happen at any time, and made the game seamless and load free. *Jak and Daxter* succeeded in creating a feeling of solidity and unity that had yet to be experienced in a character action game.

Naughty Dog had become one of the preeminent game developers on the planet, and *Jak and Daxter* was wildly successful. Our talent as game makers and storytellers kept improving, and our games kept getting better. But we were never satisfied with our own work and always pushed for more.

PlayStation supported our dreams. Without PlayStation, and especially our executive producer, Shuhei Yoshida, and our US, Japanese, and European production, marketing, PR, and QA teams, this book would likely not exist.

The decision for Naughty Dog to become part of PlayStation during the development of *Jak and Daxter* felt natural and obvious. Nobody looked up from his or her monitor.

We did look up when *GTA III* released—and the world changed. I vividly remember two eight-year-old focus group subjects telling me that *Jak II* was awesome, but it was meant for their younger brothers.

So Jak changed his attitude. As he grew up, the games grew up. Jak got a gun. Daxter's humor got more mature. The games got grittier. And we liked it. It was clear to most of the team that we were going to be making games for adults on the PlayStation 3 kits we were tinkering with in the back room.

And with the hardware, budgets, and tech all finally supporting us, we were finally going to get that action and story thing right.

But Andy and I were tired. The second decade of Naughty Dog, the *Crash* and *Jak* years, was coming to a close, and the two of us hadn't had a real vacation in years. Naughty Dog had sold more than forty million copies of our games, but each game had taken its toll on Andy and me.

The decision to "take some time off" was made easier because there was incredible leadership talent at Naughty Dog that could step in as we stepped out. Andy and I took two years to shepherd that transition, and the team never missed a beat.

In fact, as the third decade of Naughty Dog began, I felt confident that the best was yet to come.

And when I sat down to play *Uncharted 2: Among Thieves* five years later, I realized that Naughty Dog had finally fulfilled our foundational dream: story and game interwoven seamlessly in a character action game.

I had no idea that there was so much more the team still planned to do . . . but that is a story for someone else to tell.

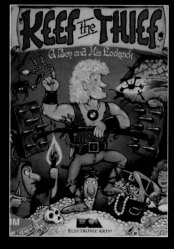

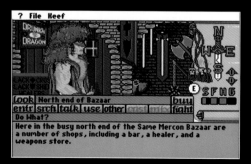

Due to file size and space limitations early on in software development, a lot had to be said using just one (rather busy) screen. Here we see a screen that lays out all the shopping possibilities for an entire bazaar.

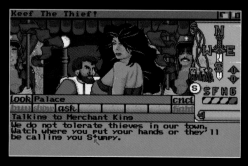

Interactions with nonplayer characters helped to move *Keef the Thief*'s story along and give personality to colorful, 2-D art.

ITERATE AND REVISE THE LIMITS

BY ANDREW GAVIN

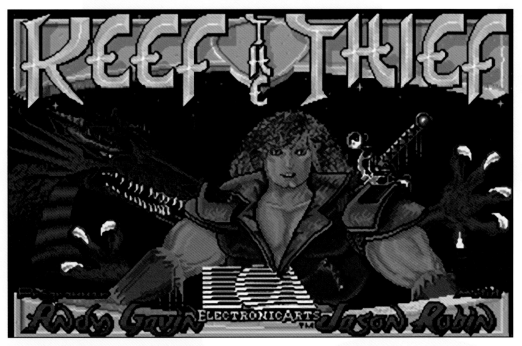

Published in 1989, Keef the Thief was the first game developed under the Naughty Dog moniker.

near each other, and only if two of those four were black and white. There was no yellow, but a horizontal line of green over a horizontal line of red looked yellowish. If your head is spinning, then I'll spare you the full rule set. Not only were the graphics oddball and finicky, but few tools existed for making them. Prior to 1984, it was common to "draw" computer art on graph paper and then type in the code that represented your paper image.

For some of Naughty Dog's earliest games, Jason resorted to using another game to draw the art. It turned out that *Pinball Construction Set* (a hit game from the eighties) allowed you to "paint" custom backboards for your pinball machines. The pixel editor (a primitive art tool) built into the game was better than any commercial art product. Too bad it only drew on three-quarters of the screen and you had to reboot your computer to "save" the art.

Then, as now, part of the challenge of making games was just figuring out how to make the art.

By the late eighties and Naughty Dog's *Dream Zone* and *Keef the Thief*, the Apple IIGS had progressed to a 320 x 240 screen with a jaw-dropping sixteen colors. But moving all this

Game production art can be as creative and detailed as you like, but in the end, it has to be displayed on real hardware. Limitations and restrictions are part of the game of making games. Over the years, platforms have become more powerful, but the struggle between what you want to do and what you can do goes on.

The earliest Naughty Dog games fit in 64K of memory. Your Facebook profile picture is probably bigger, but back then an entire game had to be smashed into this space: code, art, sound, everything. Screen resolutions were low and colors were limited. Our first machine was the Apple II. It only displayed six colors total, you could only use four of them

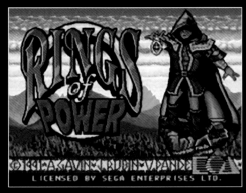

Released in 1991 for the Sega Mega Drive/ Genesis, *Rings of Power* is an isometric RPG. The player must collect the rings to defeat the evil god Void.

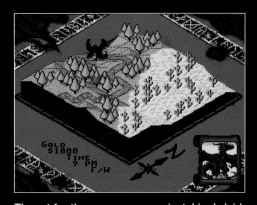

The art for these maps was painstakingly laid out one block at a time. The game world is massive and open ended; the player can go virtually everywhere.

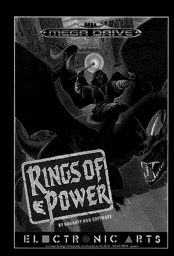

art really bogged down the computer, and it was still a challenge to make attractive-looking graphics with so few colors. You had one flesh(ish) tone, some grays for rocks, and a few blues to make water. At least the sun could finally be yellow. Everything was dithered and pixelated. But the art had its charms.

And as always, memory continued to be a huge problem. When we moved to the Sega Genesis in 1989 for *Rings of Power*, things got really tight. The entire game—and it was a big game, perhaps the largest cartridge-based RPG at that time—had to fit on one small, costly cartridge. The whole cart was a whopping megabyte (a third of an iPhone photo or one minute of MP3 music nowadays). Even with this then-massive capacity, we had to concoct upwards of a dozen tricks to cram all the stuff in. The cartridge was so big (and hence expensive) that our publisher chose not to reprint when we sold out because of the cost.

The art for *Rings of Power* was made of blocks made out of blocks made out of blocks: 8 x 8–pixel sixteen-color blocks formed the fundamental unit, then larger blocks (often about 32 x 32) were constructed out of arrangements of these smaller blocks. Jason reused as many component blocks as possible. Then these tiles were organized into a giant map that took six months to lay out, one block at a time. We are convinced it was such overkill that there are areas of the map that no gamer ever saw. Creative tricks like flipping or alternating colors were employed to spice up the often-repetitive tiled landscape. The amount of dialogue in *Rings* caused us to break the text into words that were then compressed into "dictionaries" to cram each bit as tightly as possible. And the entire save game had less than one thousand bits of space. So we had to pack data heavily. This meant that if you had 863 gold pieces and saved your game, you might only have 860 when you came back. Sorry, but most titles at the time didn't even offer a save game!

Naughty Dog's fighting game, *Way of the Warrior*, got to take advantage of revolutionary technology. The new 32-bit 3DO machine supported as many as sixteen thousand colors

Casting spells was a gameplay mechanic in Rings of Power. *This art was also put into the game one block at a time.*

Many characters populated the world, and even Keef the Thief made a cameo in Rings of Power *as a nonplayer character.*

on the screen! Wow! And even better, 3DO games came on CD-ROMs sporting 650 megabytes of data. Too bad they were so slow and the hardware was weak and didn't have much RAM. We concocted all sorts of strategies to load the massive amount of data now available (like rich, multicolor backgrounds) off that slow disk. Little did we know that this would lay the groundwork for solving many of *Crash Bandicoot*'s design and technology challenges.

Ever wonder why each successive *Crash Bandicoot* looked lusher and more detailed than any other PS one game?

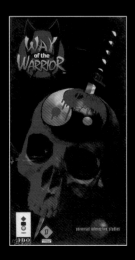

Released in 1994, *Way of the Warrior* **featured some ultraviolent finishing moves, many of them motion captured in Jason's apartment.**

Hidden characters could be unlocked with secret cheat codes.

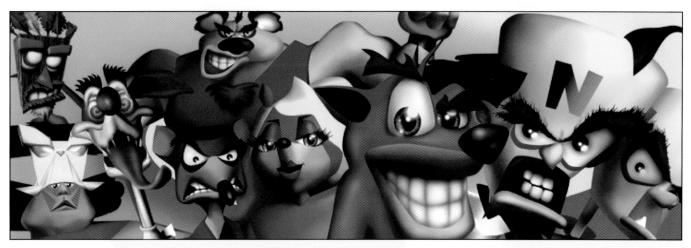

While video game development and artistry have progressed dramatically in thirty years, character detail and environmental depth have always been hallmarks of Naughty Dog games.

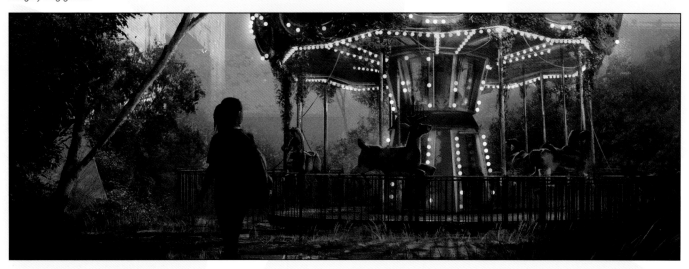

Why they had more polygons, more texture, and more detail onscreen? From the beginning we were determined to make *Crash* look like a real cartoon, and that meant great animation and detailed backgrounds. Typical *Crash* levels started off on our servers as hundreds of megabytes each. But the PlayStation could only handle eight. Complex computer code inspired by programmer Dave Baggett and my time at MIT's artificial intelligence lab cut, diced, packed, and then moved blocks of memory off the disk constantly as you played. When PlayStation saw our clever coding, they were worried because the early PS one CD drives were rated for fewer lifetime reads than one *Crash* play-through now used. We all agreed never to mention that in public (until now!). Clever tricks for compressing polygons and animation made it possible to squeeze thousands of frames of really smooth movement into the game. But building that tech was a lot of work, keeping programmers and artists busy for years.

Technical constraints drove design decisions. We chose orange as Crash's color because red-orange runs hotter (and hence more visible) on NTSC televisions. Crash wears black fingerless gloves because his fur is a fairly uniform color and the lighting model on the PS one was weak and left him monochromatic, but the gloves allowed you to see his hands in front of his body. We could have added texture to Crash,

but didn't because the PlayStation drew polygons without texture much faster. His eyes, mouth, and head were huge so you could see the details of his face on the low-resolution screen. Smaller pupils would disappear as they became less than a pixel tall.

The struggle to keep things onscreen looking as good as possible didn't end with *Crash*. *Jak and Daxter* took that quest to the next level. We wanted a seamless world with no loading and views as far as the eye could see. Every leaf, every bush, and every rock in *Jak* is carefully constructed, with several technologies designed to scale to large views. Trees lose their leaves in the distance. Bushes simplify and fade. Rocks round off their corners. Again we employed aggressive strategies to fit in memory, particularly our insanely good animation that helped bring the characters to life.

This endless battle between hardware and content continues unabated. The newest Naughty Dog games continue to push the PS3 and beyond to the absolute limits. This book will explore some of that battle and talk about what was done and what is currently done so that all Naughty Dog games win.

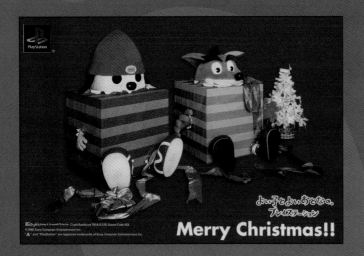

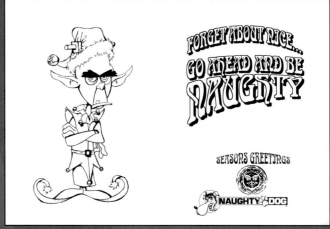

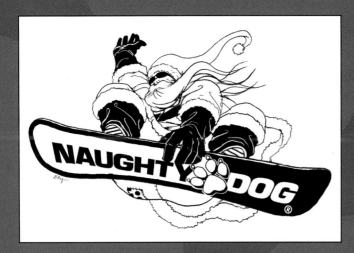

HOLIDAY CARDS

It's a Naughty Dog tradition to have one of our many talented artists share their abilities with our friends, families, and colleagues in the industry. Each year we create a new holiday card to send out. In addition, all our launch parties get their own unique invites. Our characters are treated as part of the family and we use them to express our joy and friendship on our holiday cards and invitations. We've had cameos from other PlayStation IP such as PaRappa the Rapper, and even Pogo, one of the resident Naughty Dogs we have had throughout the years, made an appearance one year.

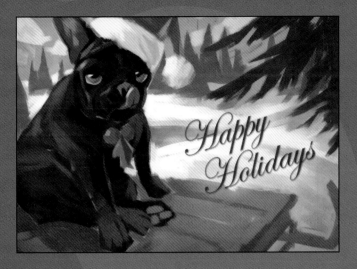

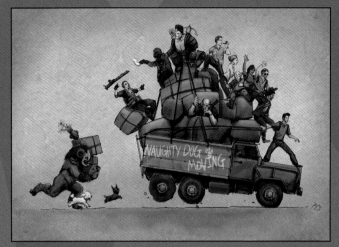

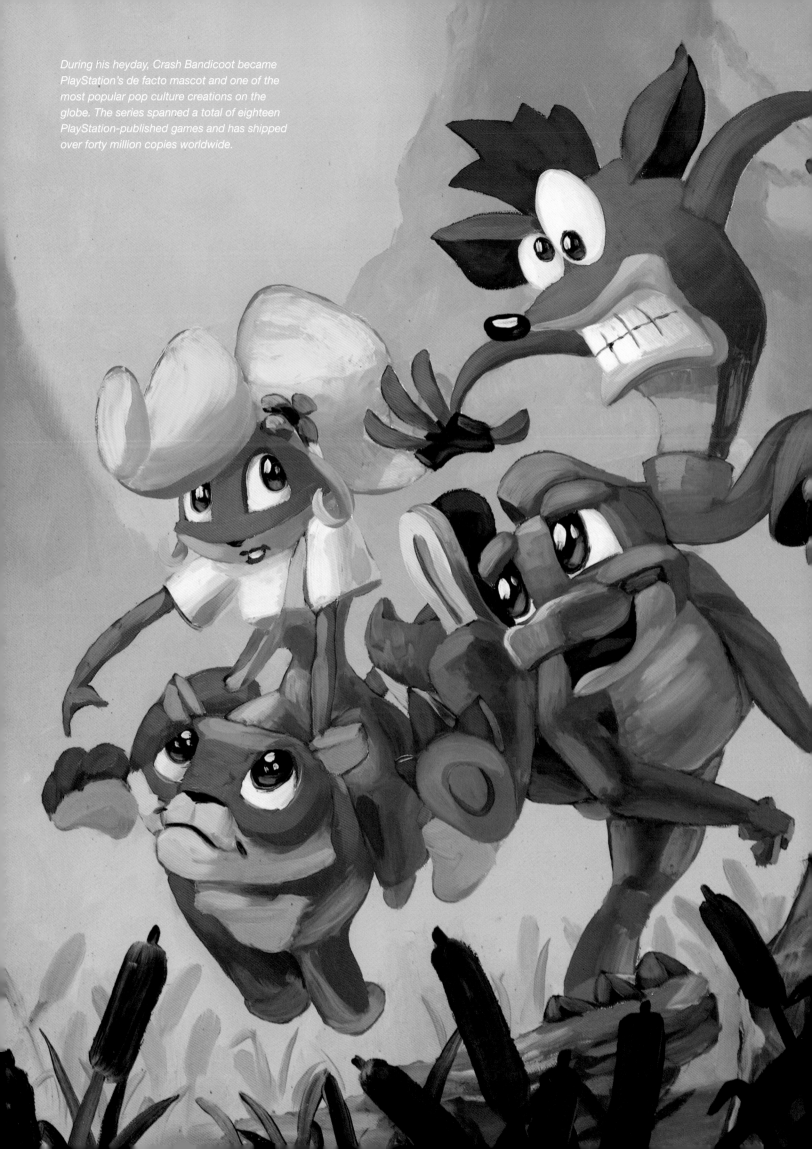

During his heyday, Crash Bandicoot became PlayStation's de facto mascot and one of the most popular pop culture creations on the globe. The series spanned a total of eighteen PlayStation-published games and has shipped over forty million copies worldwide.

CRASH BANDICOOT

1996–1999

BY BOB RAFEI AND ERICK PANGILINAN

During the original Playstation days, mascots dominated the industry, and we developed a surprise contender. Mario was still everyone's darling, and Sonic was nowhere to be found. PlayStation was looking for a mascot, and our new character became a natural fit. But we were battling the icons of the industry with fewer than ten people, and we had less than a year to finish the first game. Looking back, it's hard to believe *Crash Bandicoot* actually got made in that small room on top of a parking lot building in the armpits of Universal Studios.

The early discussions of Project "Willy Wombat"—the production name we thankfully later changed to *Crash Bandicoot*—felt unbounded. There were revolutionary plans to turn the camera found in a traditional side-scrolling game on its head to allow it to follow a character in 3-D. We had set our sights in a classic *Looney Tunes* direction through a stylized world with smooth-, squash-, and stretch-style animations. Some very smart decisions were made in the preliminary days of *Crash* in design, tech, and art direction. Artistically speaking, having animation veterans like Joe Pearson and Charles Zembillas on the project helped us set strong visual targets for environment and character personalities from the start. To make sure we could bring Crash and the rest of our fun designs to life, we studied the art of many Disney features, in particular in the book *The Illusion of Life*, to ensure we applied classic principles. Soft-body animation is pretty commonplace today, but back in 1995 it was rare in games. We placed a lot of emphasis on fluid animation, exaggerated cartoon

The quest to create lush, rich organic environments became a staple in Naughty Dog's early days and carries on in the studio's DNA today. However, lush settings have a way of quickly finding hardware limitations. We decided to keep Crash on a path and the camera in a spline so we could precompute what was visible at any given frame. This allowed us to create very dense jungle paths, but in order to stay within proper frame rates, only 900 polygons (raised to 1,200 on *Crash 2* and roughly 1,350 on *Crash 3*) could draw at any point along the spline. (To put this in perspective, Drake's *head* in *Uncharted 4* is more than 30,000 polygons by itself.) This meant we could pack several hundred thousand poly environment meshes into any given level by only rendering a handful of them at any time; everything else was occluded. Knowing where the camera would be at any given time also allowed us to plan for mesh and texture density based on how close or how far away we were in relation to the main path.

Jason made Andy place a buzzer sound every time we went over in-game poly limits during development. That buzzer became the bane of the art team's existence. Some of us can still hear that damn buzzer today! Many all-nighters were had trying to get whole sections (typically vistas) or a few frames here and there to fall under proper poly counts before major deadlines.

But this environmental density caused a major production challenge for our small team of eight people. How would we ever have enough time to assemble, texture, light, and fix bugs in our levels?

Enter "Dave's Level Editor," a.k.a. the DLE.

Dave Baggett wrote an editor that allowed us to use color values from a picture file (a top-down map of the level) to assemble level environments. Typically one pixel on this image was one meter in game space. We had to set up text-based look-up parameters, such as exact RGB values, and support them visually with an assortment of puzzle pieces that represented each "chunk" or strip of the level. We were essentially creating environments using Photoshop! Our first proof-of-concept level for *Crash 1* became a jumbled mess of eight-bit-looking vomit. We learned a lot from that first level and with iteration found the best practices for using it.

As a result, our environments packed more detail and color than any game made at the time that was not prerendered. This, coupled with the facts that the characters cycled through several different, colorful, unique locations and the game changed camera angles to keep pacing fresh and interesting, made us realize we had something special. The graphics used more polygons and textures than anything that was out there. Crash became truly mascot worthy.

Over the span of *Crash 2* and *3*, the DLE became very sophisticated, with many features, like bump map, vertex color map, texture map application, object placement, etc. By *Crash 3* it was like looking at the Matrix.

The DLE ultimately was a huge asset for *Crash* but also had many limitations, the greatest of which was restricting more freeform modeling outside a grid-based system. As we developed a more standard, wide-linear-format world for *Jak and Daxter*, we had to leave the DLE behind along with the PS one.

As *Jak and Daxter* started to take shape and *Crash* development began to wind down, we expanded to around thirty people. We were running out of space in our old office, and some of us felt worried that we would turn corporate or lose the nimble, small-company feel. Naughty Dog felt like a band where everyone worked hard together and shared the pain and glory together. We never lost that feeling. There was a lot of pride in making Crash Bandicoot into what he became—the de facto mascot of an internationally renowned brand. We proudly wore that Naughty Dog badge around our necks when walking into Nintendo's and Sega's booths during E3.

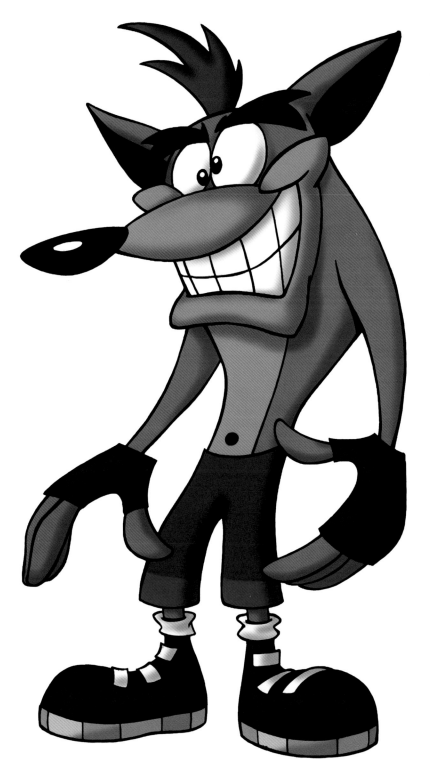

CRASH BANDICOOT

Based on an eastern barred bandicoot, Crash represents a genetically mutated version of this marsupial. Crash was originally called Willie the Wombat before the idea for his final name came along. Coming in at 512 polygons when put in the game, Crash's cartoonish design embodies the goofy, fun-loving personality a would-be mascot needs to have.

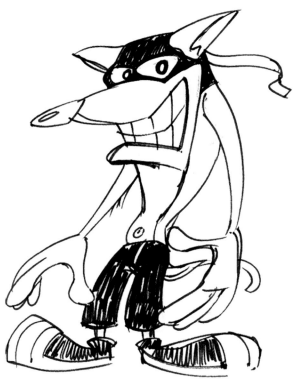

The first drawing of Crash that stuck and led to his final look.

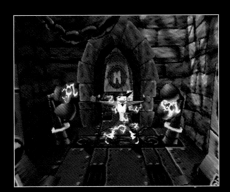

A signature of the series was the huge variety of ways that Crash could meet his demise. Since players would be dying a lot, we thought entertaining deaths would take some of the sting out.

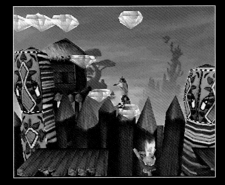

The *Crash* games were also notorious for their difficult-to-find secrets. Here you see Crash following a chain of gem platforms to reach one such secret.

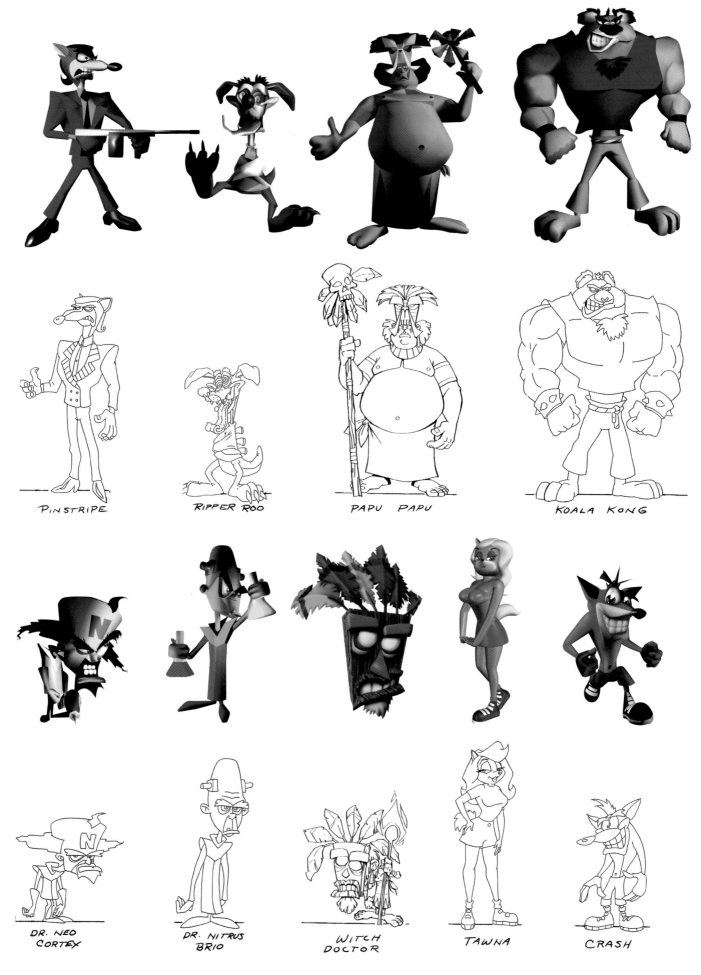

PINSTRIPE

RIPPER ROO

PAPU PAPU

KOALA KONG

DR. NEO CORTEX

DR. NITRUS BRIO

WITCH DOCTOR

TAWNA

CRASH

CHARACTERS

Various secondary characters and villains are depicted here, but Dr. Neo Cortex, clearly recognizable by the giant N on his forehead, was the main antagonist of the series. Cortex had to exhibit tons of attitude and be all about minions in the way only evil-genius villains can.

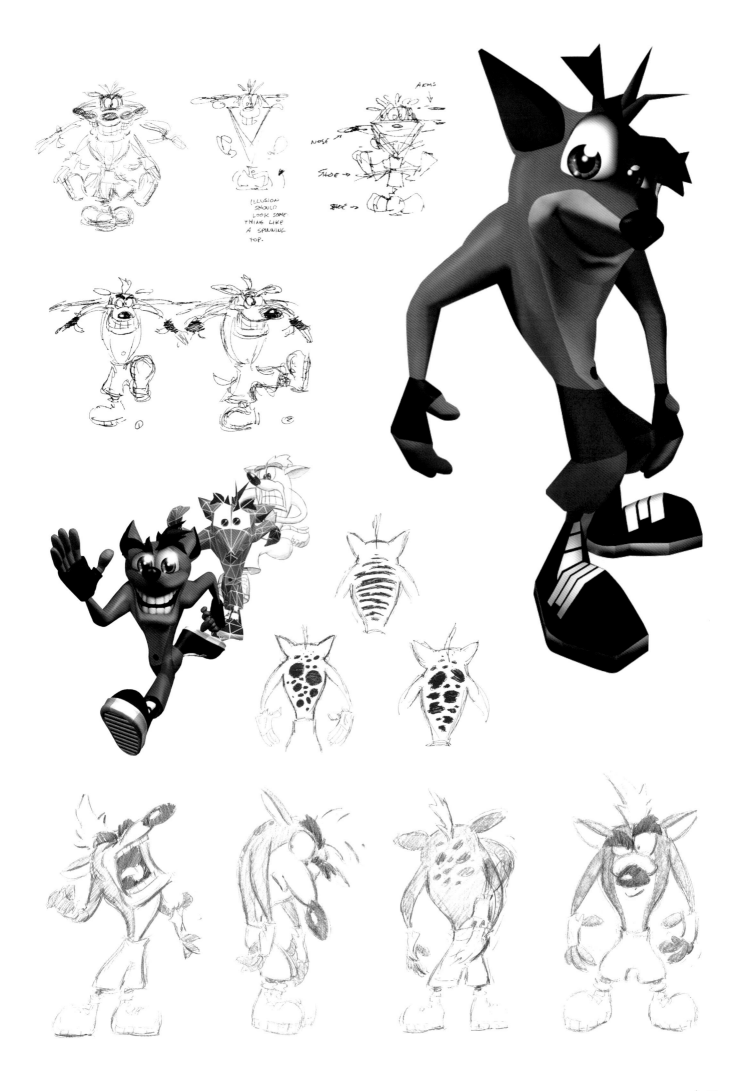

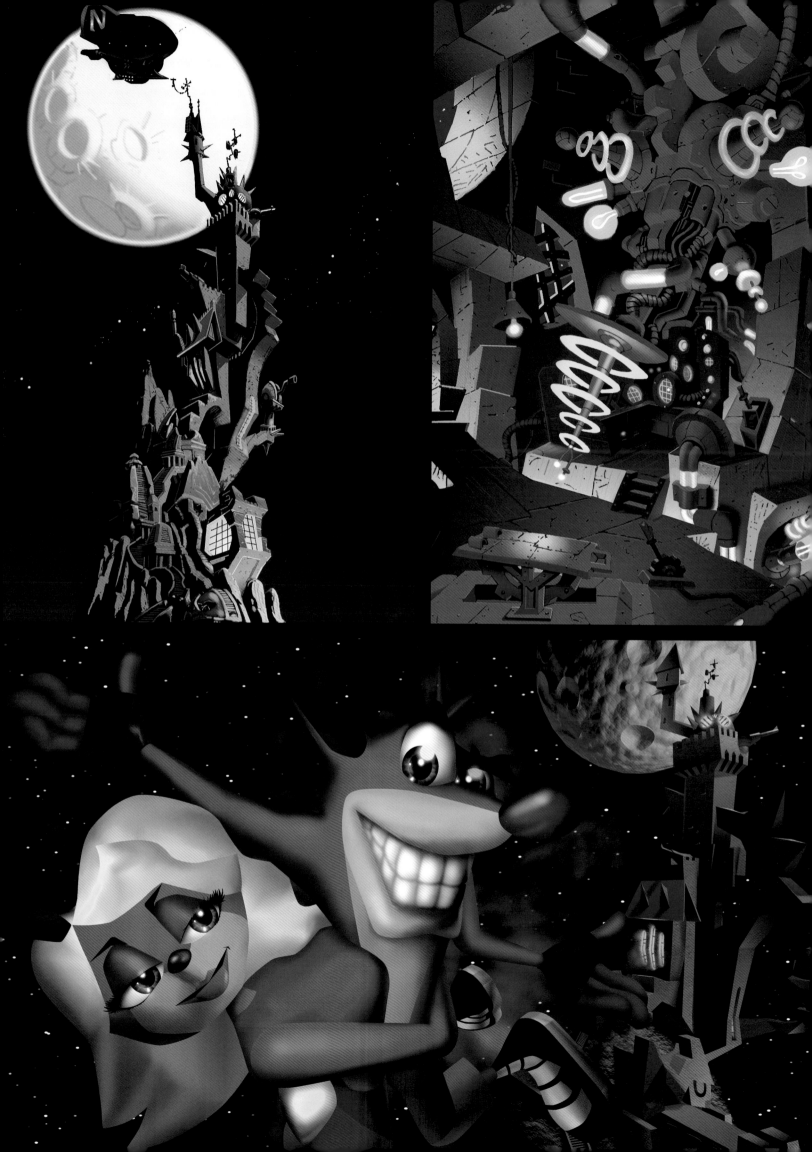

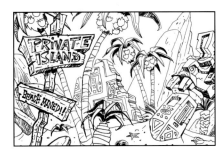

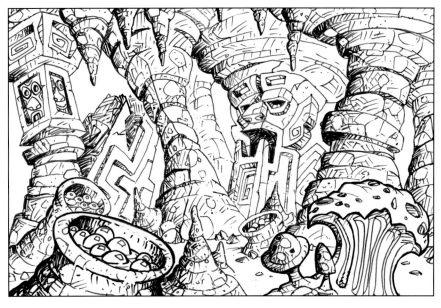

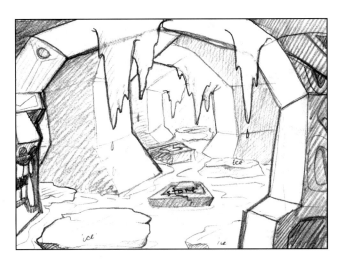

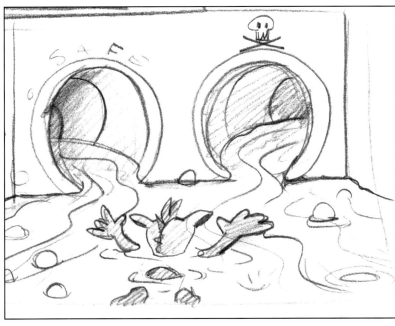

longer blocks sink from weight at ends - balance in center - if tilted in one direction, Crash slides in that direction

LEVEL DESIGN

Several sketches of the different environments that Crash would explore in his first adventure.

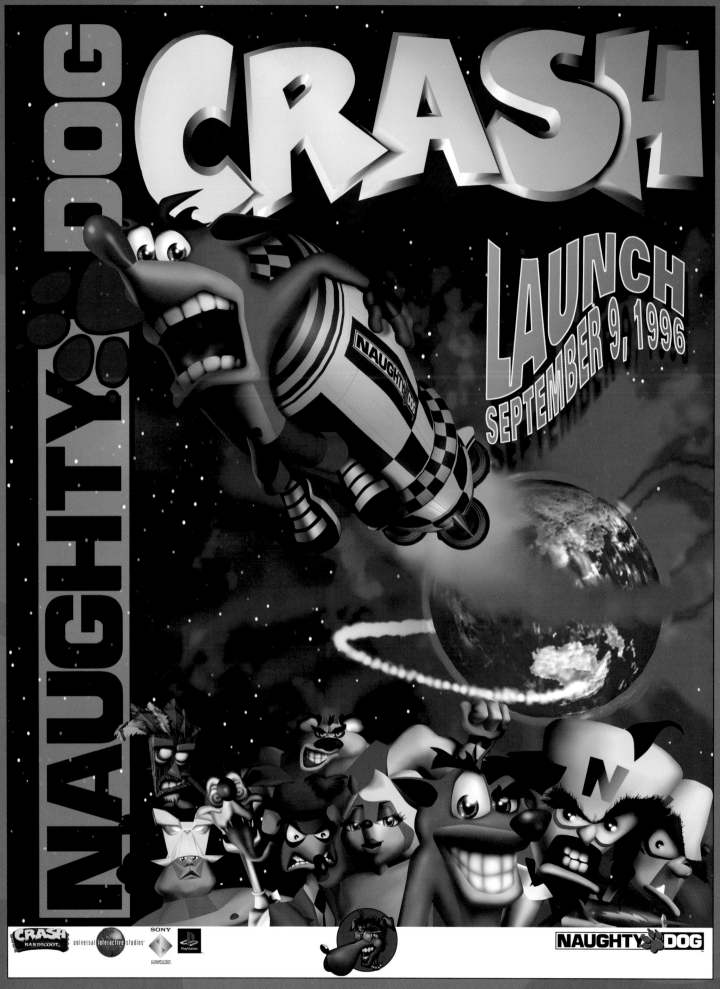

LAUNCH POSTER

The launch poster for the original Crash Bandicoot. The development teams always sign the prints, and this poster didn't need to leave much space for the mere eight team members who created the game!

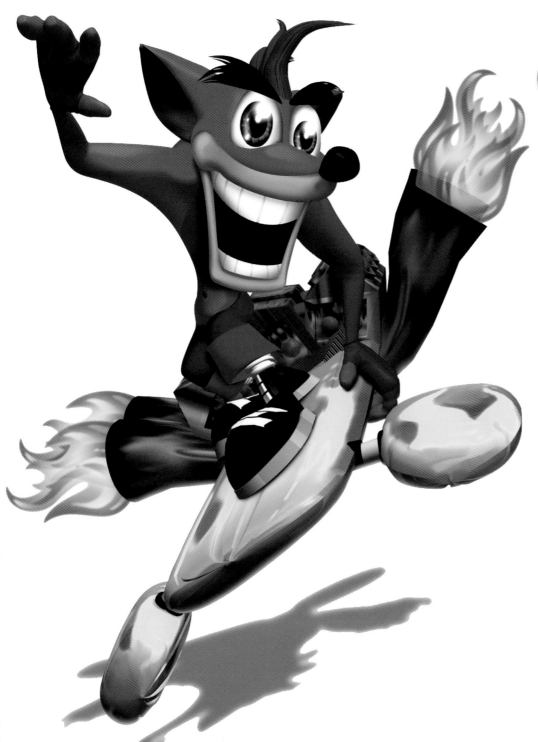

CRASH BANDICOOT 2: CORTEX STRIKES BACK

By Crash 2, the character was ready to take off. A new engine named "Game-Oriented Object LISP 2" (GOOL 2) was built that could handle twice the polygon count and ran three times faster. This meant the characters would be reworked and progress along with the tech.

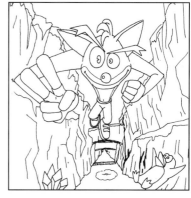

Crash riding his jet-powered surfboard upriver while dodging deadly nitro crates.

Crash after first donning his jetpack in one of the later levels of *Crash 2*.

COCO

Crash 2 introduced Crash's younger sister Coco, along with one of our finer moments of storytelling: the game's entire mission is to help her find her missing laptop battery.

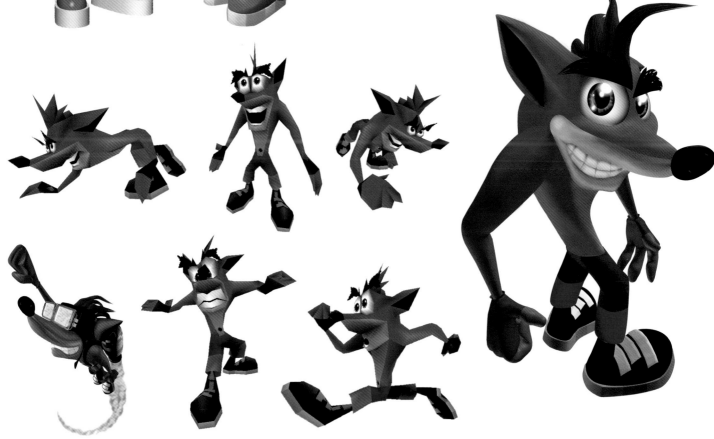

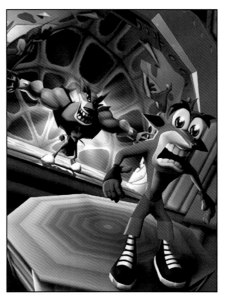

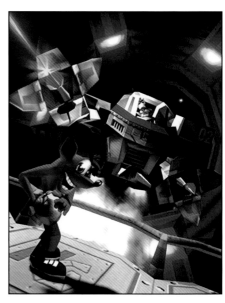

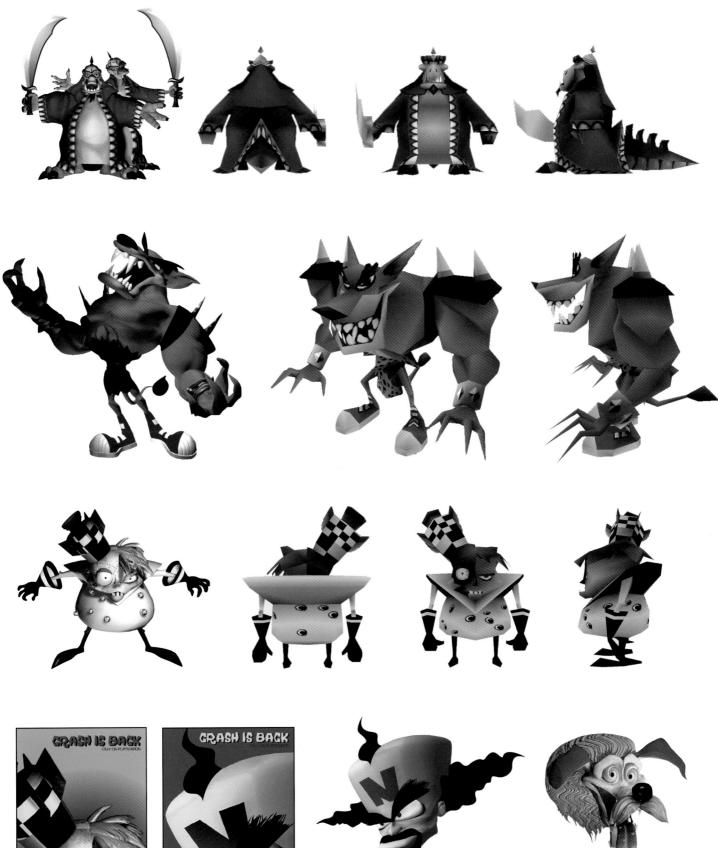

BOSS FIGHTS

Tiny Tiger, the Komodo Brothers, and Dr. N. Gin were boss characters with special move sets. There was a big argument between the programmers and the animators about the N. Gin boss fight. We ran out of memory for animation, which is why Crash shoots wumpa fruits from his "butt." Animators were not happy about that.

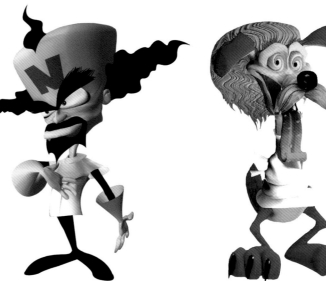

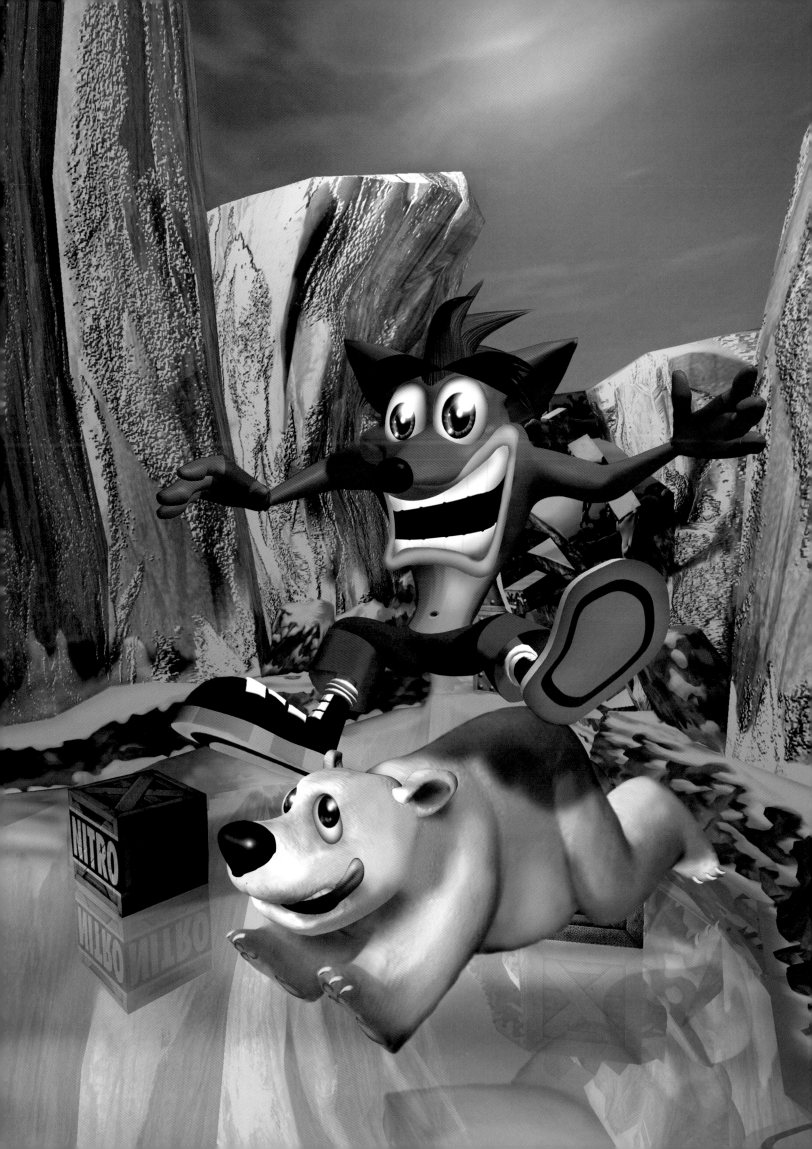

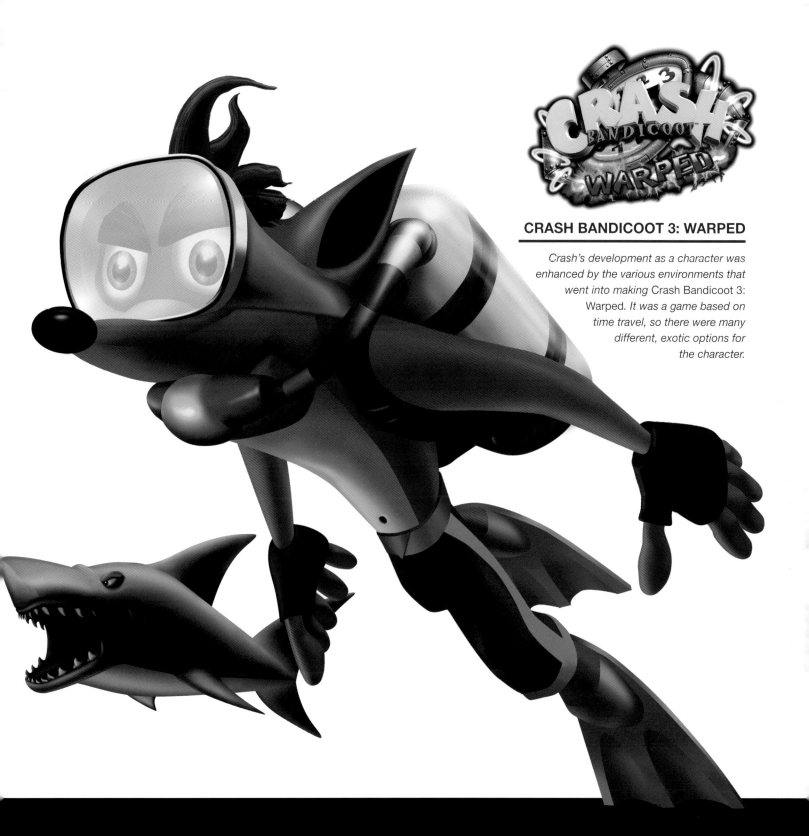

CRASH BANDICOOT 3: WARPED

Crash's development as a character was enhanced by the various environments that went into making Crash Bandicoot 3: Warped. It was a game based on time travel, so there were many different, exotic options for the character.

As Crash traveled through time, he visited a medieval land, complete with

Coco gets in on the action as she rides along the Great Wall of China on the

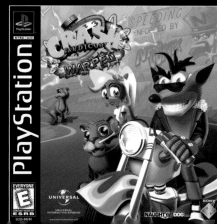

CHARACTERS

Coco Bandicoot and the time-travel premise of *Warped* gave our artists free rein to get imaginative with character designs and companions. Pura, Coco's pet tiger, made its first appearance and was a complementary character to Polar, Crash's pet polar bear.

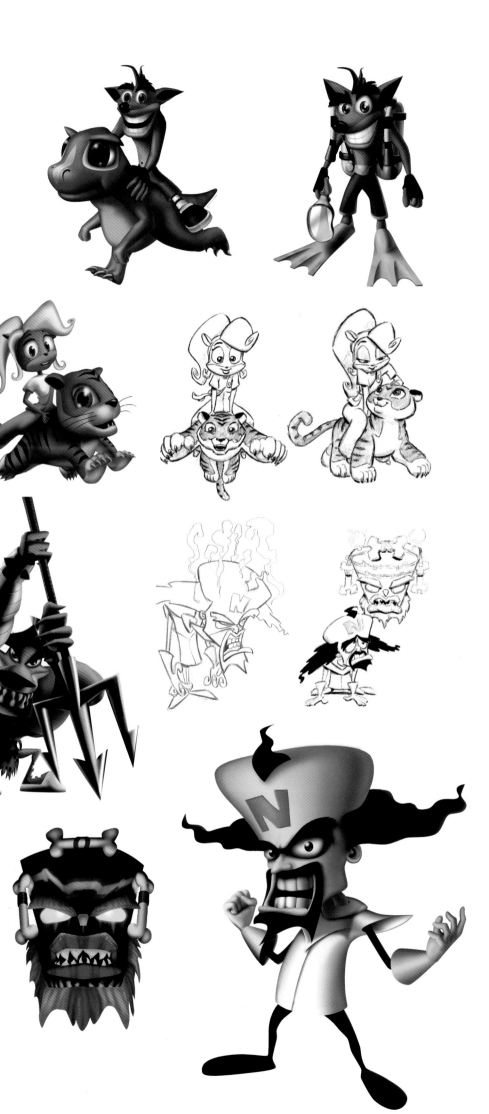

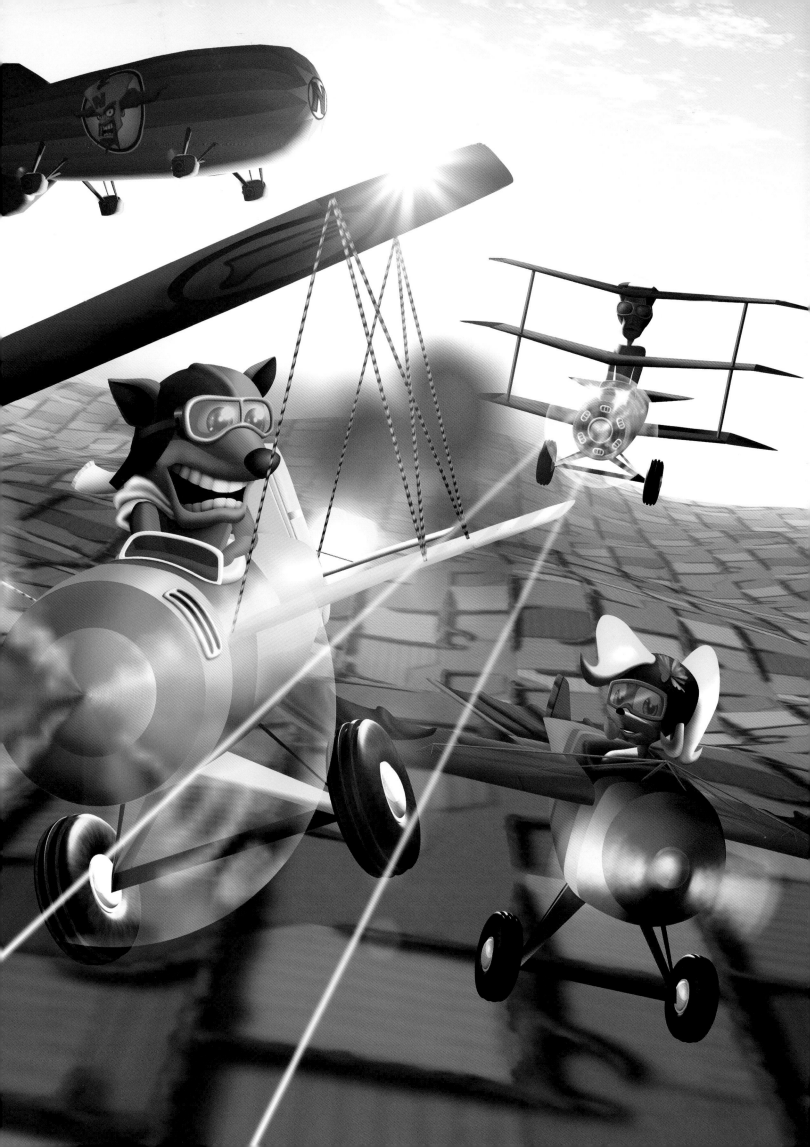

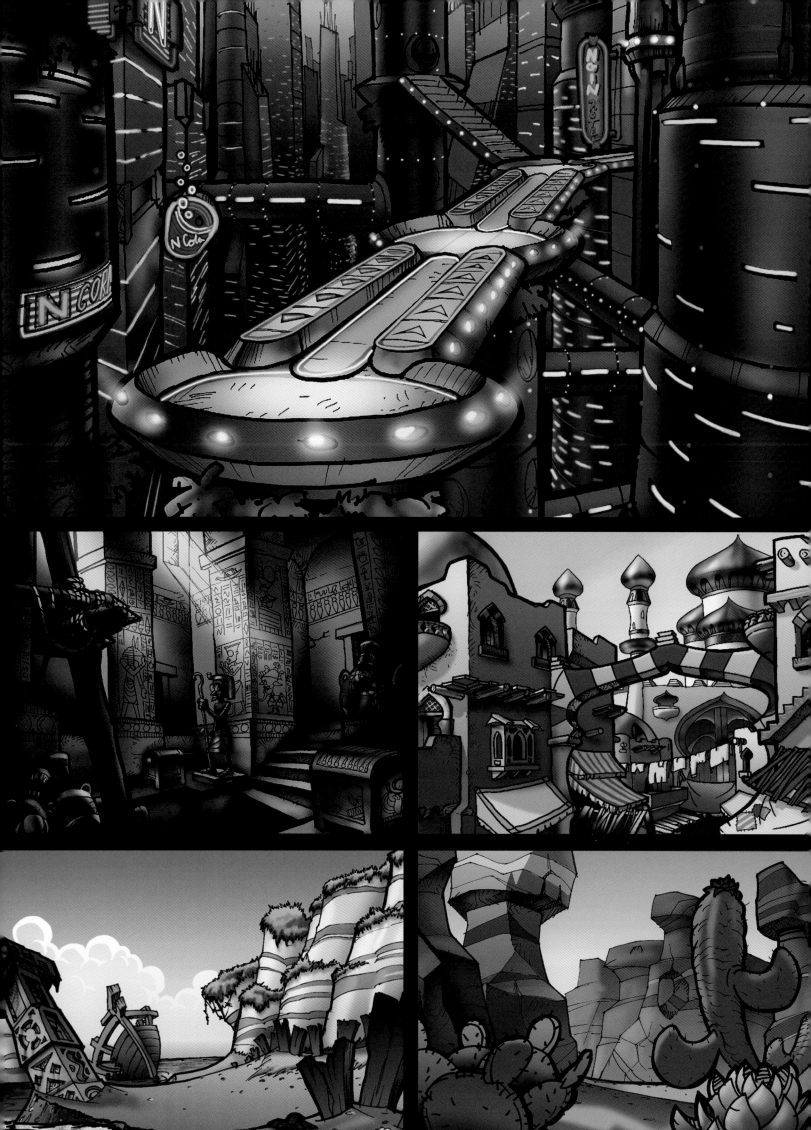

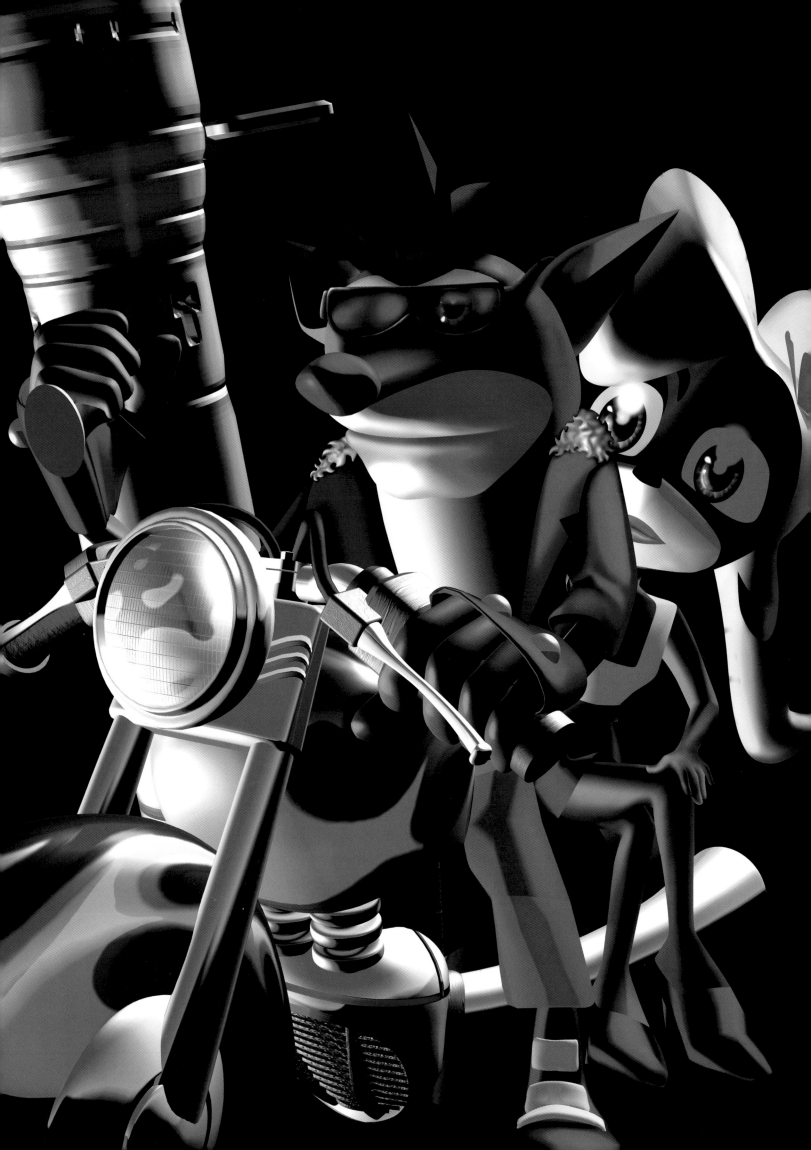

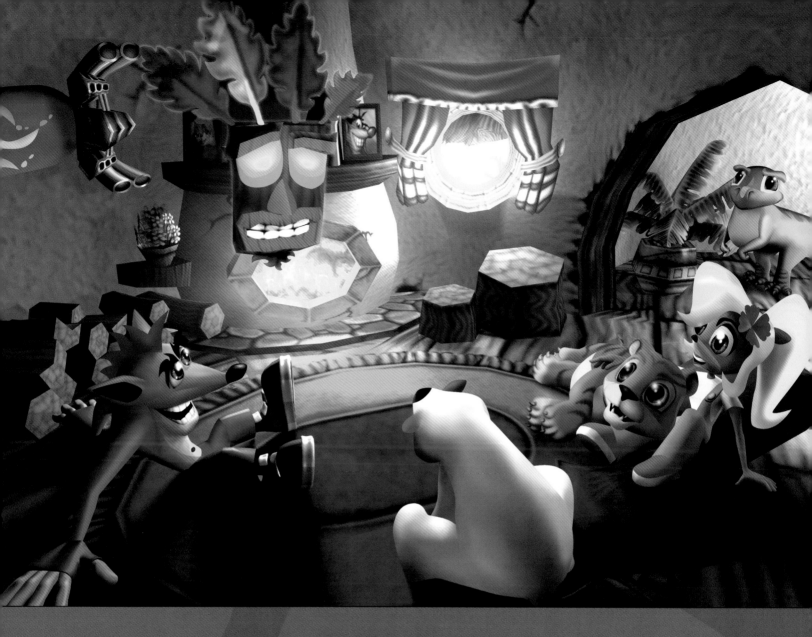

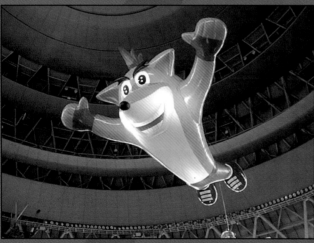

As Crash's popularity grew, the mascot versions of him spread around the world. Crash was our first and (so far) only character to become a giant, inflatable balloon!

CRASH TEAM RACING

A bit of a departure from Crash's normal adventures but the perfect activity for a fun-loving bandicoot, Crash Team Racing launched in 1999. Development for CTR began after Crash 2, when the new game engine that was used for Crash 3 took shape.

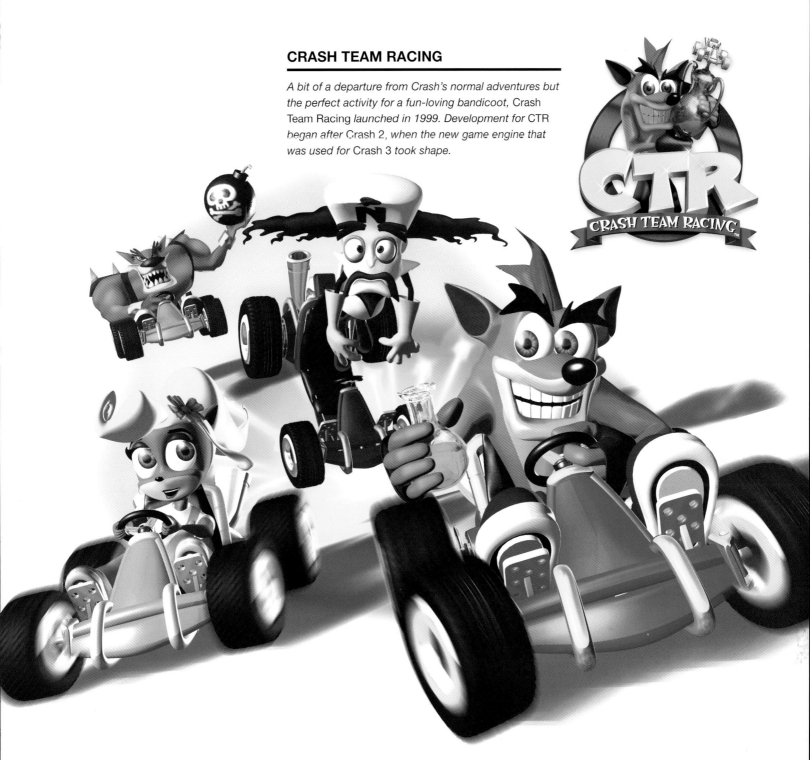

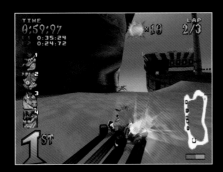

Crash races into first place as he rounds the corner on the game's first track, Crash Cove.

Four-player split screen is where *Crash Team Racing* really shined.

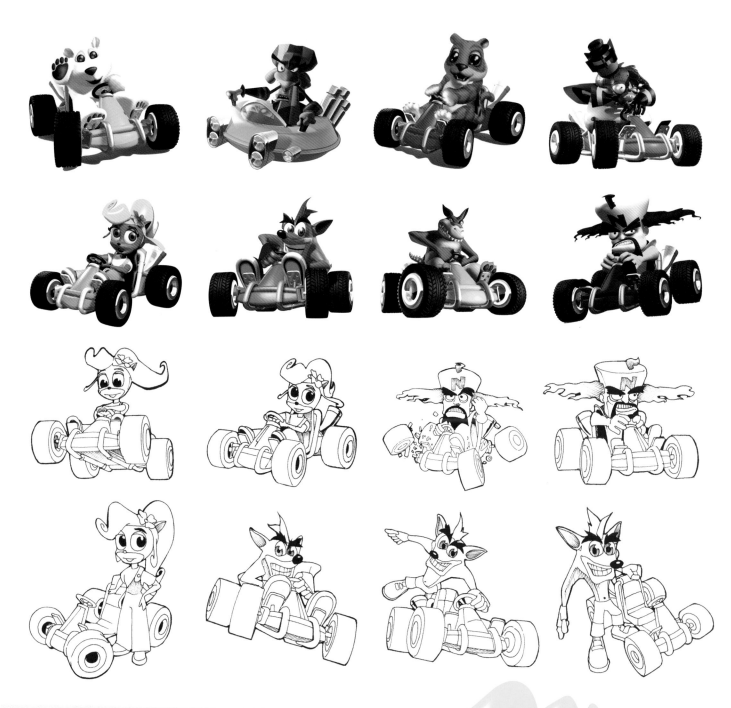

KARTS

To deal with the challenge of possibly having up to sixty-four kart tires on a four-player split screen for PS one, Greg Omi developed an efficient way of rendering them as camera-based sprites.

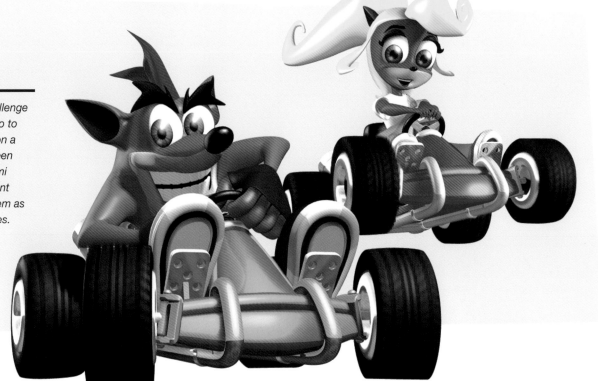

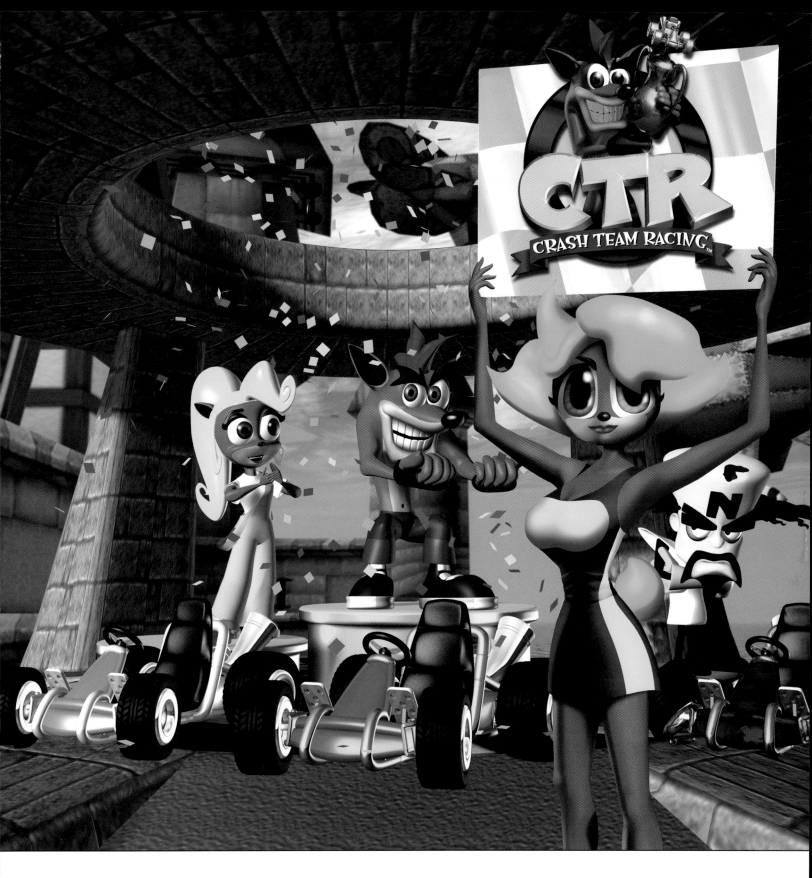

POWER-UPS

Power-ups are a key staple of the kart-racing genre, and CTR had a wide selection that could be "juiced up" by collecting wumpa fruit.

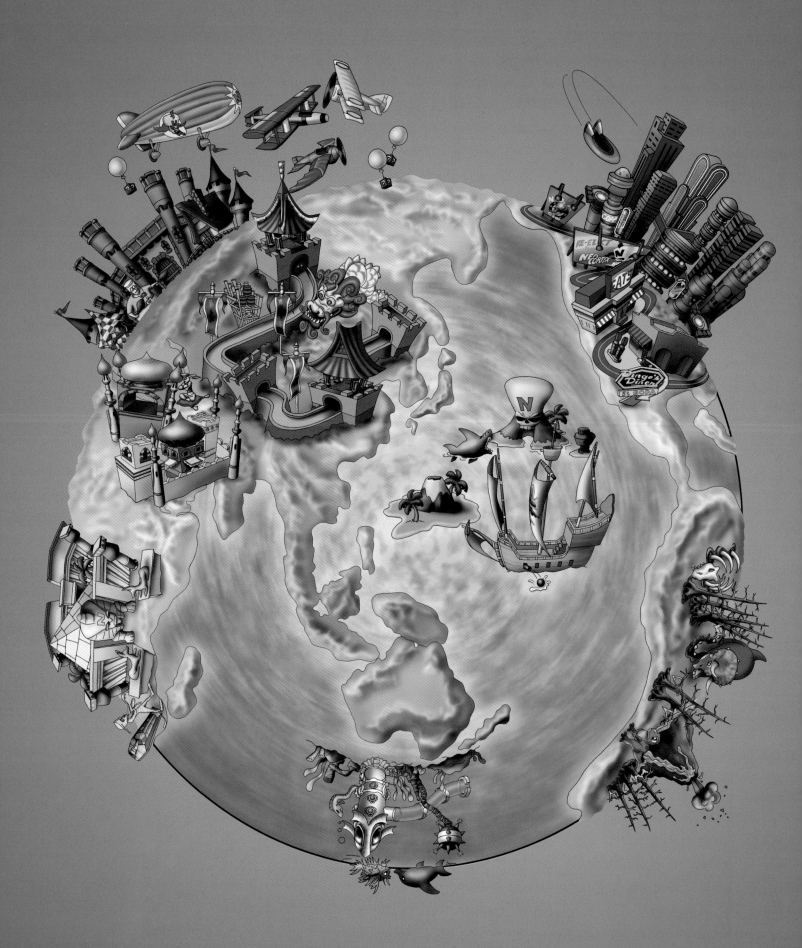

We love variety in our environments, and
we usually end up globetrotting to different
locations or even time traveling to different
periods. This is a trademark in all ND games,
as we try to keep the consistency in style
while creating a fresh look for every level.

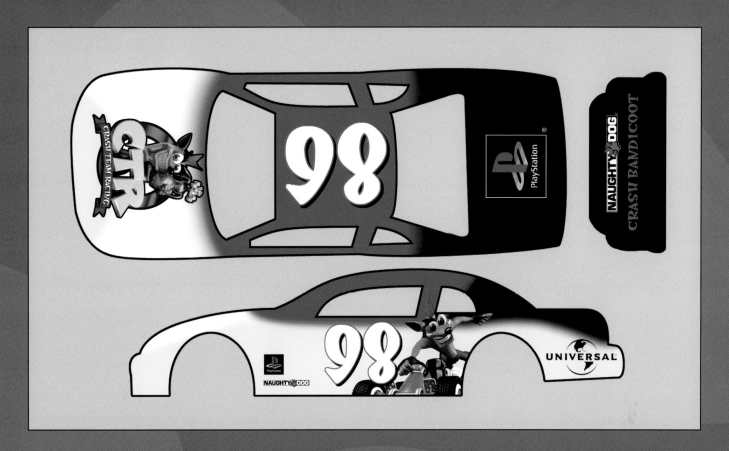

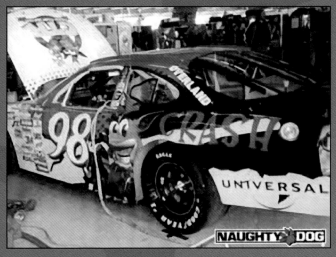

E3 AND NASCAR

By the time Crash Team Racing was released, the bandicoot was popular enough to get his very own, themed promotional race car.

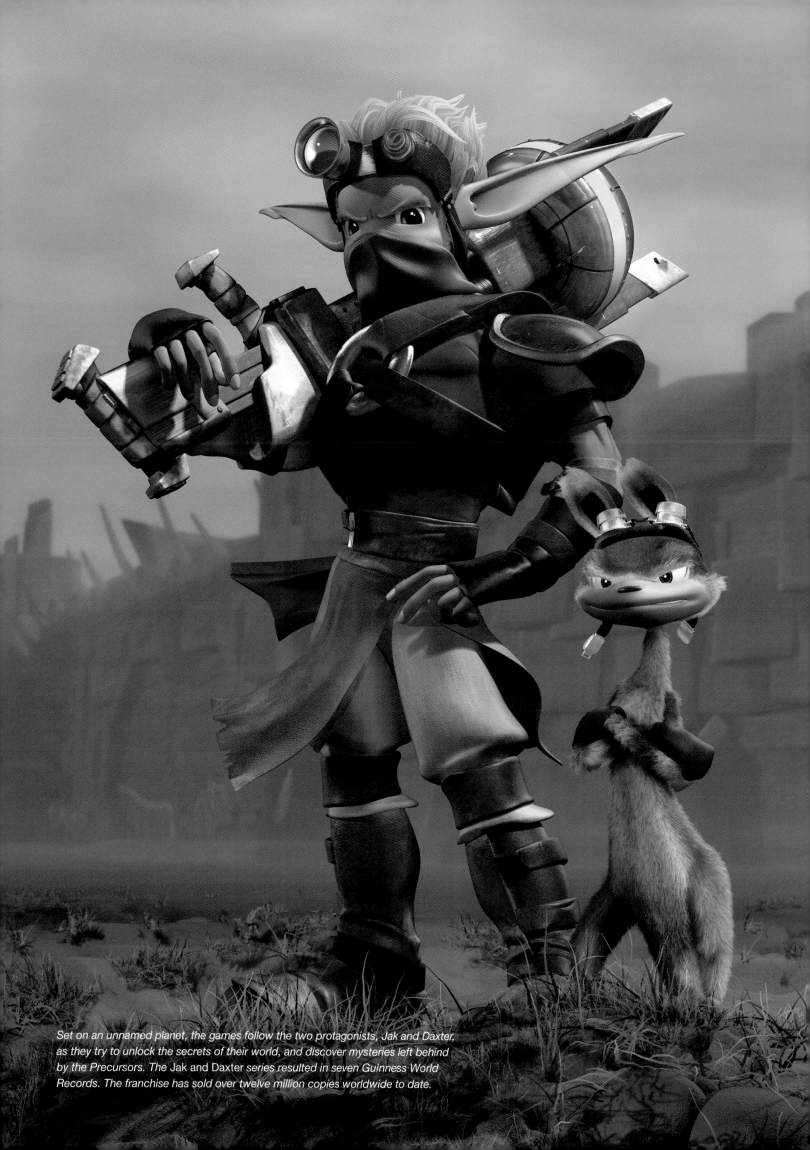

Set on an unnamed planet, the games follow the two protagonists, Jak and Daxter, as they try to unlock the secrets of their world, and discover mysteries left behind by the Precursors. The Jak and Daxter series resulted in seven Guinness World Records. The franchise has sold over twelve million copies worldwide to date.

JAK AND DAXTER

2001–2005

BY BOB RAFEI AND ERICK PANGILINAN

After shipping *Crash Team Racing*, the entire company took a well-deserved break for the whole month of December 1999. When we returned, it was a new century and we faced a daunting task: developing the next big IP for PlayStation. It was a scary and exciting time. How do you top *Crash Bandicoot*—a franchise universally loved and universally popular (to the tune of millions of units worldwide)? We had to throw out all the stylistic habits of the past years and develop something new. There was a lot of anxiety about whether it would stack up.

A lot of people outside the company wondered, "Why not just do another *Crash Bandicoot* for the next system?" But Universal maintained partial control of the *Crash Bandicoot* franchise and in the three-way marriage between them, PlayStation, and Naughty Dog, we couldn't find a workable solution to make it happen. We were used to making the unofficial PlayStation mascot and wanted to continue to occupy that niche on the PlayStation 2. All during 1999 Andy and a few programmers had worked on new technology, but the art design didn't begin until the new millennium. Every artist took out their drawing pads and pencils—yes, we still used pencils in those days—and started sketching ideas for the game. We furiously scribbled characters and environments, putting all our ideas on the table for review.

Animator John Kim drew a very rough sketch of an elf-like character who was tall, slender, and agile. Caught in an aerial roundhouse kick, this character sported jaunty, spiky hair. John described his style as "BAM!"—an internal phrase that caught on and served as a mantra for the exaggeration, weight, and thickness all the *Jak* characters shared. Daxter started with a sketch of an otter by character artist Rob Titus. Our art director, Bob Rafei, refined the characters, adding color and detail in an iterative process until they looked like the lovable pair we know today.

Jak 1 shared many mechanical characteristics with *Crash Bandicoot*. The game featured a spin attack, high jumps, orb collecting, Naughty Dog's signature squash-stretch animation, and a main character that didn't speak! In those days we thought this was a good thing, allowing the player to emotionally stand in Jak's shoes (uh, foot bandages), but during *Jak II*, as our story became more complex, we changed our minds and gave him dialogue.

Bob drew the first environmental sketch: huts perched over a series of cascading waterfalls. This defined the look for Jak's village, and the rest of the world followed from this basic style. Breaking away from a linear path and railed cameras, we followed *Super Mario 64* into the realm of free-roaming platformers. *Jak and Daxter* opened up so many creative possibilities, allowing us to design an entire new world from scratch. This was the first time we felt the shift in 3-D technology from the PS one to the PS2, and it was filled with promises and high expectations. We used the concept of "wide linear," which opened up the world enough to explore, but still funneled the player forward to engage the story and gameplay points. We wanted to provide the player with a continuous adventure by seamlessly connecting all of the levels, free of loading screens. To give the feeling of a real world, we felt that we needed to observe the passage of time, so we lit each level for different times of day and cycled through them. If you stood in one place long enough, you would see the whole cycle from day to night and back again. We even built dynamic skies that cast cloud shadows on the ground. Pushing the polygon limit and graphical fidelity has always been the Naughty Dog way, and we wanted to make sprawling environments that could be seen from a high vantage point. We refined a successful level of detail technology from *Crash Team Racing*, which morphed the terrain from high resolution to low resolution. By extending this to even trees and bushes, we put more objects on screen and allowed for wide-open vistas.

The *Jak* series was an evolutionary period for Naughty Dog. We transitioned from cartoony mascot titles to more mature, character-driven games throughout the *Jak and Daxter* trilogy. Each *Jak* game was less cartoony and provided darker, more mature stories and gameplay. We also experienced a growth spurt in our studio. With growth came the need for more specialization, necessary for larger productions. For the first time in our history we added team members dedicated to certain disciplines: lighting, special effects, cinematic animators, concept artists, rigging, modeling, etc. *Crash* development started with eight team members, ended with fifteen; *Jak 1* shipped with thirty-five, and *Jak 3* had upwards of sixty people working on it by the time we transitioned to the PS3. It was an exciting time, and the formerly flat management structure had to grow some layers to support the larger teams. This new DNA made us stronger, and everything we learned from *Crash* and *Jak* equipped us with the tools and confidence to push the limits even further with the PS3.

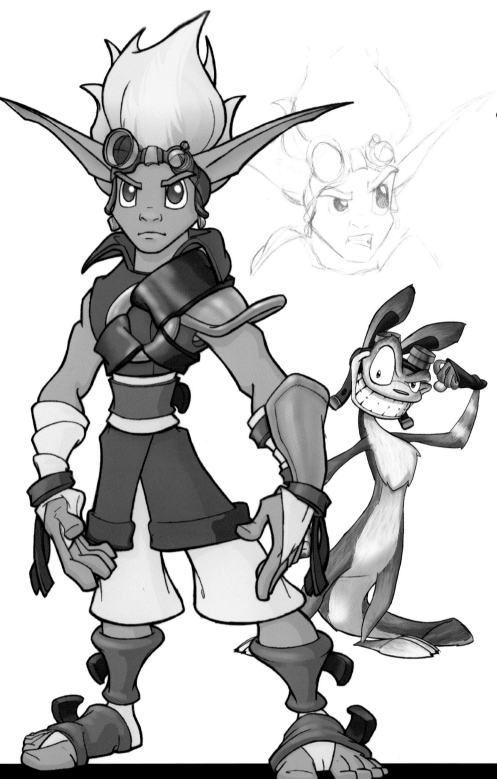

JAK AND DAXTER: THE PRECURSOR LEGACY

Jak and Daxter were born out of the idea that the PlayStation 2 needed a mascot much like the original Playstation had Crash. The game was originally conceived with three main characters, but Jak and Daxter quickly took hold and developed into the two leads.

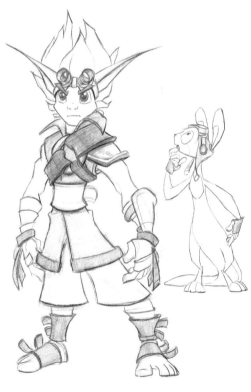

Sandover Village is the first level, where players get familiar with the game mechanics and the story and characters are established. It had the definitive *Jak and Daxter* look from the beginning.

Misty Island is the second level of the game, where the skills players learned in the first level are tested with increasing difficulty.

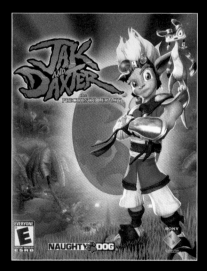

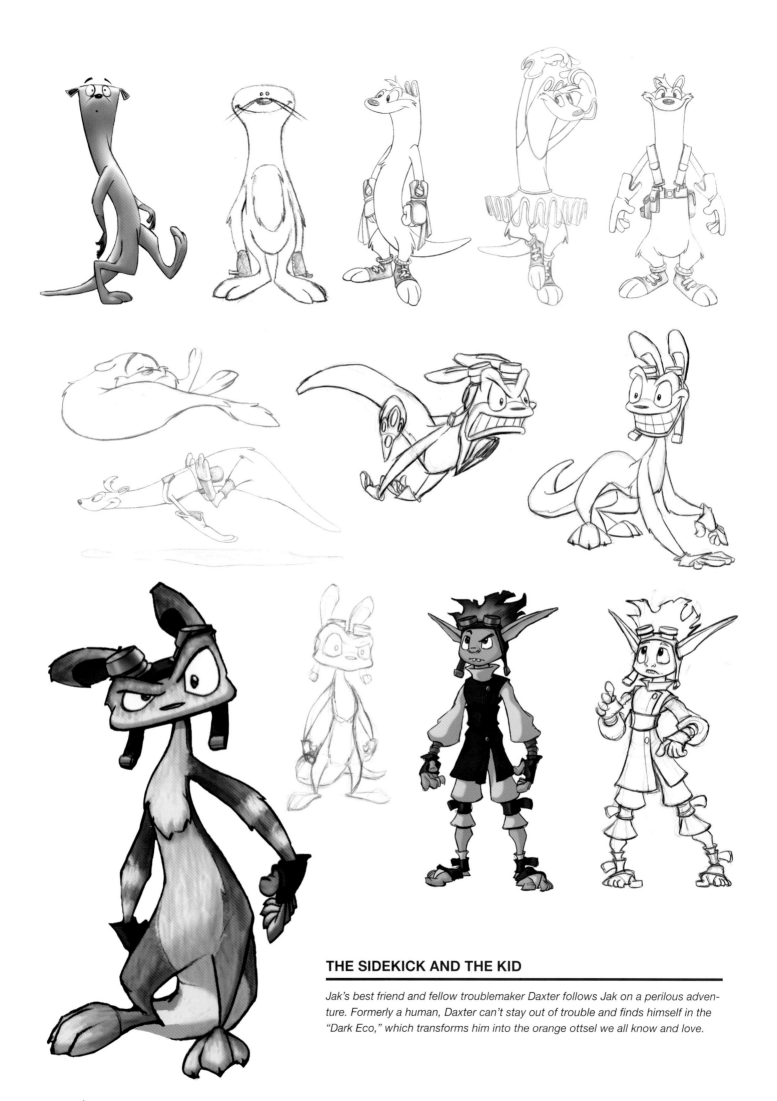

THE SIDEKICK AND THE KID

Jak's best friend and fellow troublemaker Daxter follows Jak on a perilous adventure. Formerly a human, Daxter can't stay out of trouble and finds himself in the "Dark Eco," which transforms him into the orange ottsel we all know and love.

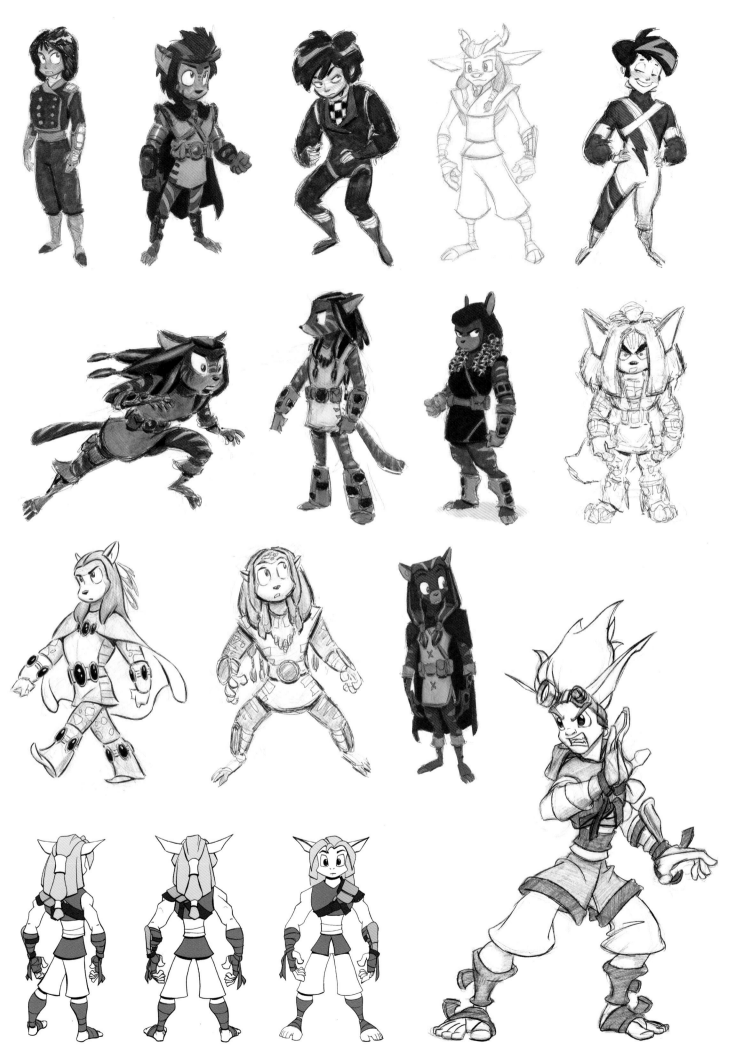

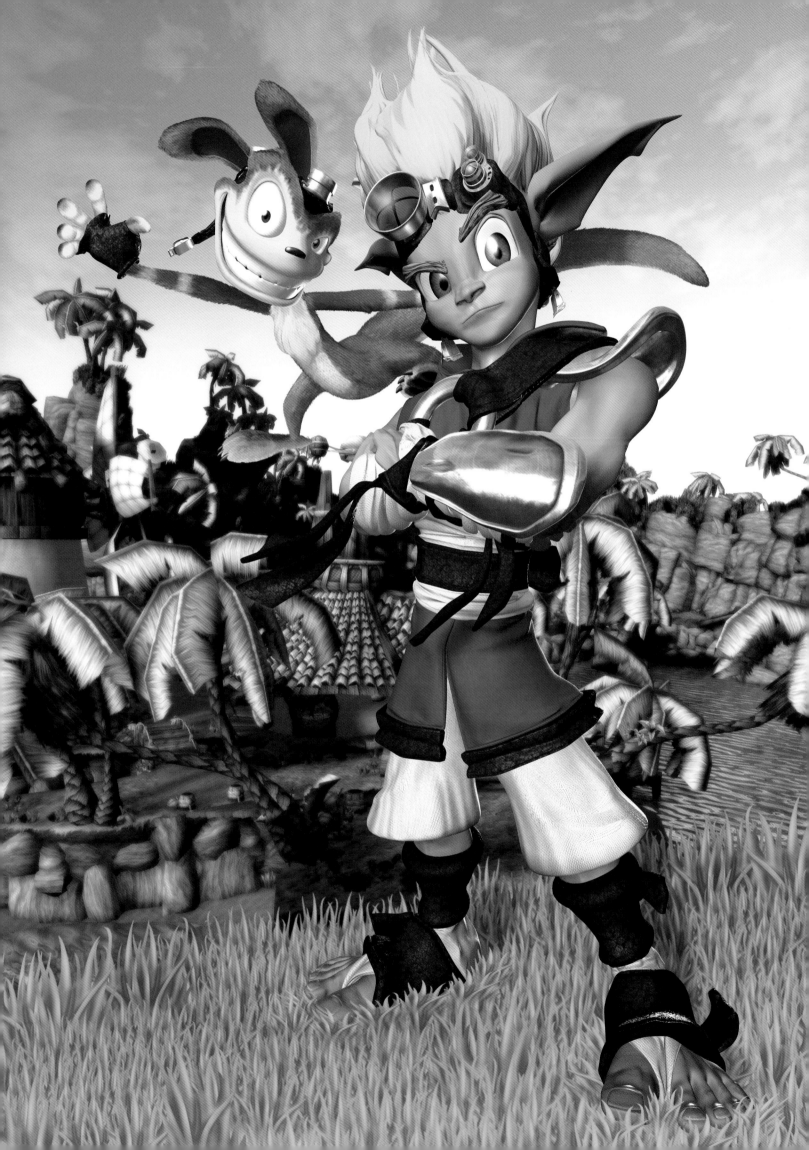

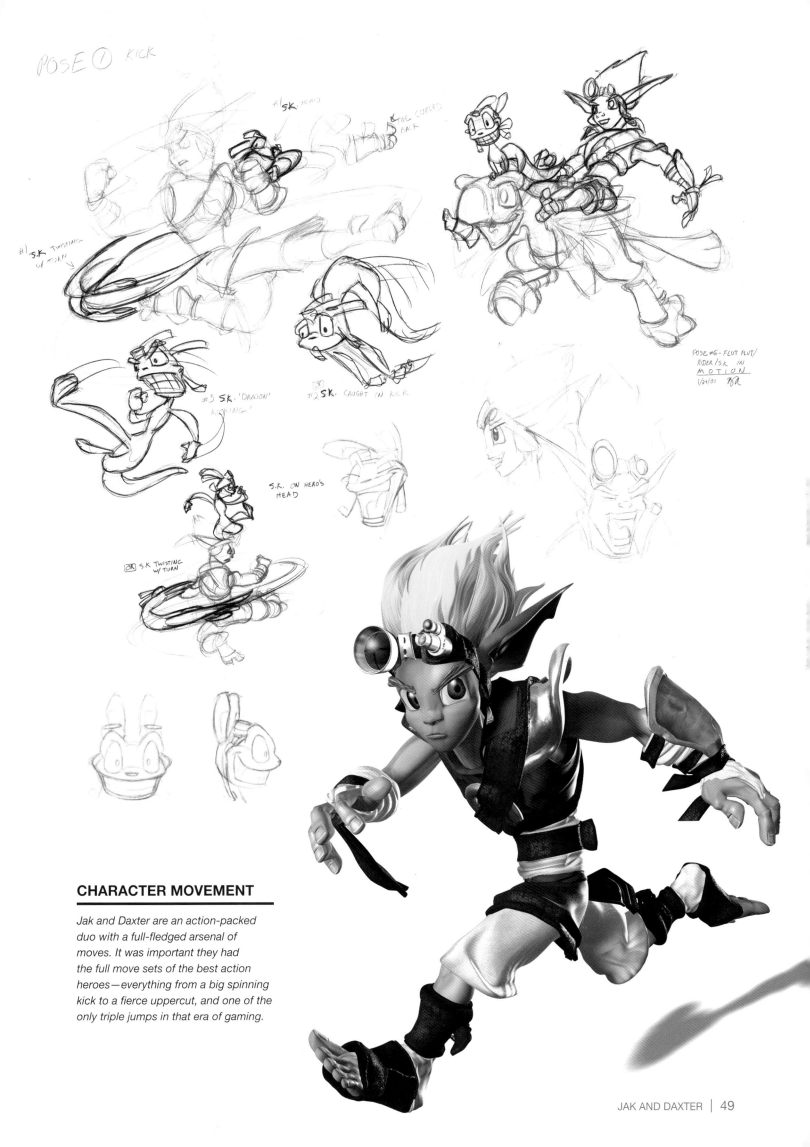

POSE ① KICK

#1 S.K. HEAD

TOE CURLED BACK

#1 S.K. TWISTING W/ TURN

POSE #6 - FLUT FLUT/ RIDER/S.K. IN MOTION 1/24/01

#2 S.K. CAUGHT IN KICK

#3 S.K. 'DRAGON' KICKING

S.K. ON HERO'S HEAD

S.K TWISTING W/ TURN

CHARACTER MOVEMENT

Jak and Daxter are an action-packed duo with a full-fledged arsenal of moves. It was important they had the full move sets of the best action heroes—everything from a big spinning kick to a fierce uppercut, and one of the only triple jumps in that era of gaming.

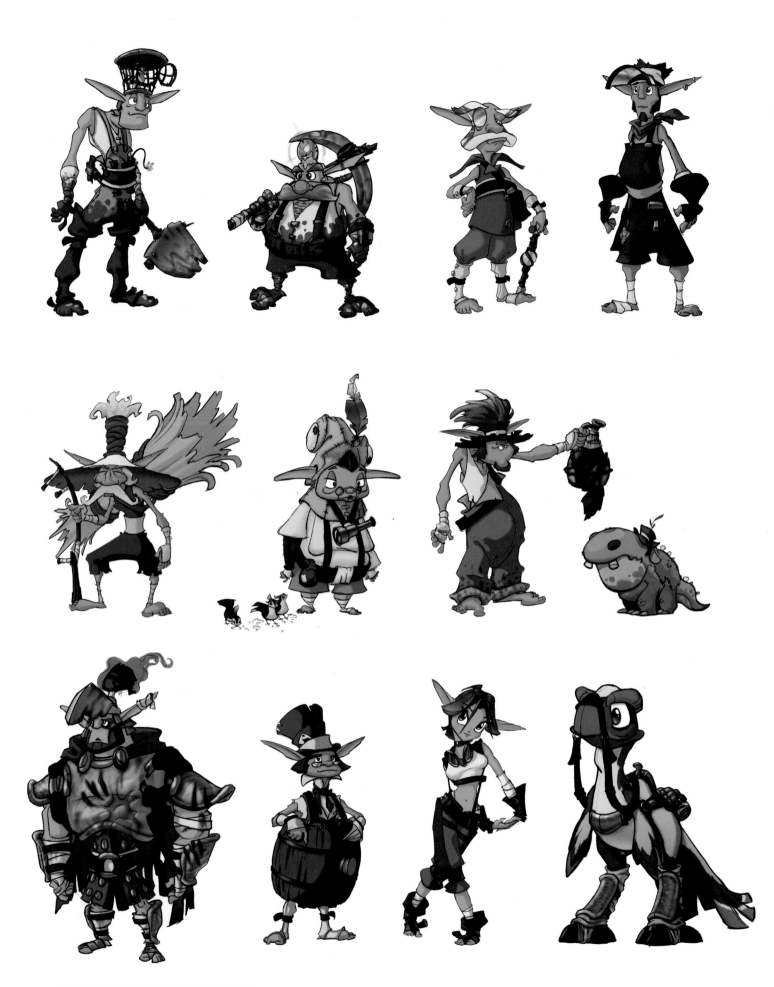

SECONDARY CHARACTERS

Jak's world was very big and diverse. Introducing characters early on helped ground the world and create a history for the franchise. From Jak's uncle, the Explorer, to the ego-battered "Ass Kicked" Warrior, the world was rich with backstory.

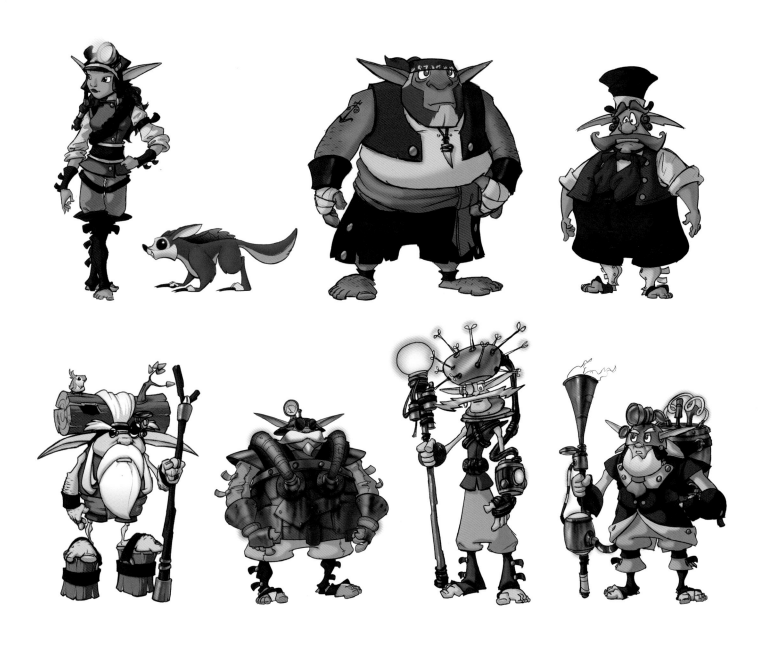

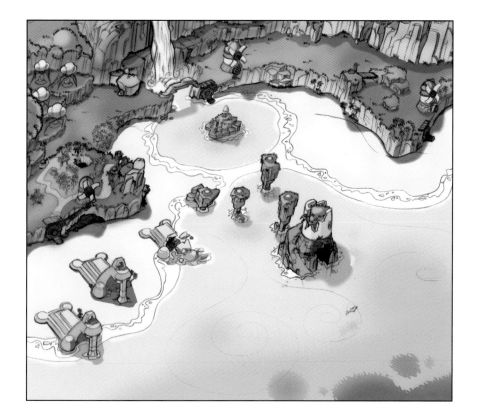

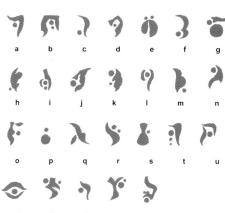

PRECURSOR ALPHABET

We developed an alphabet for the Precursors in Jak and Daxter. *Those who take the time to decrypt the words throughout the* Jak *games will find a ton of hidden messages.*

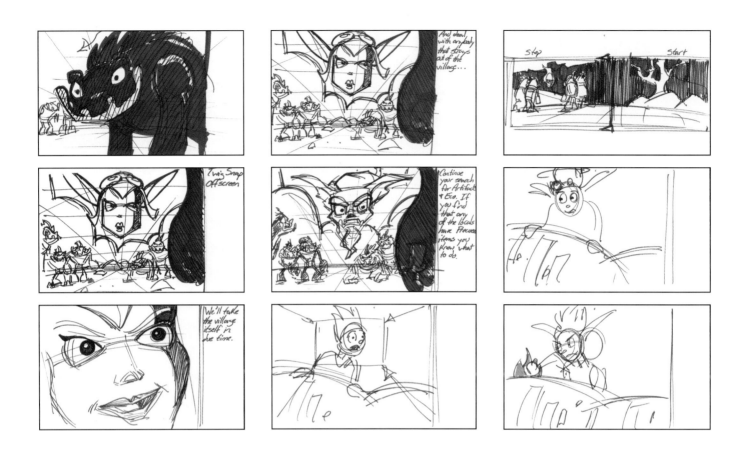

These are the storyboards for the opening cut scene of Jak and Daxter, where players witness Jak's best friend transform into ottsel form. Storyboarding our cut scenes was soon abandoned, as we found it faster to get in and start work in 3-D as quickly as possible.

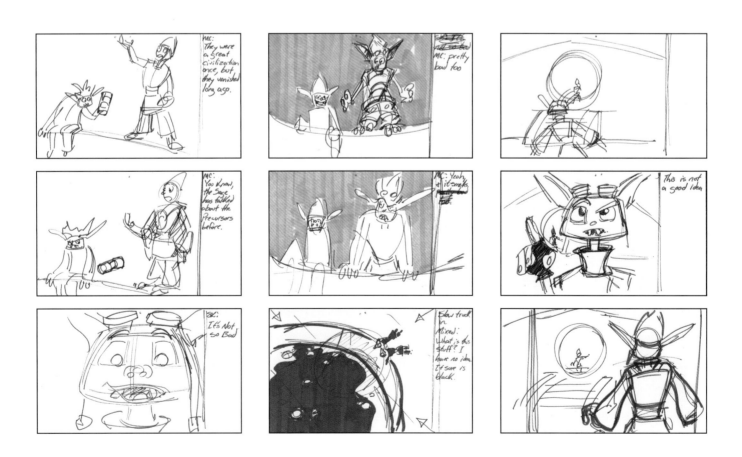

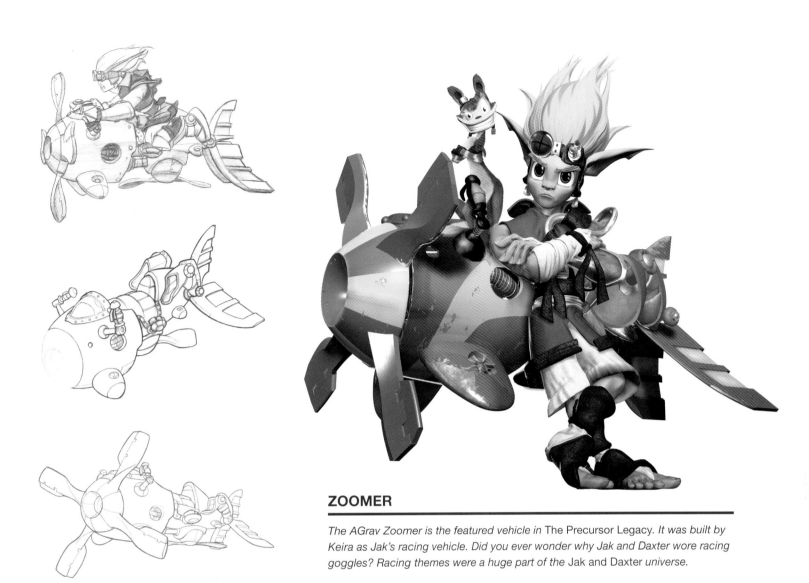

ZOOMER

The AGrav Zoomer is the featured vehicle in The Precursor Legacy. *It was built by Keira as Jak's racing vehicle. Did you ever wonder why Jak and Daxter wore racing goggles? Racing themes were a huge part of the* Jak and Daxter *universe.*

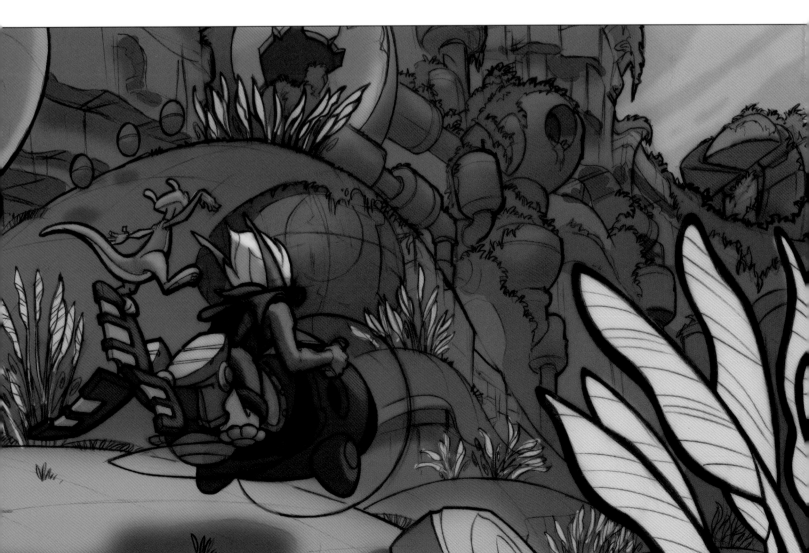

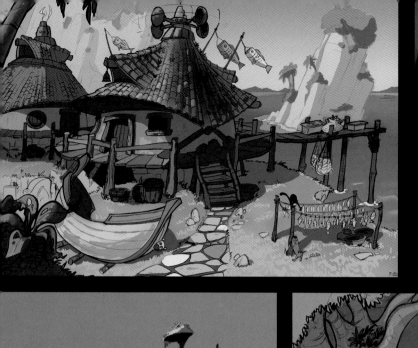
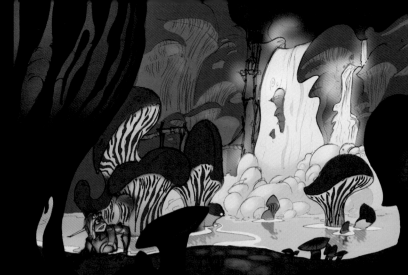
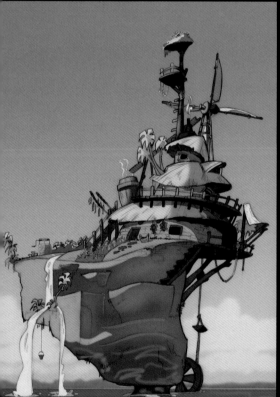
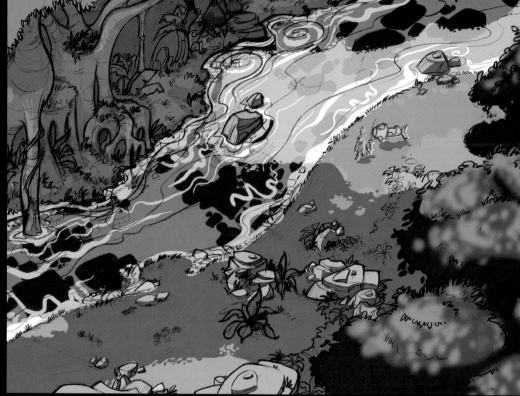
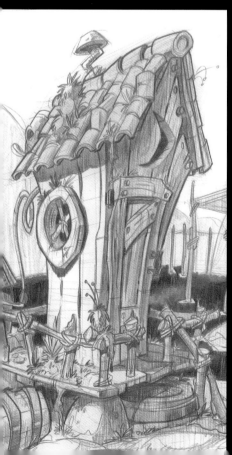

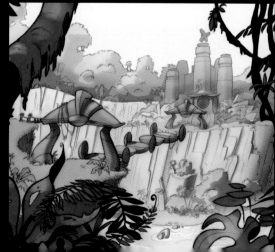
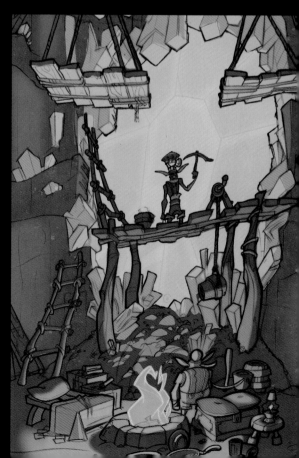

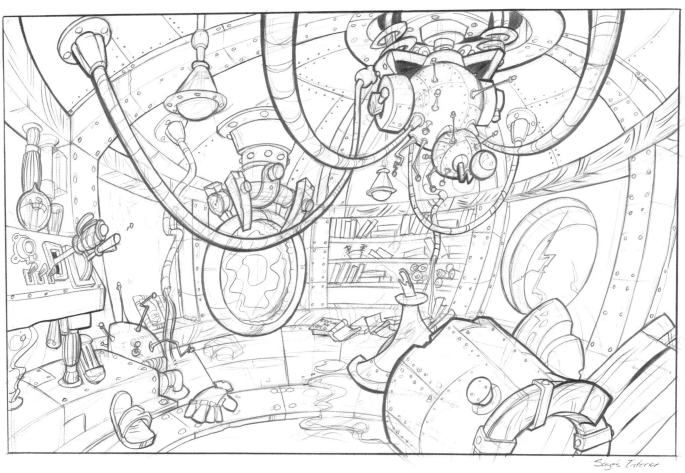

Sage's Interior

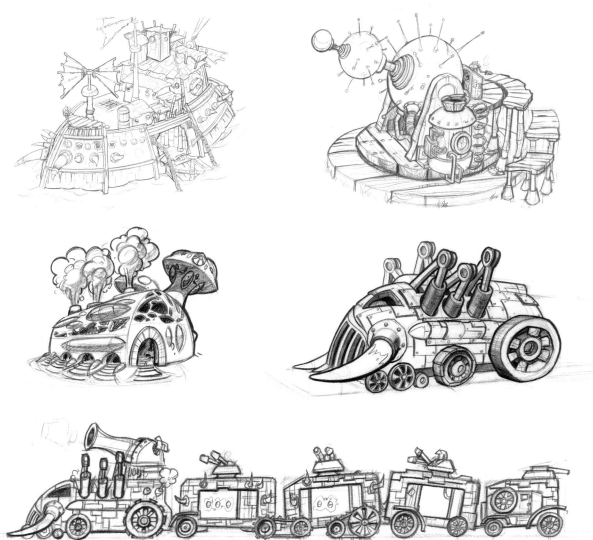

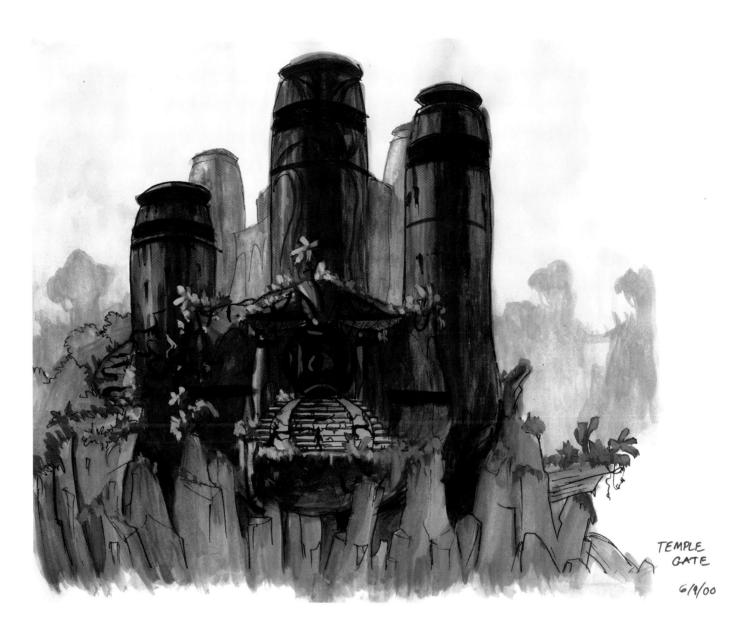

TEMPLE
GATE

6/9/00

PRECURSOR TECHNOLOGY

The Precursors, a super-advanced culture that occupied the world long ago, left many artifacts across the land. The Precursors used Eco to benefit their civilization, but their eventual downfall remains a mystery.

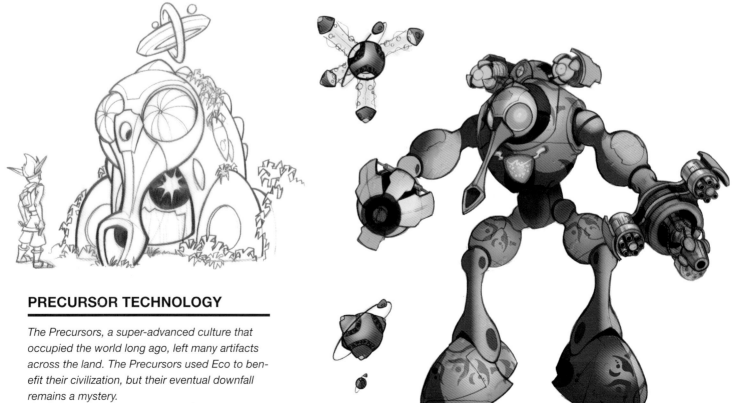

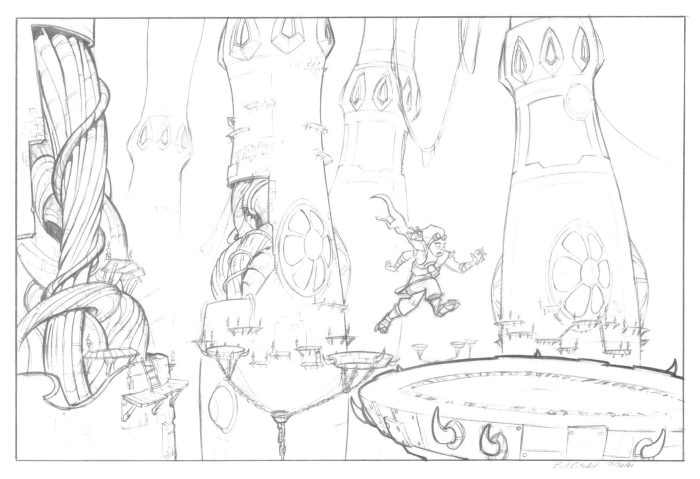

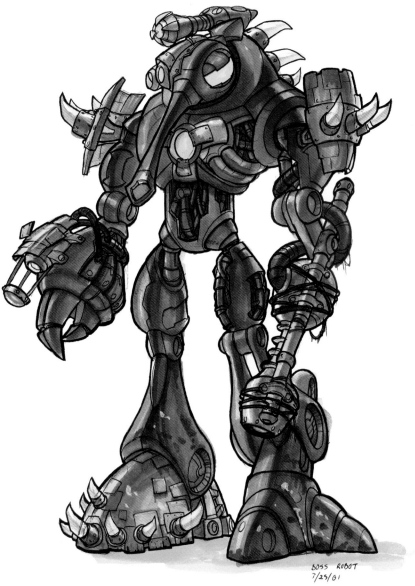

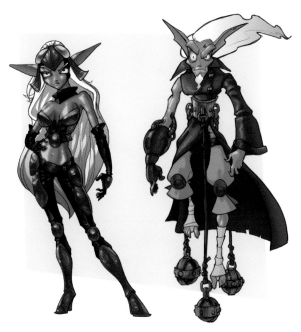

GOL AND MAIA

Named after Goal, the custom compiler we used to write our code, and Maya, the 3-D software we used, Gol and Maia were the primary antagonists in The Precursor Legacy.

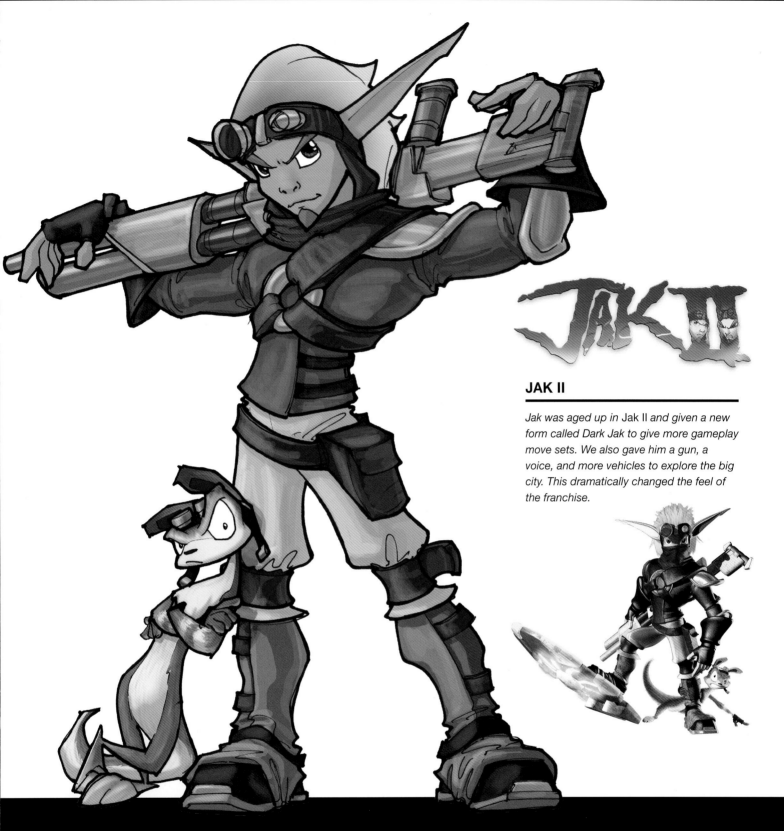

JAK II

Jak was aged up in Jak II *and given a new form called Dark Jak to give more gameplay move sets. We also gave him a gun, a voice, and more vehicles to explore the big city. This dramatically changed the feel of the franchise.*

An open world led this to be one of the largest *Jak* games of them all.

You could hijack any zoomer and use it to traverse the large Haven City with style. Jak also had a hoverboard he could pull out anywhere to further help him zoom along.

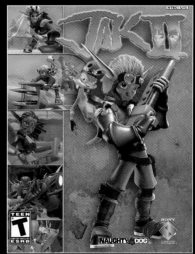

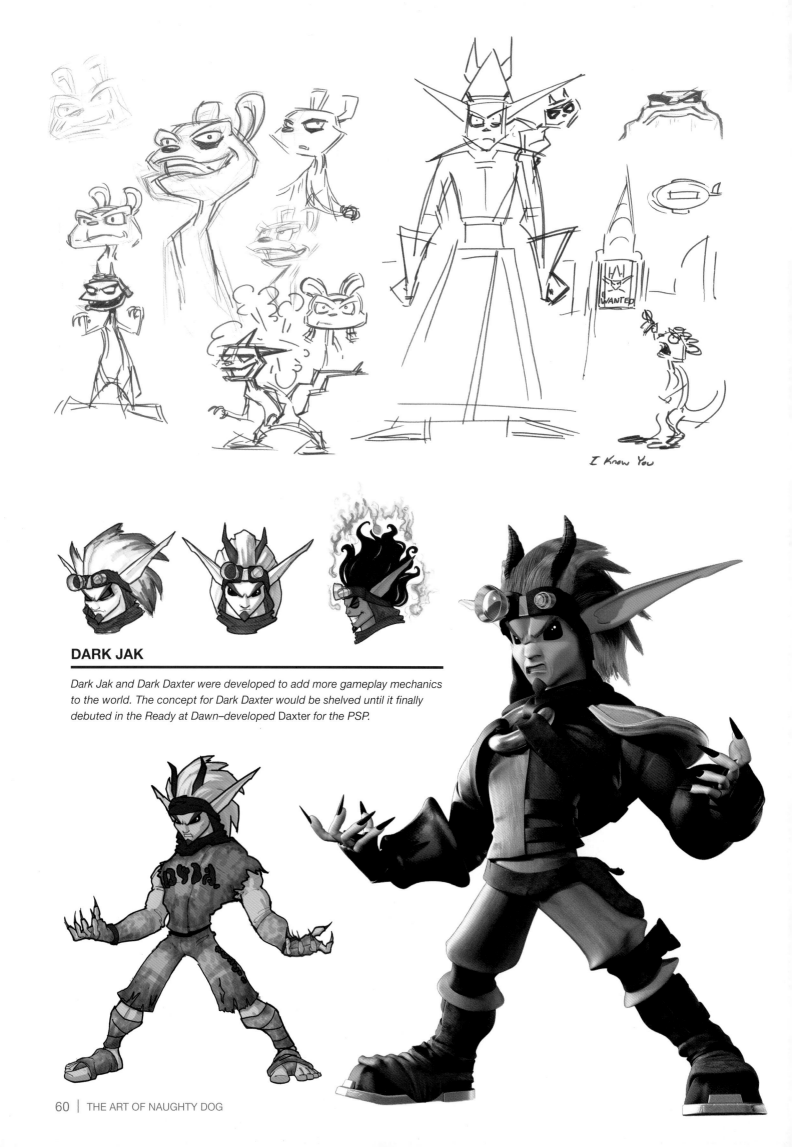

I Know You

DARK JAK

Dark Jak and Dark Daxter were developed to add more gameplay mechanics to the world. The concept for Dark Daxter would be shelved until it finally debuted in the Ready at Dawn–developed Daxter for the PSP.

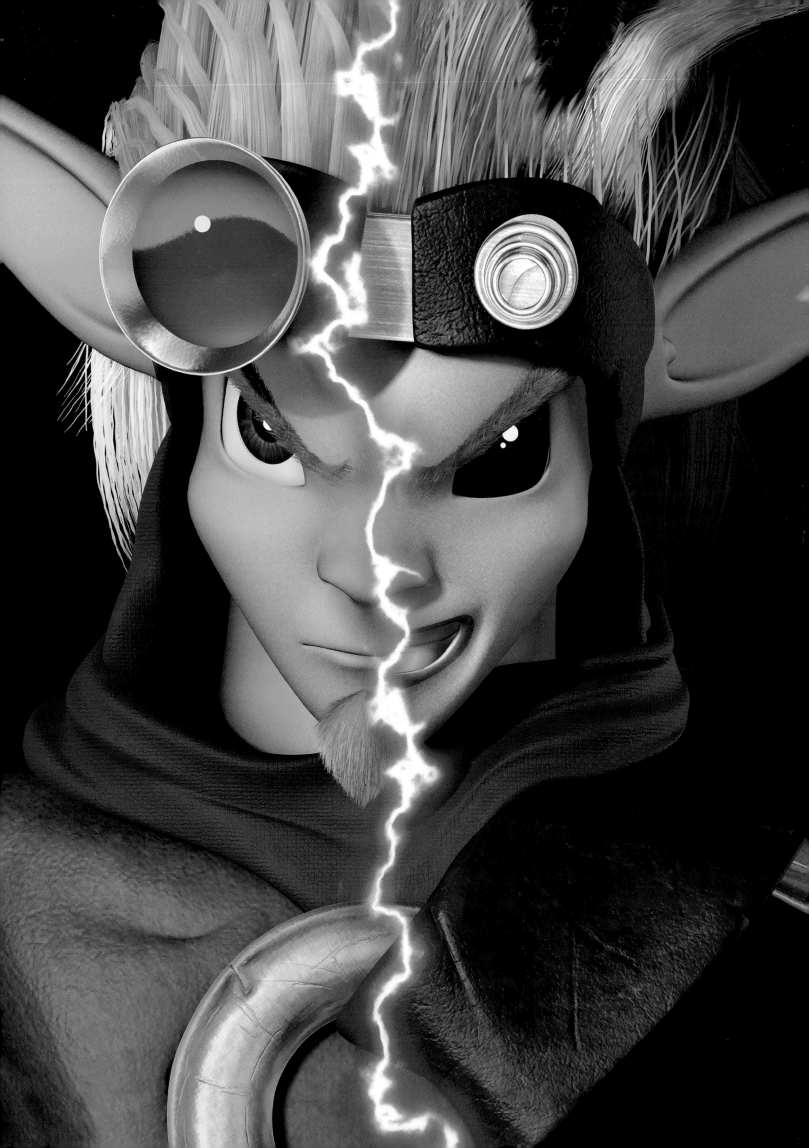

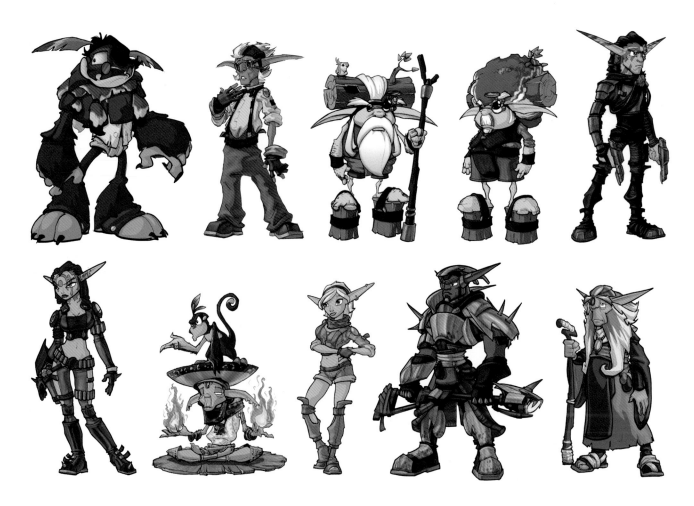

SECONDARY CHARACTERS

As with our previous game, characters played a huge role in telling the types of stories we have become known for: character-driven games with strong narratives. From the Baron to his daughter Ashelin and Jak's friend/foe Torn, each character had a rich backstory that helped the game's story progress.

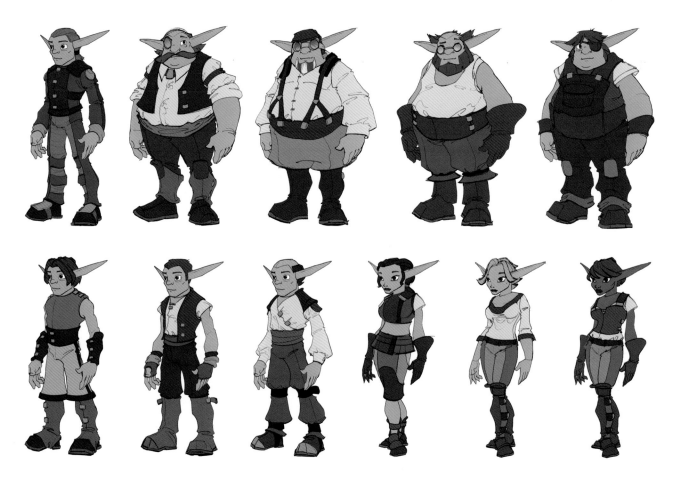

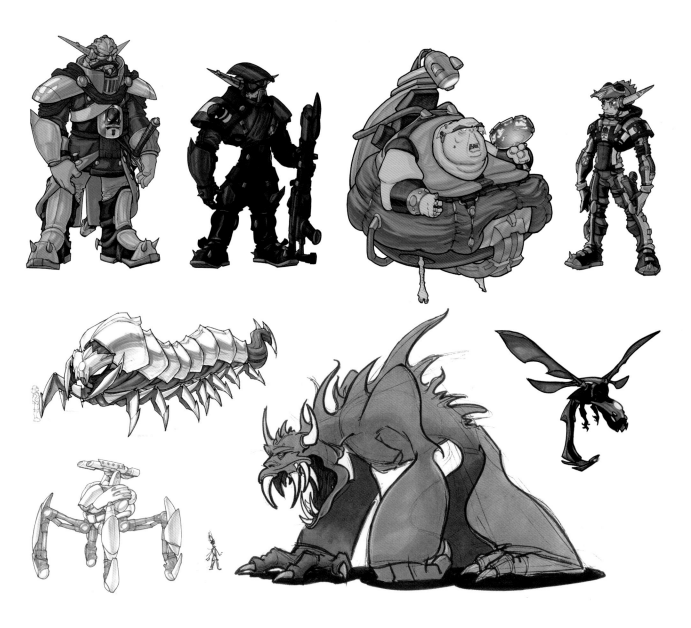

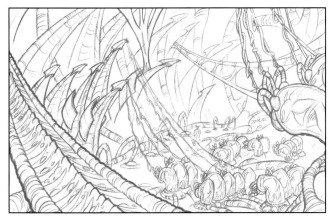

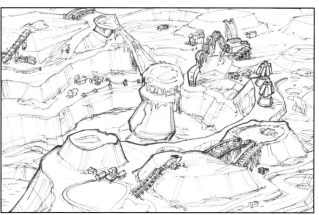

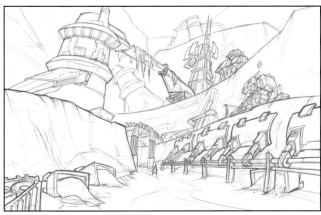

OUTSIDE THE CITY

Sketches of the environments found outside the walls of Haven City. The strip-mine level shown above and to the left was our first proof-of-concept environment that had multiple missions leveraging both Jak's new morph gun and his hoverboard.

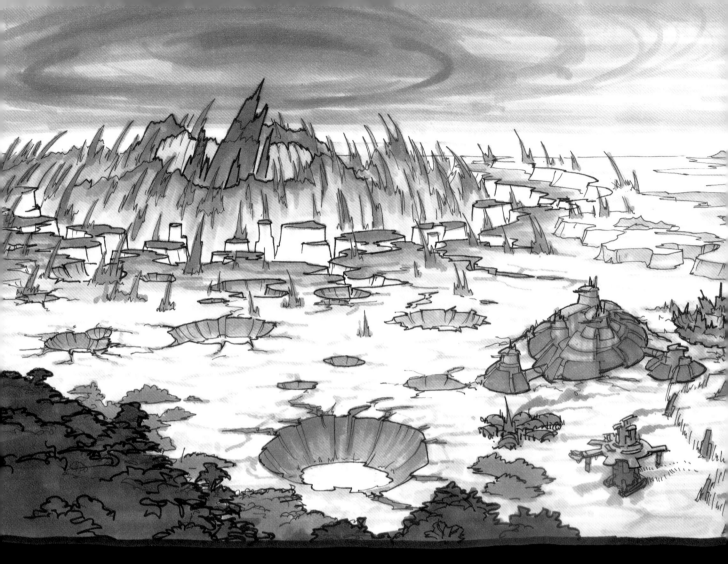

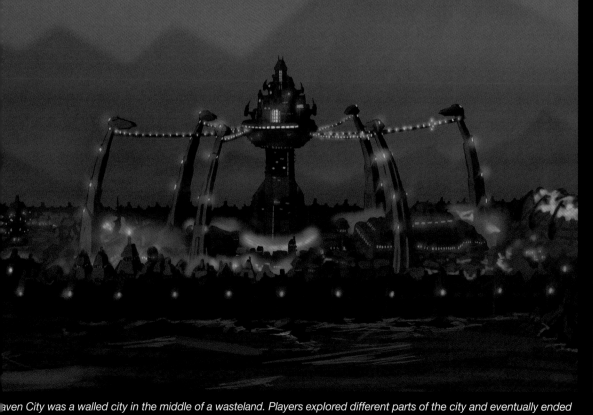

aven City was a walled city in the middle of a wasteland. Players explored different parts of the city and eventually ended
in the center tower. The next game, Jak 3, allowed players to journey outside the walls and into the wasteland.

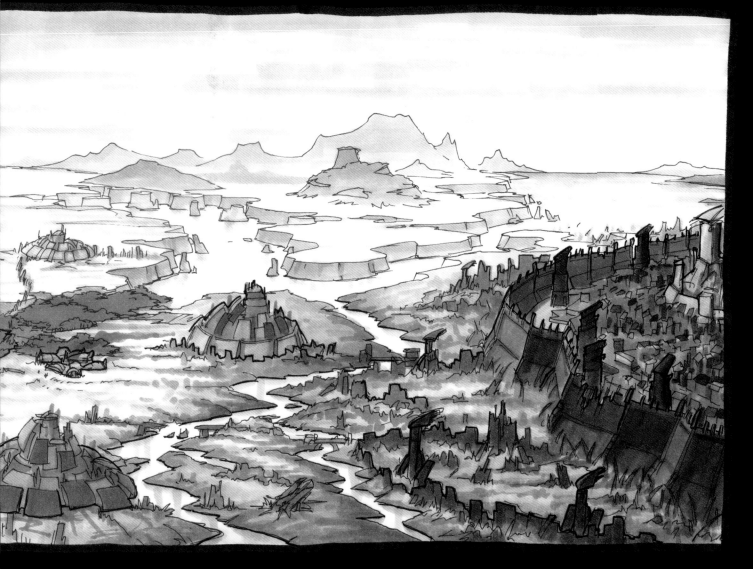

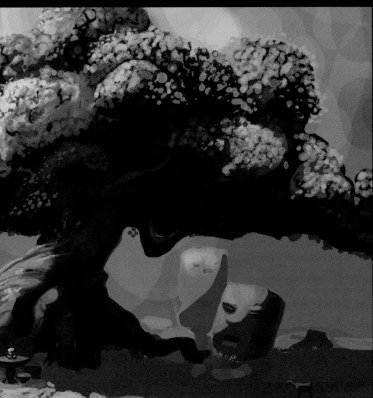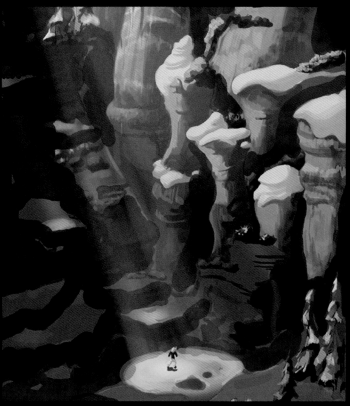

Back in the Crash days, lighting was done by hand-coloring each vertex. A single, dedicated artist did that for the entire project. The Jak series' increased polygon count and changing time of day required a smarter solution, so we set up a lighting rig that automatically lit locations for each hour of the day and night, with twelve different settings for each level. If a player stood around in one area long enough, it would eventually become night.

HELLCAT CRUISER

The Krimson Guard patrol Haven City in their heavily armored Hellcat Cruisers.

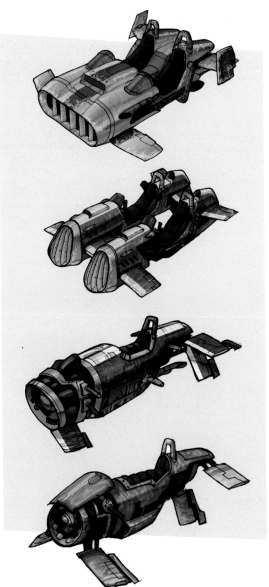

MORPH GUN

Jak's morph gun could transform into four different shapes to utilize four different types of Eco.

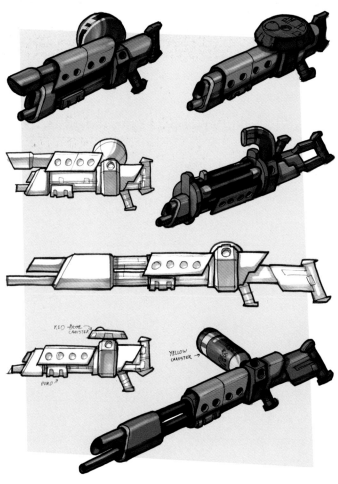

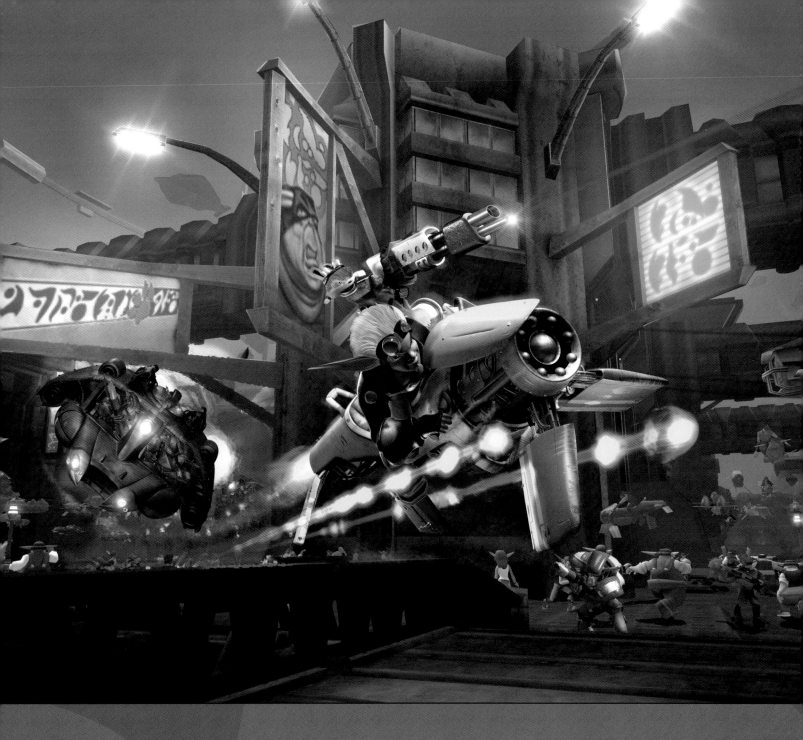

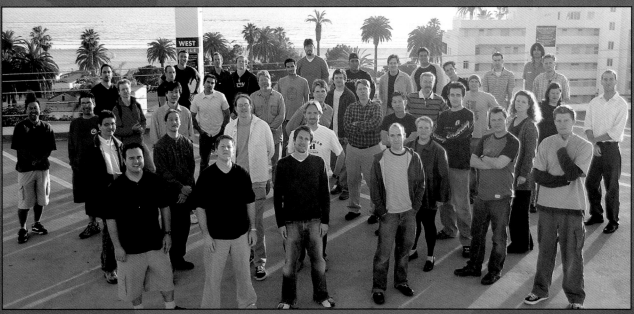

A Naughty Dog team photo atop a Santa Monica parking structure near our office on the Third Street Promenade.

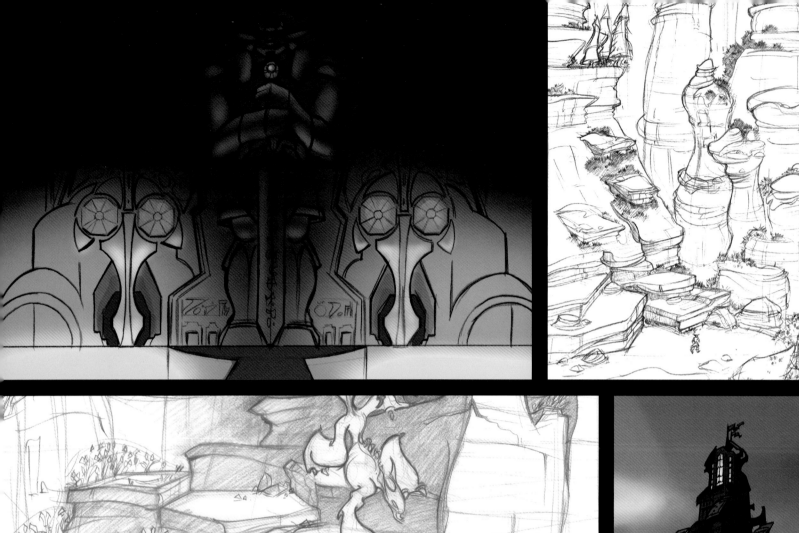
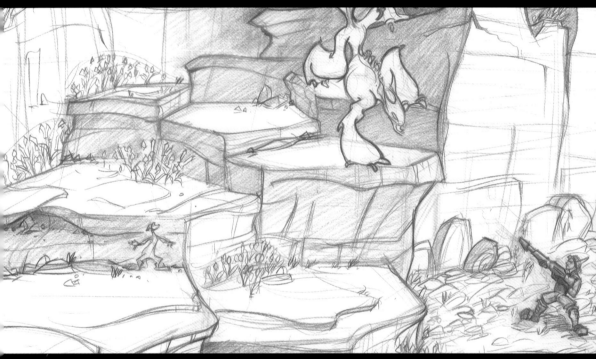
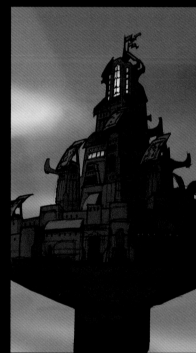
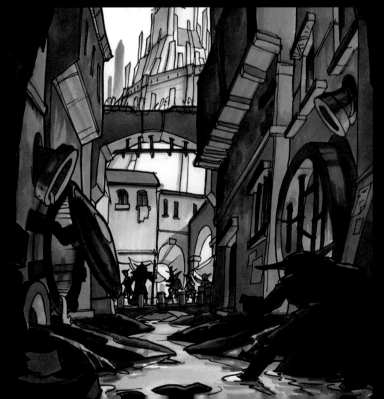
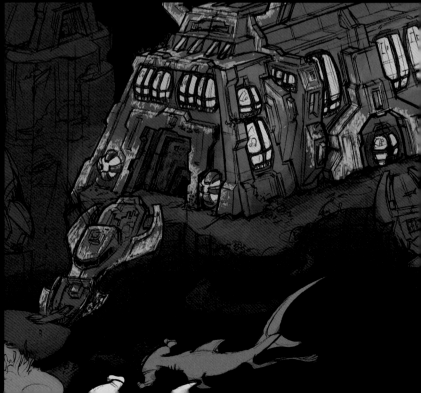

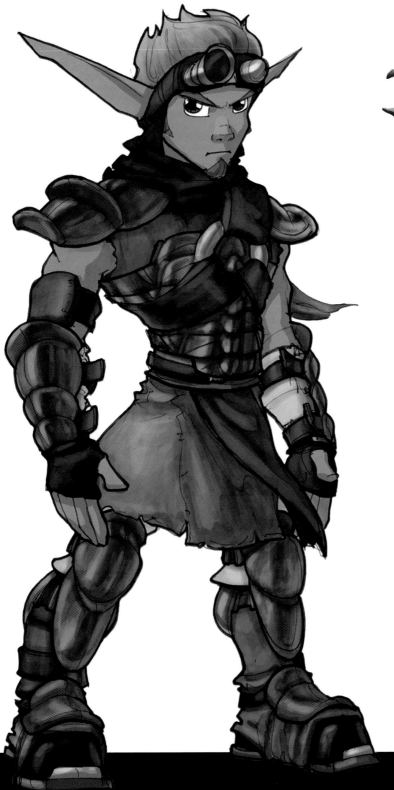

JAK 3

After going dark in Jak II, Jak had to appear a bit more mature and hardened for Jak 3. The character's attire appeared a bit tougher, and we even experimented with a full beard before realizing that wasn't cool.

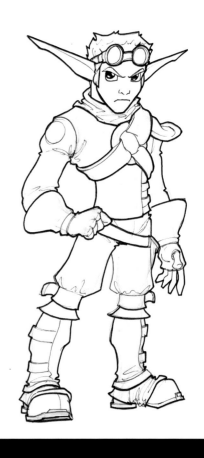

We wanted to push the open world even further with *Jak 3*, taking him outside the walled city. We wanted to expand on the weapons, and added flying so players could see the entire world.

The dune buggy vehicle mechanics were very important. It needed to be fun and able to make huge jumps.

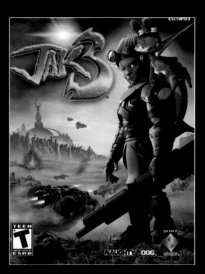

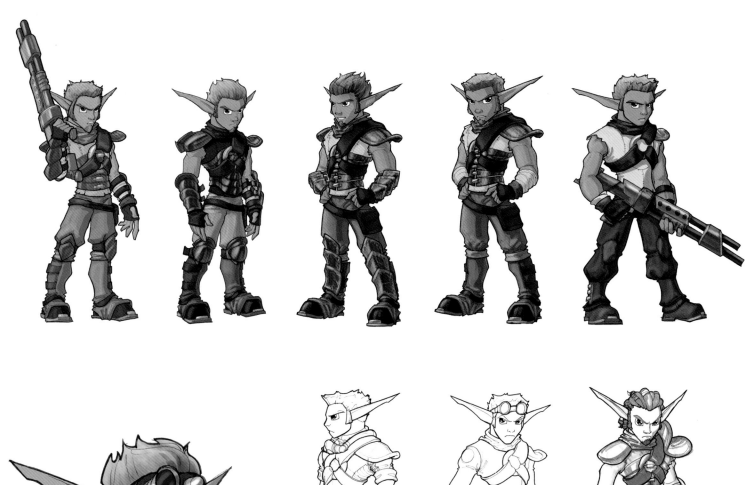

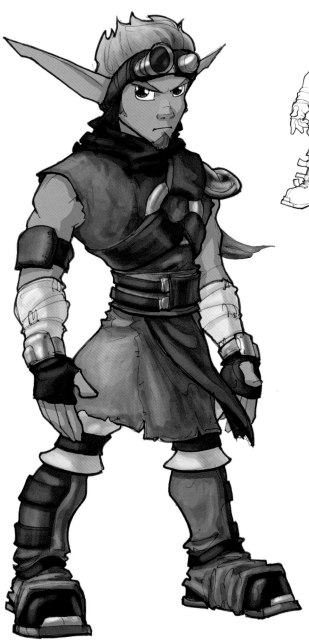

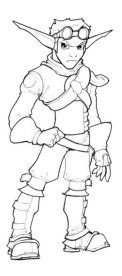

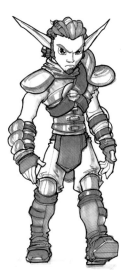

JAK
DEVELOPMENT

Various looks, more militaristic, cropped hair, and armor plating were added to Jak to see how he could grow as a character. Jak's dark form underwent exploration as well, to make sure the more mature character growth was evident in all incarnations of the character.

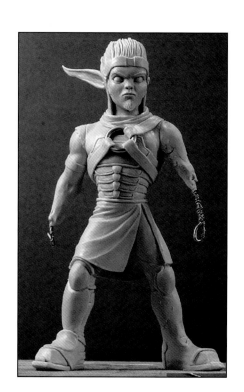

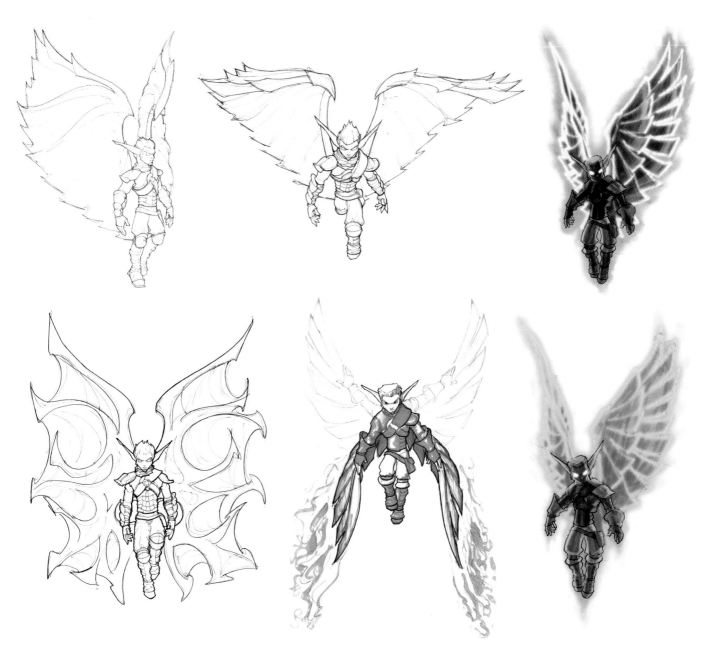

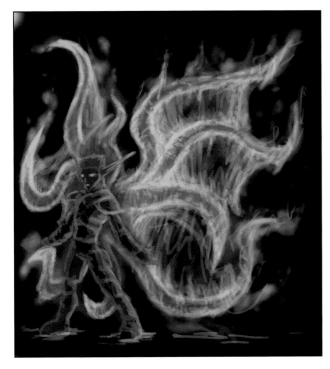

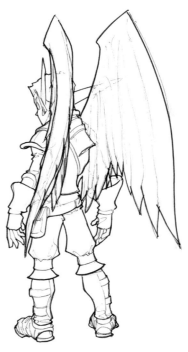

LIGHT JAK

One of the big new features added to Jak 3 was the inclusion of Light Jak. While Dark Jak was all about aggression and different attacks, Light Jak gave players the powers of flight and healing.

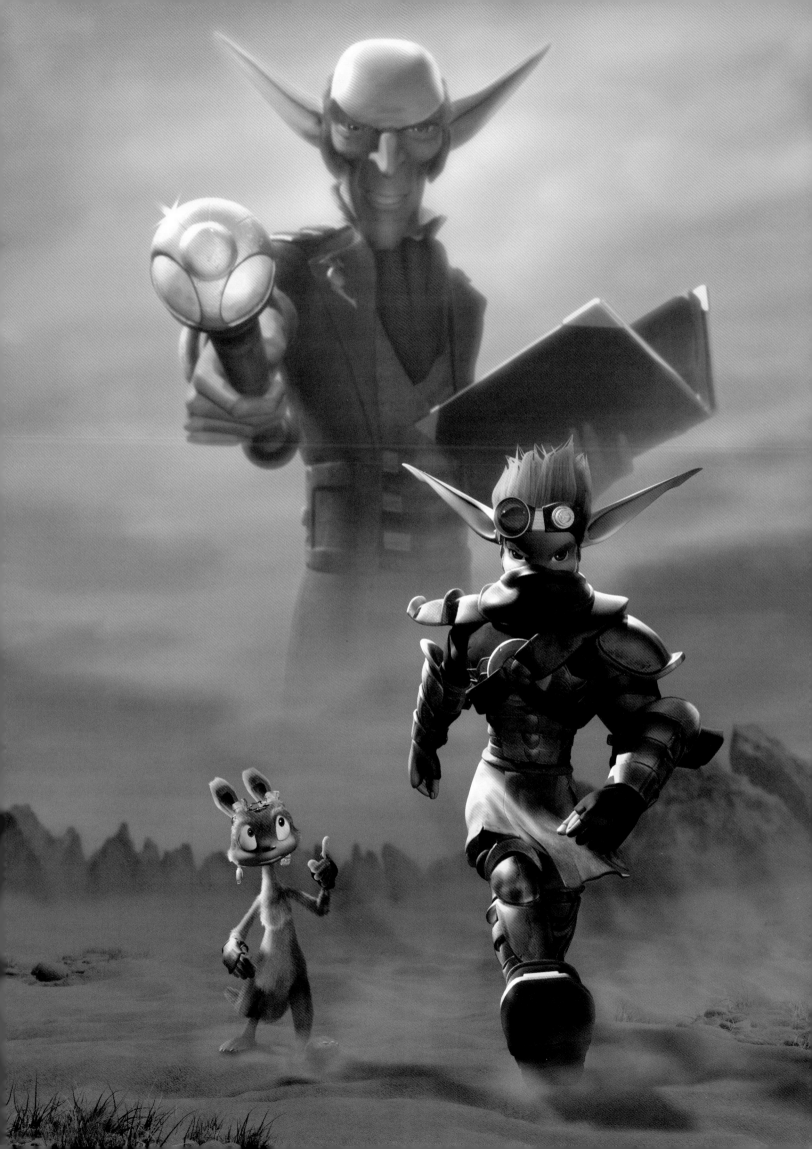

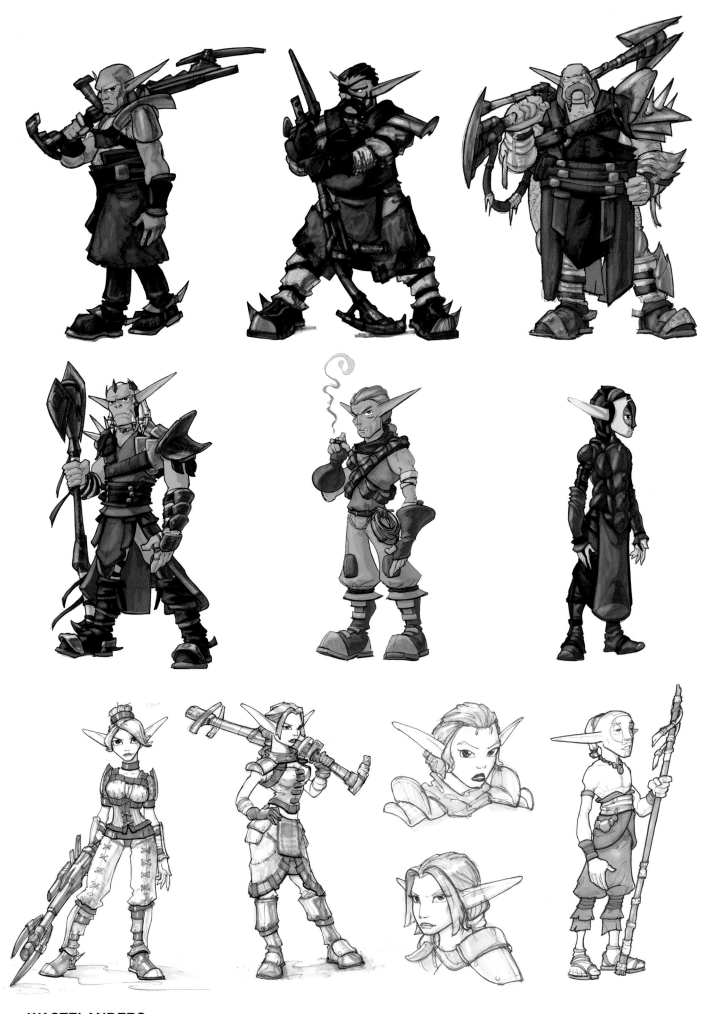

WASTELANDERS

Banished from Haven City to the Wasteland, Jak and Daxter encounter a whole host of characters that have had to adapt to the harsh conditions of the environment.

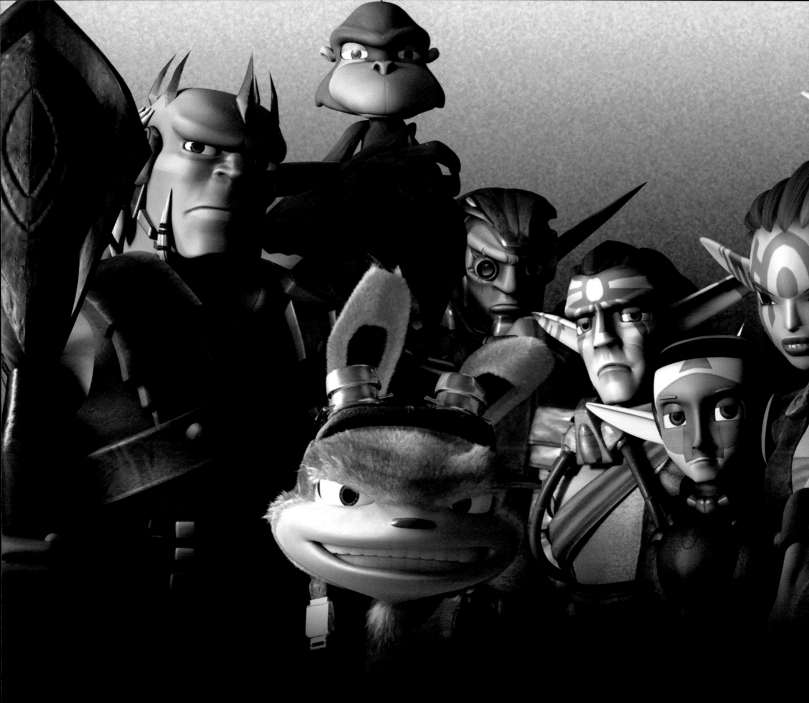

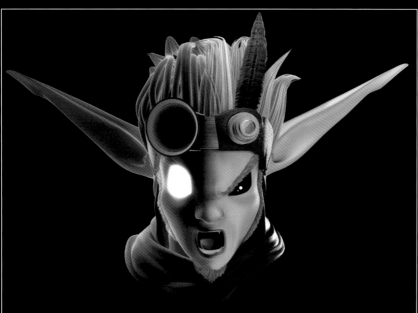

As our games grew, so did our characters. We gave them some edge and made them more mature, often pretty hardcore, as in this Sopranos parody image.

Facing page: *We have our girls of gaming, and Daxter finally gets some pants!*

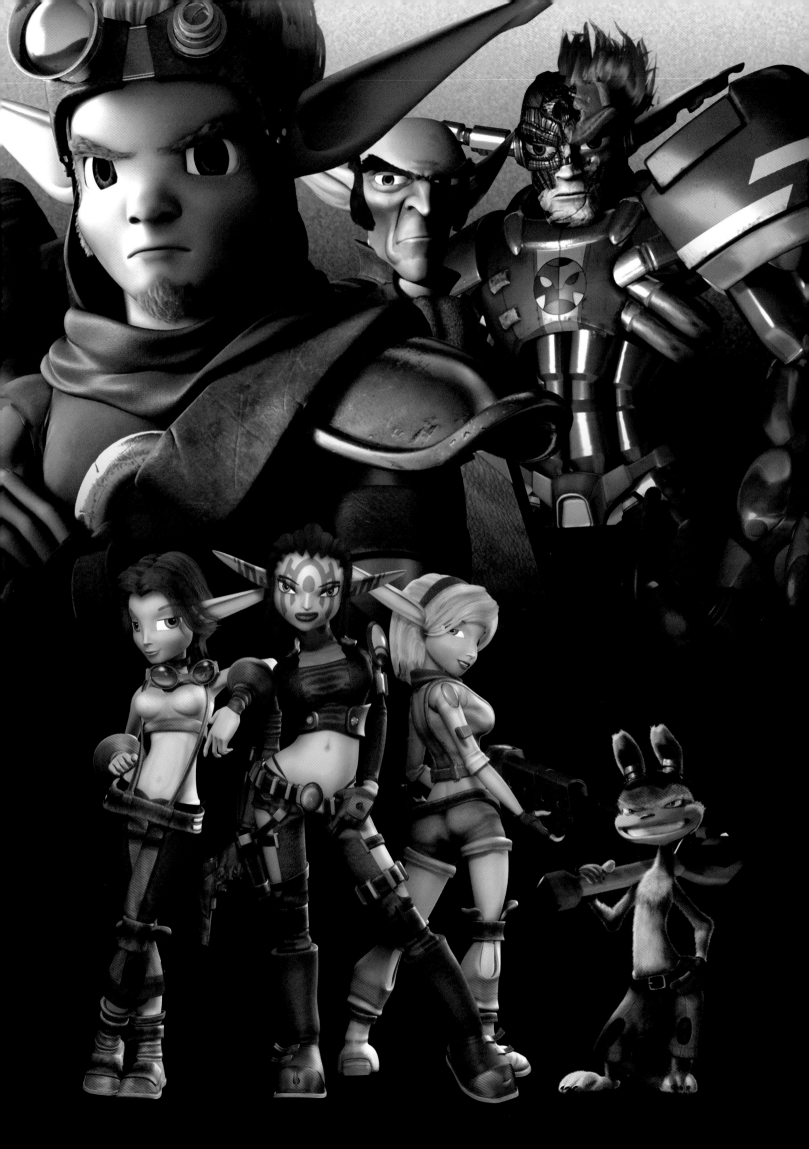

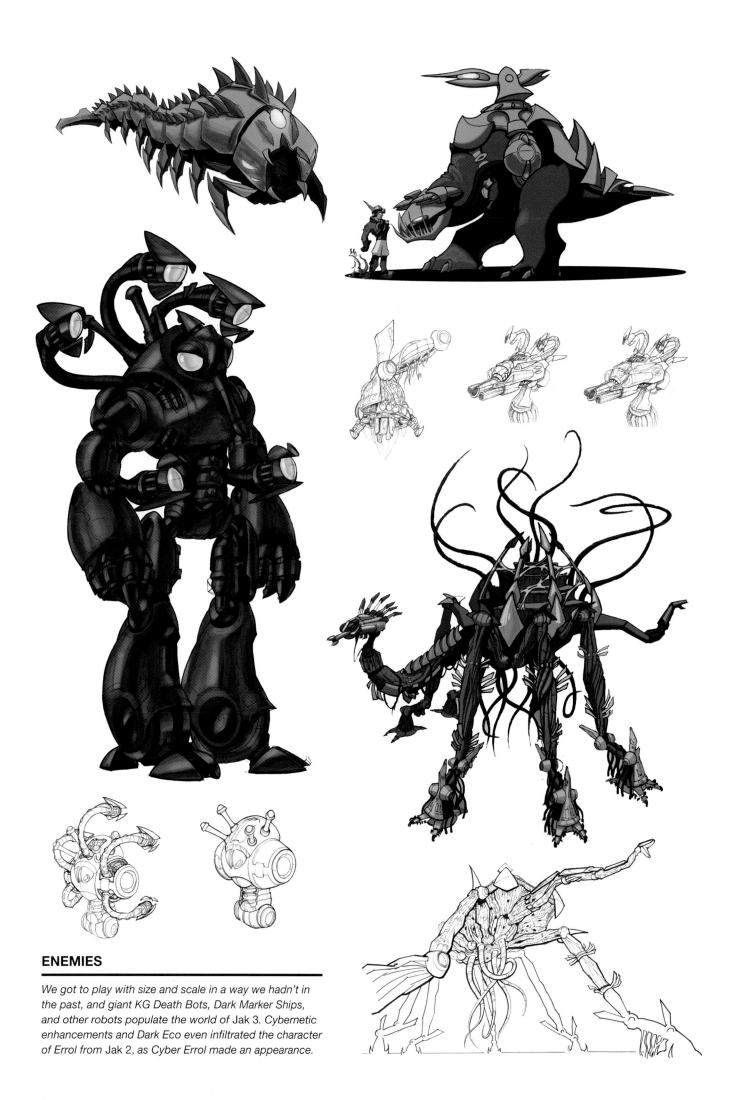

ENEMIES

We got to play with size and scale in a way we hadn't in the past, and giant KG Death Bots, Dark Marker Ships, and other robots populate the world of Jak 3. Cybernetic enhancements and Dark Eco even infiltrated the character of Errol from Jak 2, as Cyber Errol made an appearance.

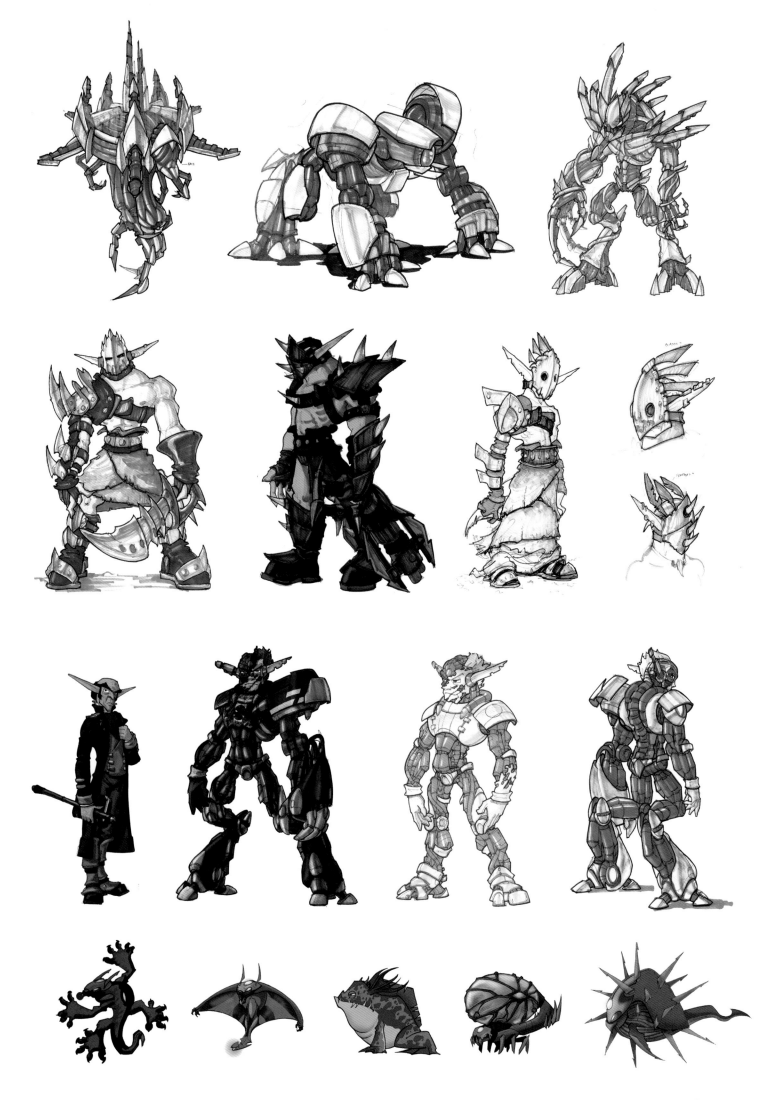

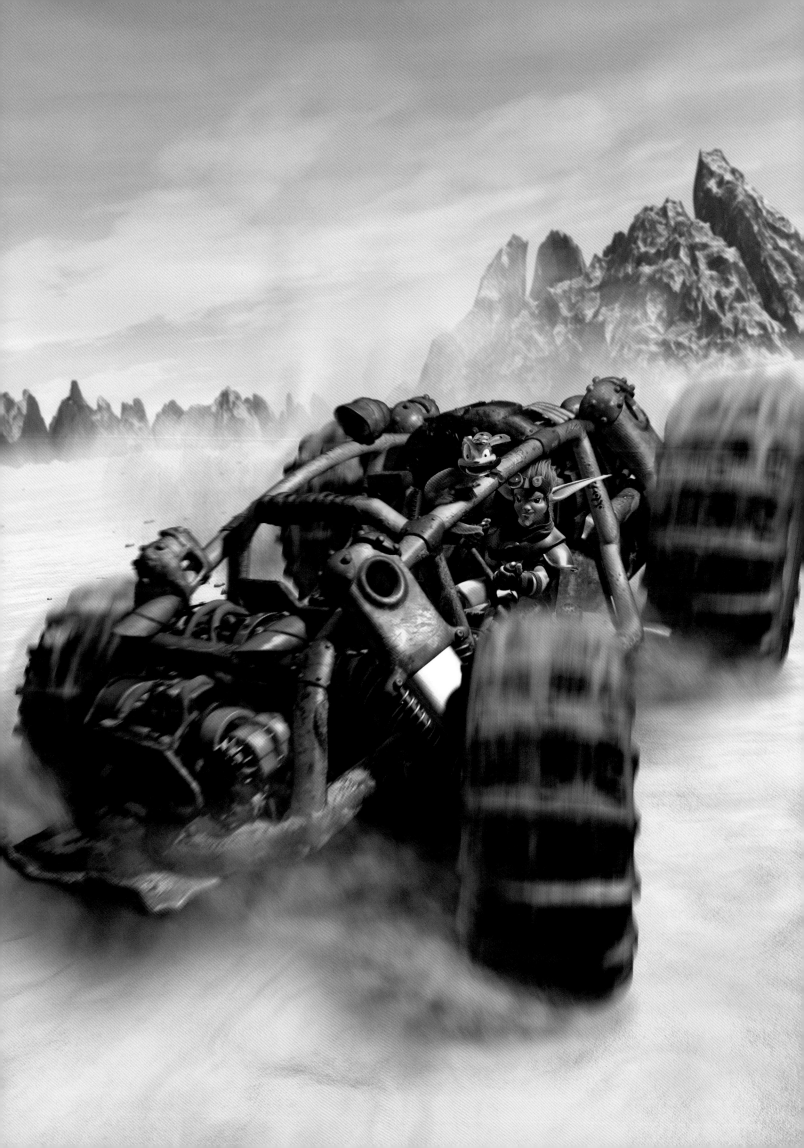

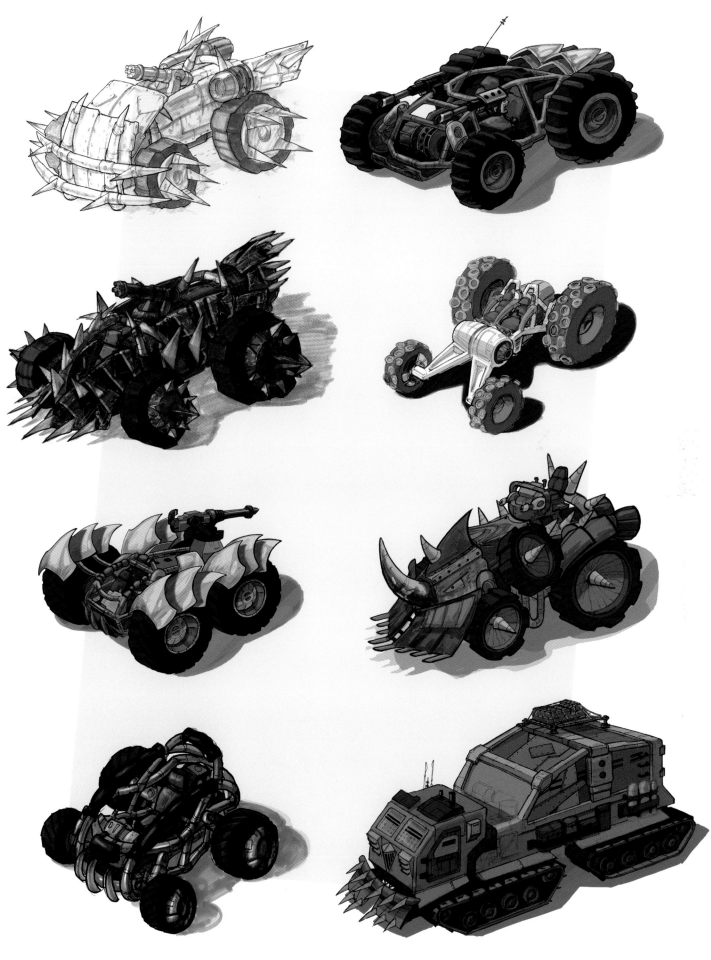

VEHICLES

The desert environment gave us the chance to explore dune buggies and various futuristic, mystical iterations of those vehicles. With names like Sand Shark, Gila Stomper, Marauder Buggy, and Tough Puppy, it's clear that this exploration was a lot of fun.

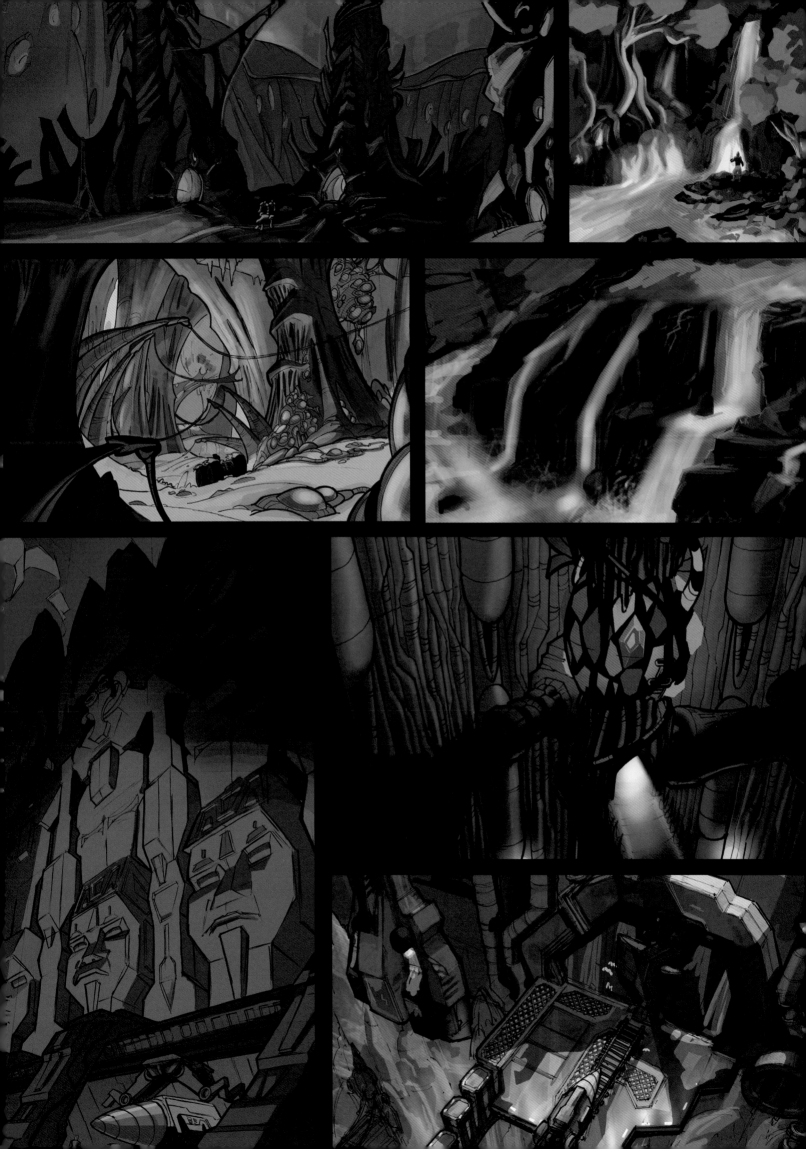

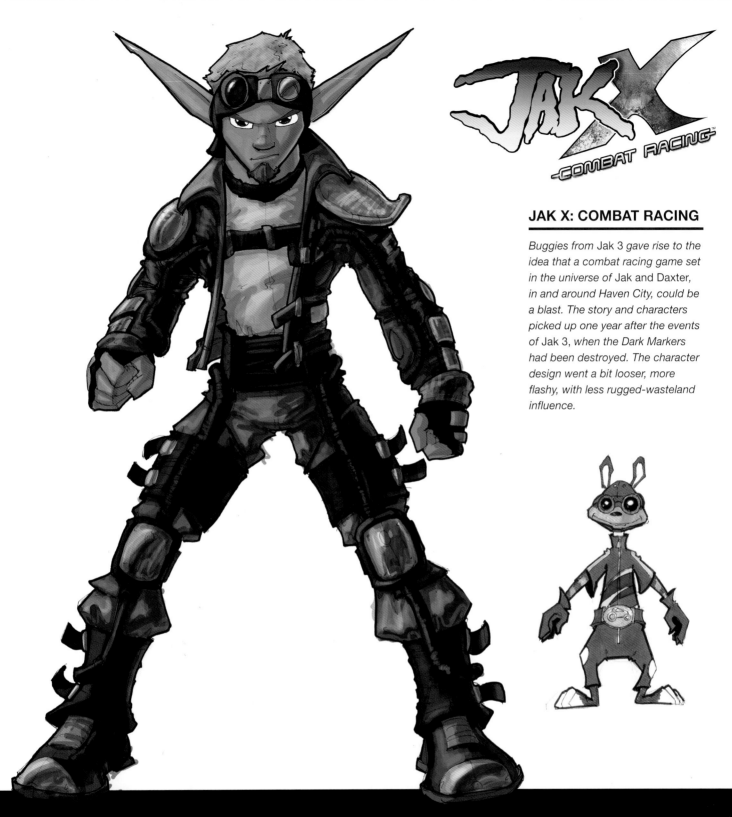

JAK X: COMBAT RACING

Buggies from Jak 3 gave rise to the idea that a combat racing game set in the universe of Jak and Daxter, in and around Haven City, could be a blast. The story and characters picked up one year after the events of Jak 3, when the Dark Markers had been destroyed. The character design went a bit looser, more flashy, with less rugged-wasteland influence.

The tracks in *Jak X* were big and had many hidden paths. It was interesting how we combined multiple tracks together to make a bigger track.

Many of the metropolitan locations, such as Kras City, Haven City, and Spargus City, provided our designers and artists with opportunities to reimagine popular locations as potential racetracks.

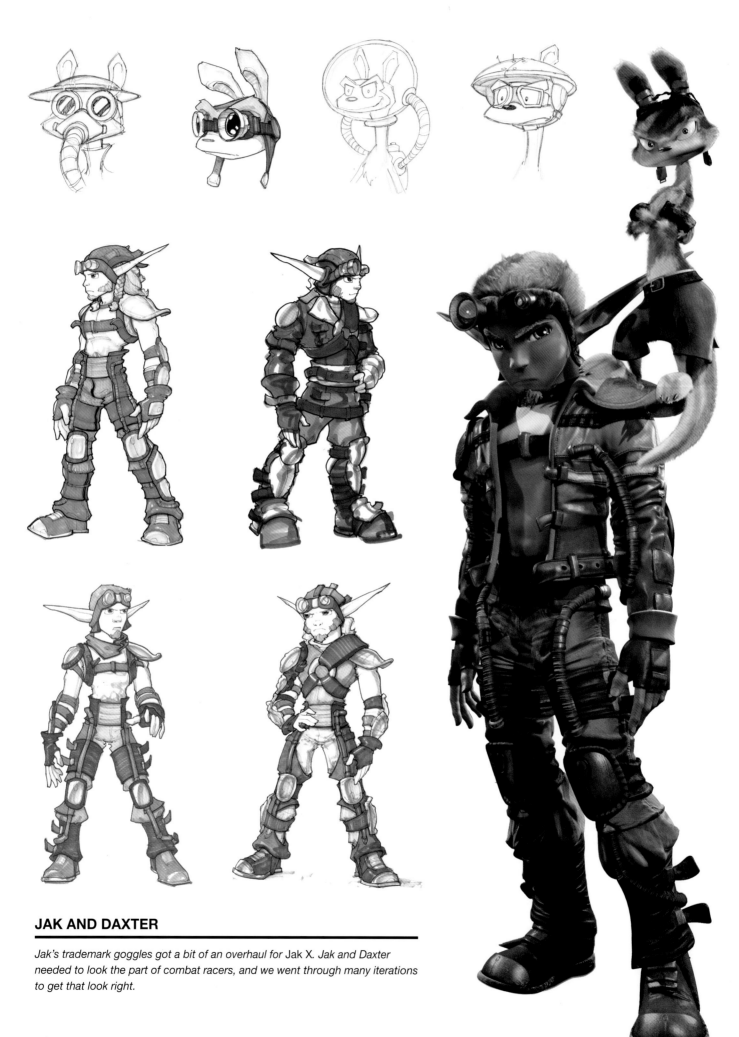

JAK AND DAXTER

Jak's trademark goggles got a bit of an overhaul for Jak X. Jak and Daxter needed to look the part of combat racers, and we went through many iterations to get that look right.

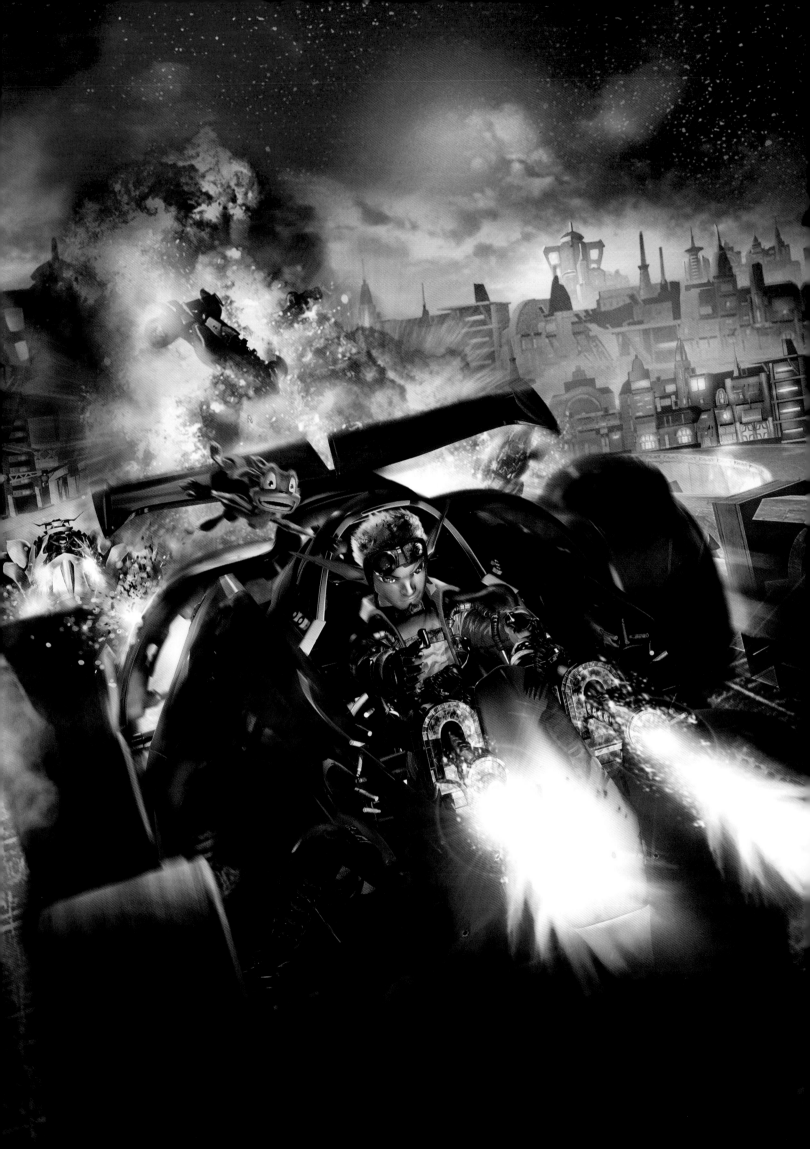

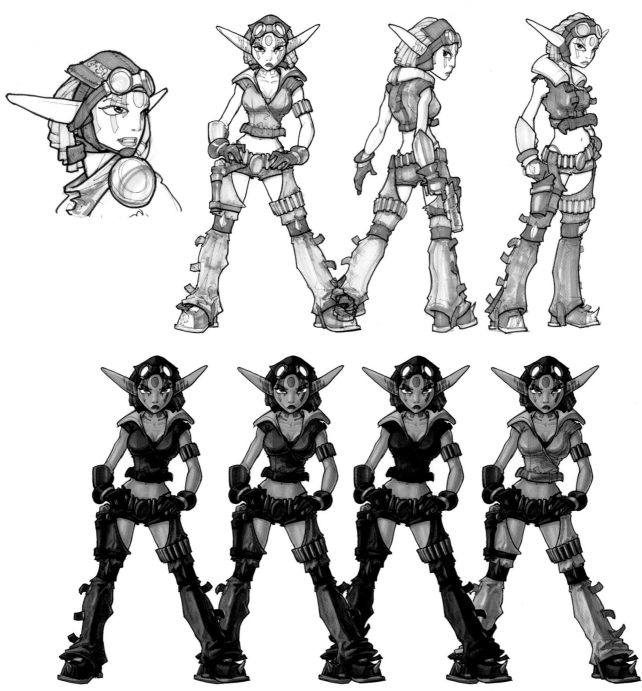

ASHELIN AND TORN

Ashelin Praxis had played a prominent supporting role in Jak II and Jak 3, and with Jak X she took center stage. Her love Torn also had a prominent supporting role in Jak II and Jak 3, and his character became more chiseled in Jak X. Torn and Ashelin are linked both with the Krimson Guard and romantically to each other, so their style of dress reflects that.

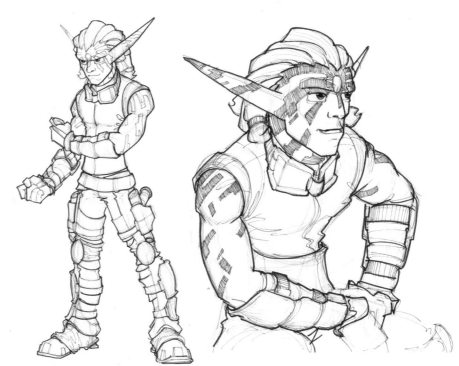

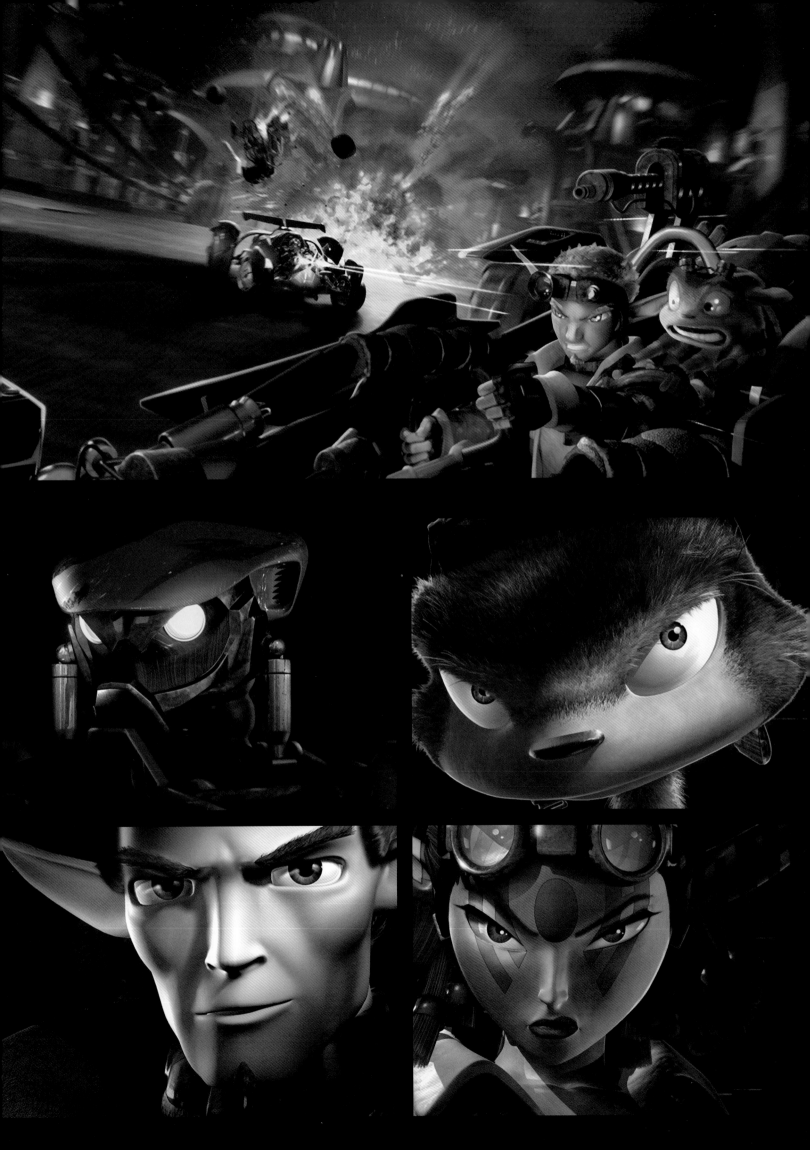

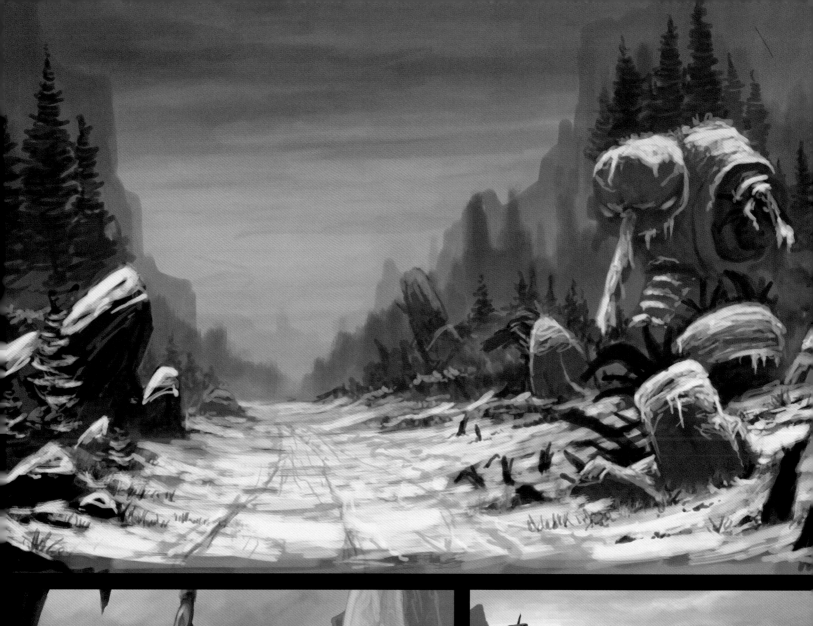

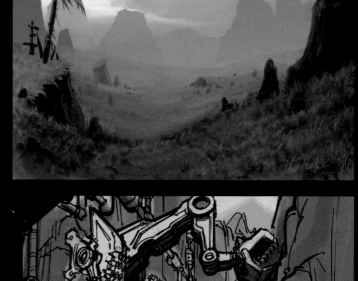
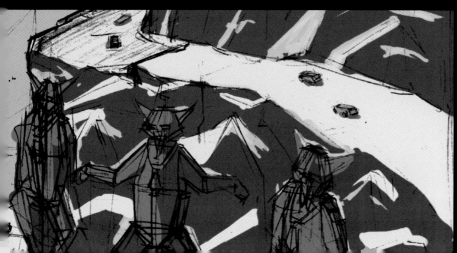

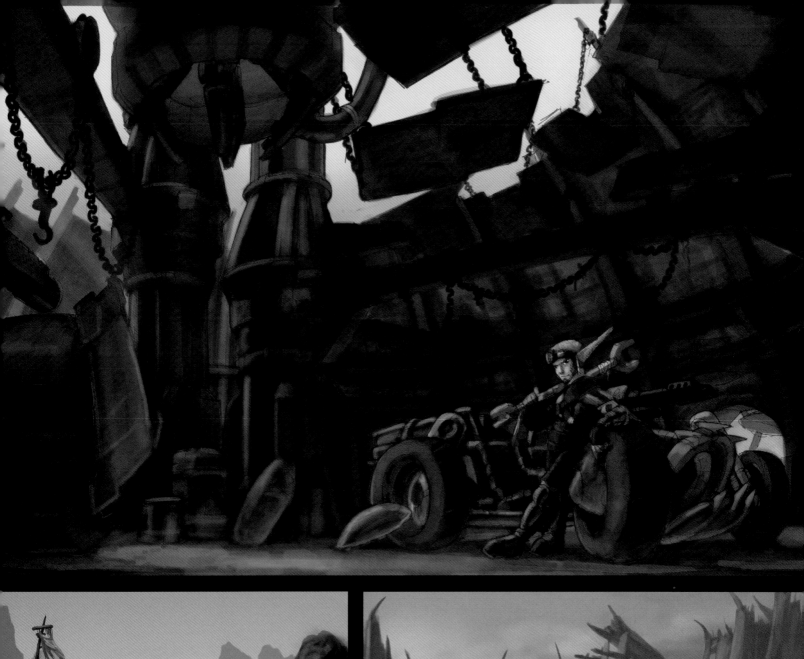
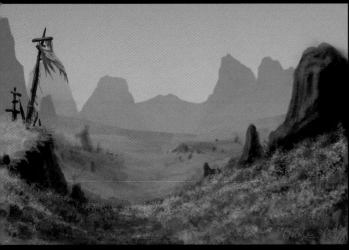
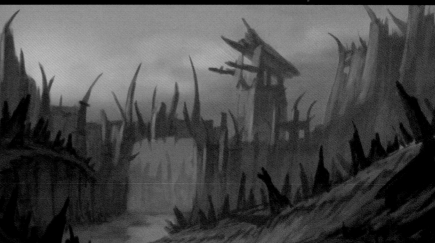
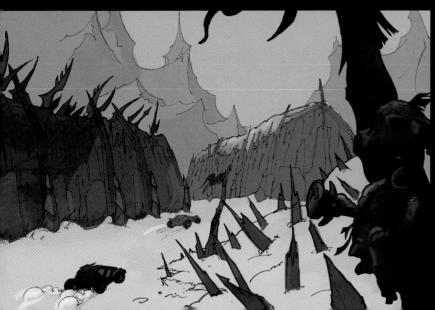
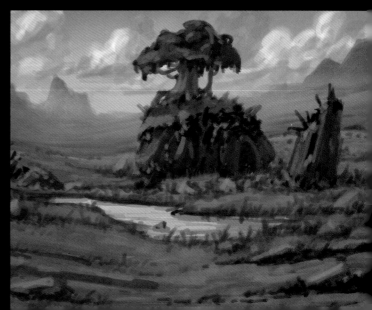

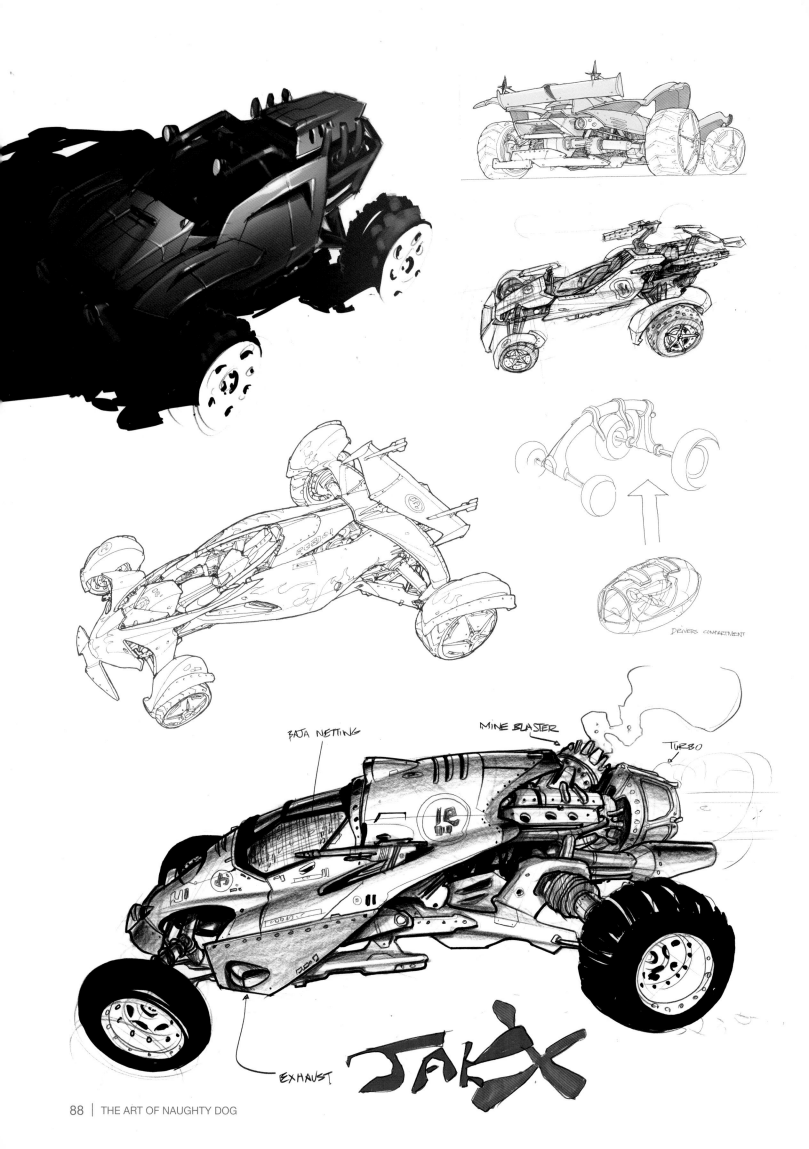

BAJA NETTING

MINE BLASTER

TURBO

DRIVERS COMPARTMENT

EXHAUST

JAK X

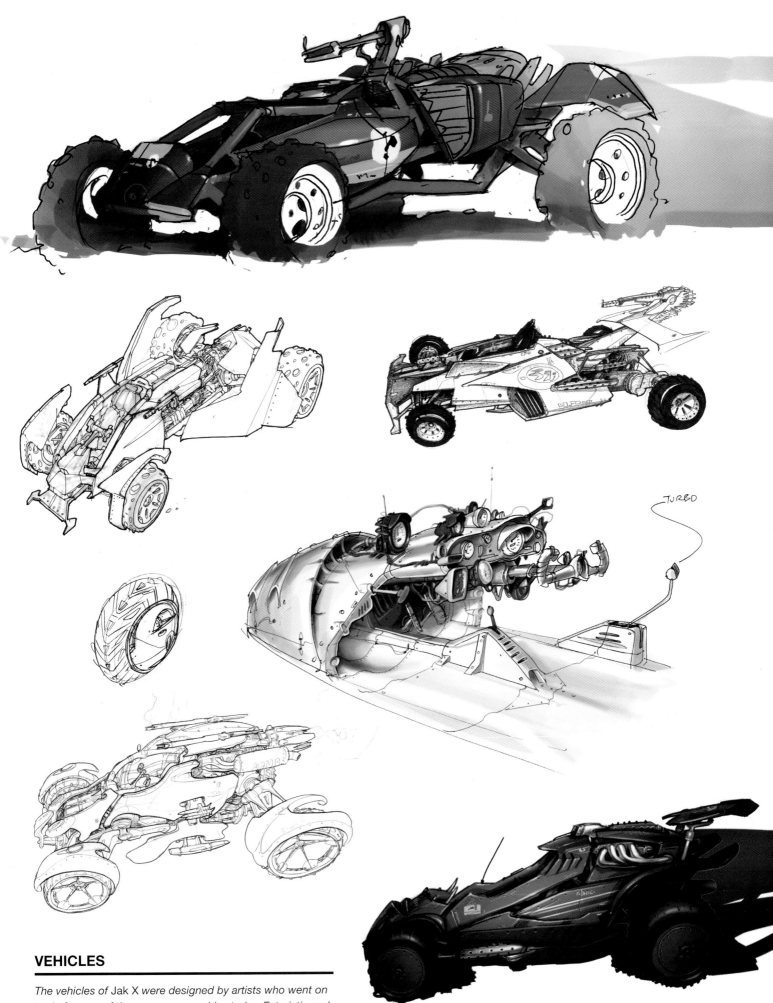

VEHICLES

The vehicles of Jak X were designed by artists who went on to draft some of the cars you now drive today. Futuristic and sleek, these concepts represent how movement and graphic special effects were thought about in the game.

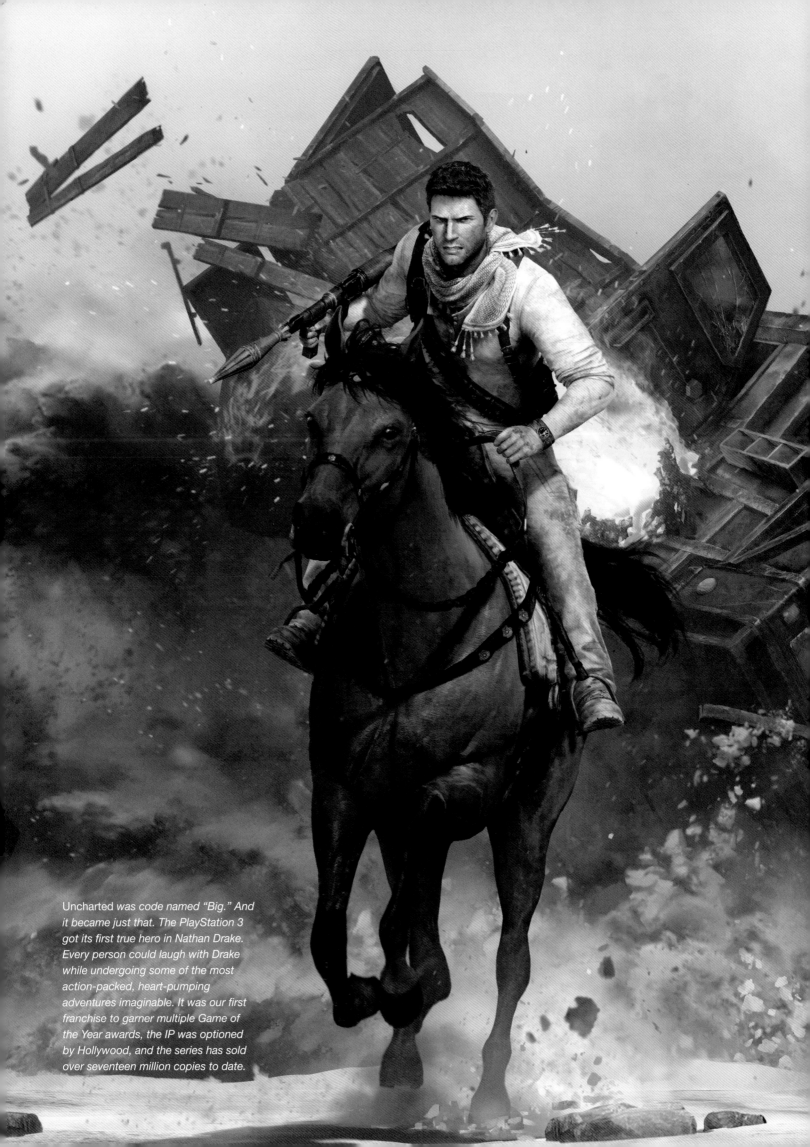

Uncharted *was code named "Big." And it became just that. The PlayStation 3 got its first true hero in Nathan Drake. Every person could laugh with Drake while undergoing some of the most action-packed, heart-pumping adventures imaginable. It was our first franchise to garner multiple Game of the Year awards, the IP was optioned by Hollywood, and the series has sold over seventeen million copies to date.*

UNCHARTED

2007–PRESENT

BY EVAN WELLS AND CHRISTOPHE BALESTRA

Setting out to design a new franchise that will hopefully span several games is a daunting task in and of itself. Add the pressure of following up two enormously successful franchises from the previous two generations of PlayStation hardware, and now you're really feeling it. Next, imagine the two cofounders of Naughty Dog passing the torch to new management, and things are getting even more interesting. Oh, and did we mention we were switching to brand-new rendering technology with the extraordinarily complicated hardware architecture of the PS3, and literally building our entire code base up from scratch? Yeah, there was that too. So suffice it to say, the years from 2004 to 2007 were far from smooth sailing for us at Naughty Dog. In fact, we had some of our darkest days in that period of history. Dozens of proposals thrown out, months and months of tool work completely scrapped, and for three or four months straight, no fewer than one employee quitting every week as they lost hope we'd pull out of our slump. But thankfully we did pull through and went on to create the *Uncharted* franchise, which has become Naughty Dog's most successful brand in its history.

During this transition to the PS3, we knew that we finally could make the leap from the stylized cartoon fantasy worlds of our previous franchises and tackle a story that takes place in the real world, featuring real people. We decided to develop a performance capture pipeline utilizing motion capture instead of our traditional hand-key animation approach (which was initially met with significant resistance from our animation team!). The technology would allow us to tell more sophisticated and

subtle stories, since we could capture facial expressions and emotions that just weren't possible on previous generations of hardware. And finally, when picking a direction, we wanted to set ourselves apart from the overwhelming number of titles coming out that were dark, brooding, melodramatic sci-fi or fantasy games. We found inspiration from the classic pulp adventure genre found in TV, film, comics, and novels throughout the twentieth century. The environments would be exotic and colorful. The characters would be charming, humorous, and relatable. Though it seems less radical by today's standards, we wanted to create the feeling of playing a classic summer blockbuster where you were in control of the hero the whole way through. This is how Nathan Drake was born.

The wonderful thing about following Nate on his adventures around the world is the opportunity it gives the team to develop such a huge variety of fantastic art. We get to explore all corners of the globe, visiting not only undiscovered jungles, ruins, and temples, but also cities and museums, and sometimes uncovering secrets in what might seem like the most mundane locations.

We wanted the environments to have as much character as the heroes and enemies that populated them. We were pushing the rendering tech to give us dynamic shadows so that we could have dappled light shining through the overhead jungle foliage. Water was to be a pervasive theme and present in every location, whether it was an ocean, a raging river, a gentle stream, a waterfall, or just water droplets dripping from the ceiling of a cave. These goals dictated a lot of the technology that we developed for the game.

Nathan Drake, our new hero, was going to be just a guy in a T-shirt and jeans. Not only was this a departure from the norm from a design perspective, but it presented us with technical challenges that you wouldn't have to deal with if your hero was wearing hard-surfaced metallic armor. We had to make clothes fit and move realistically. We had to render hair. Thankfully, we somehow managed to pull the first game off, and it was successful enough for us to immediately launch into the sequel.

By the time *Uncharted 2: Among Thieves* started development, we had so many unrealized goals and ideas on the cutting-room floor that we started moving at a rapid pace. The team was energized, finally getting to work with mature technology, and the programmers were finally comfortable with taking advantage of the very powerful hardware we were working with. Of course, as with any project, it had its ups and downs, but as we were approaching the end, we realized we were working on something special. It came down to the wire, and we were jamming in as much polish as possible at the last second, but it all paid off. The game went on to win countless Game of the Year awards and established *Uncharted* as one of the PlayStation's most important franchises.

Following up with a third iteration after a success like *Uncharted 2* was a huge amount of pressure. But now the team was so familiar with the engine and the universe that we were really firing on all cylinders. Our rendering tech continued to improve, which allowed the artists and designers even more creative freedom. While there's debate among members of the gaming community about which *Uncharted* is their favorite, there's no debating that *Uncharted 3: Drake's Deception* was a fitting end to the franchise on the PlayStation 3.

During the development of these three *Uncharted* games, Naughty Dog created countless art assets. What we've included here is a mix of the cream of the crop and our early ideations, but it's just scratching the surface of all the art that it takes to create an *Uncharted* adventure. Our next adventure, which you'll see a glimpse of in the Future Projects section, will be *Uncharted 4*. We hope you'll peruse this section to understand how we got where we are and the Future Projects section to see where we are going.

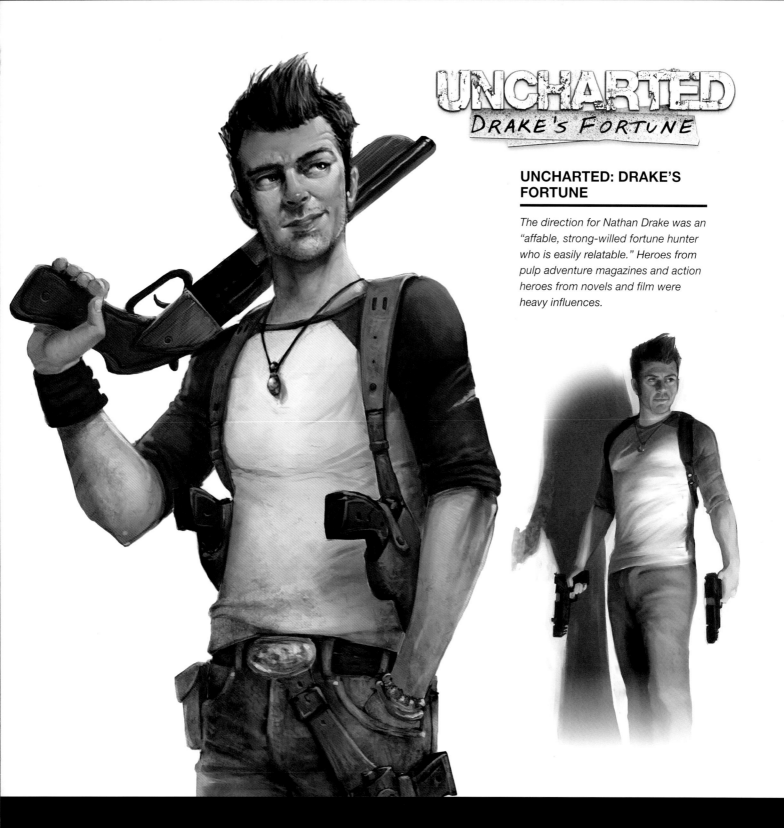

UNCHARTED
DRAKE'S FORTUNE

UNCHARTED: DRAKE'S FORTUNE

The direction for Nathan Drake was an "affable, strong-willed fortune hunter who is easily relatable." Heroes from pulp adventure magazines and action heroes from novels and film were heavy influences.

Colorful, scenic vistas and exotic locations are hallmarks of the series. Drake's climbing prowess needed equal grandeur.

The diary of Sir Francis Drake. Journals are a staple of the franchise. They provide clues for what's coming next.

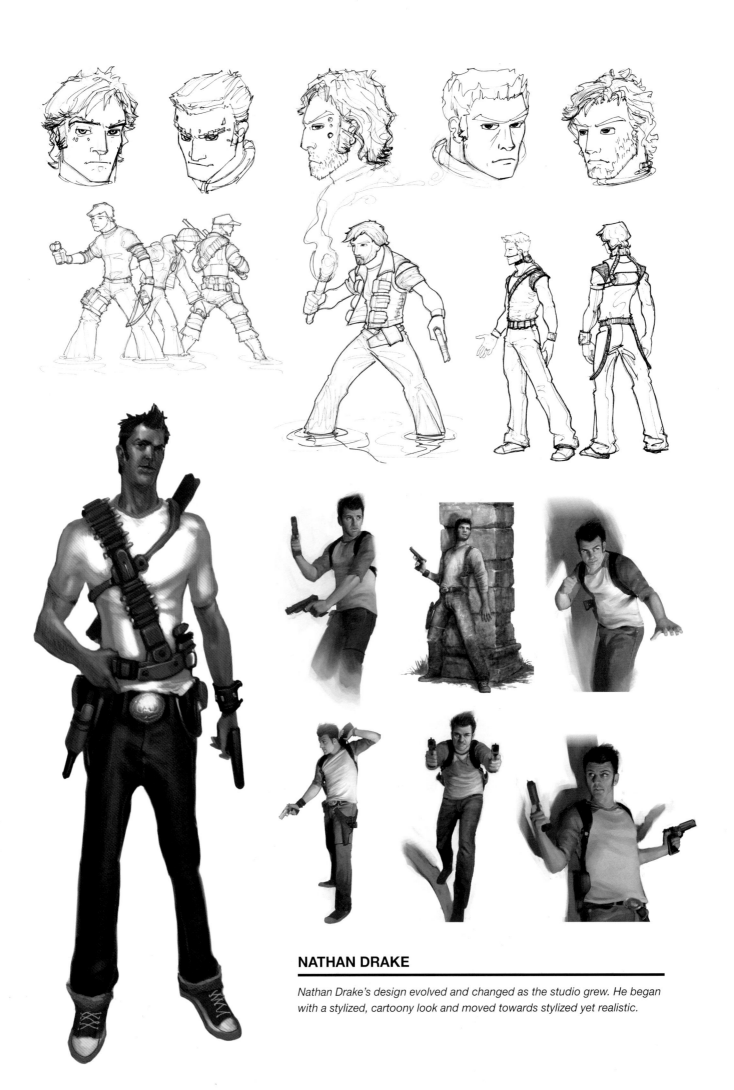

NATHAN DRAKE

Nathan Drake's design evolved and changed as the studio grew. He began with a stylized, cartoony look and moved towards stylized yet realistic.

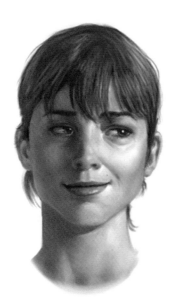

ELENA FISHER

Elena underwent many iterations and multiple hairstyles. We even released a Game Informer cover on which she had shorter brunette hair before we settled on the blond color.

 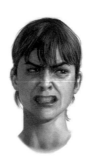

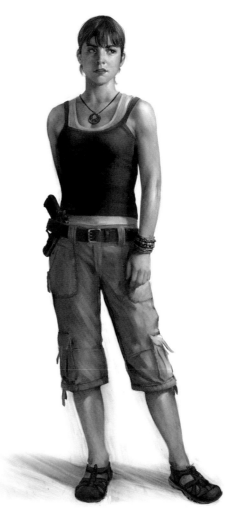

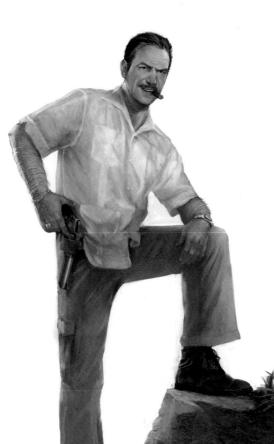

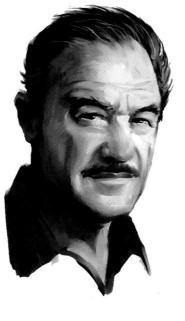

VICTOR SULLIVAN

Sully, Drake's mentor and father figure, straddles a line between macho toughness and approachability. His trademark cigar completes the character's persona.

 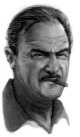 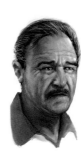

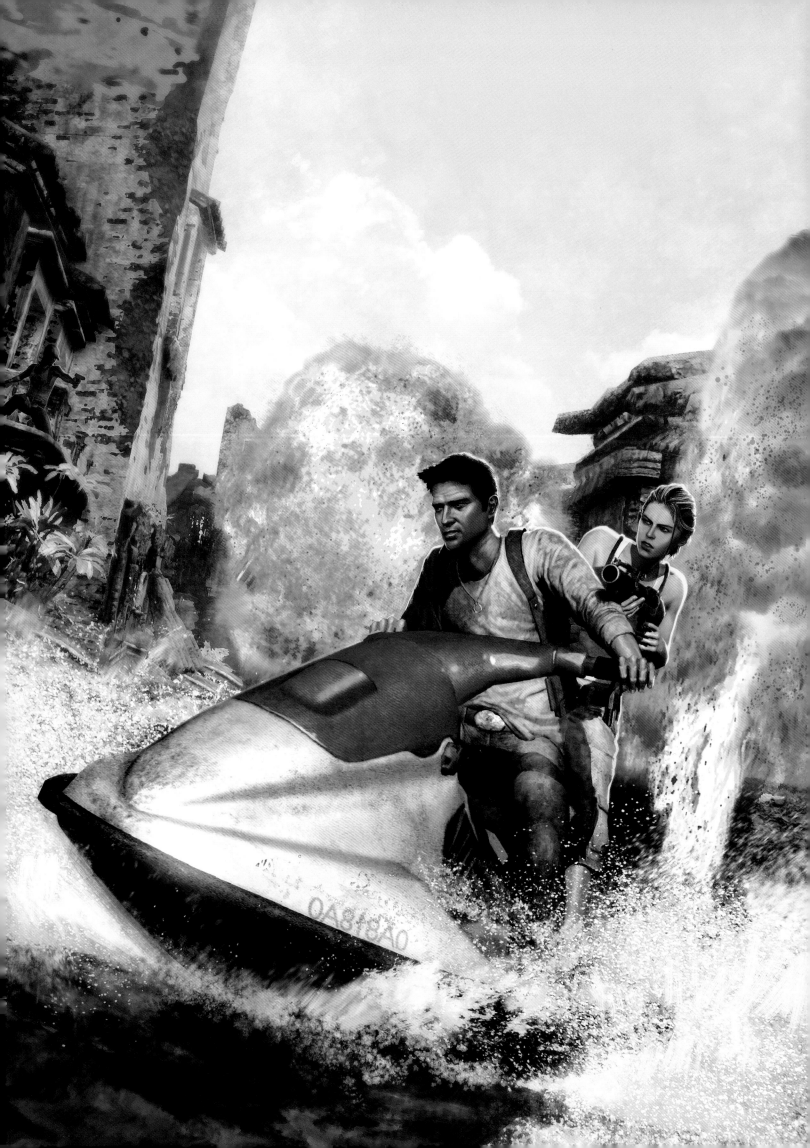

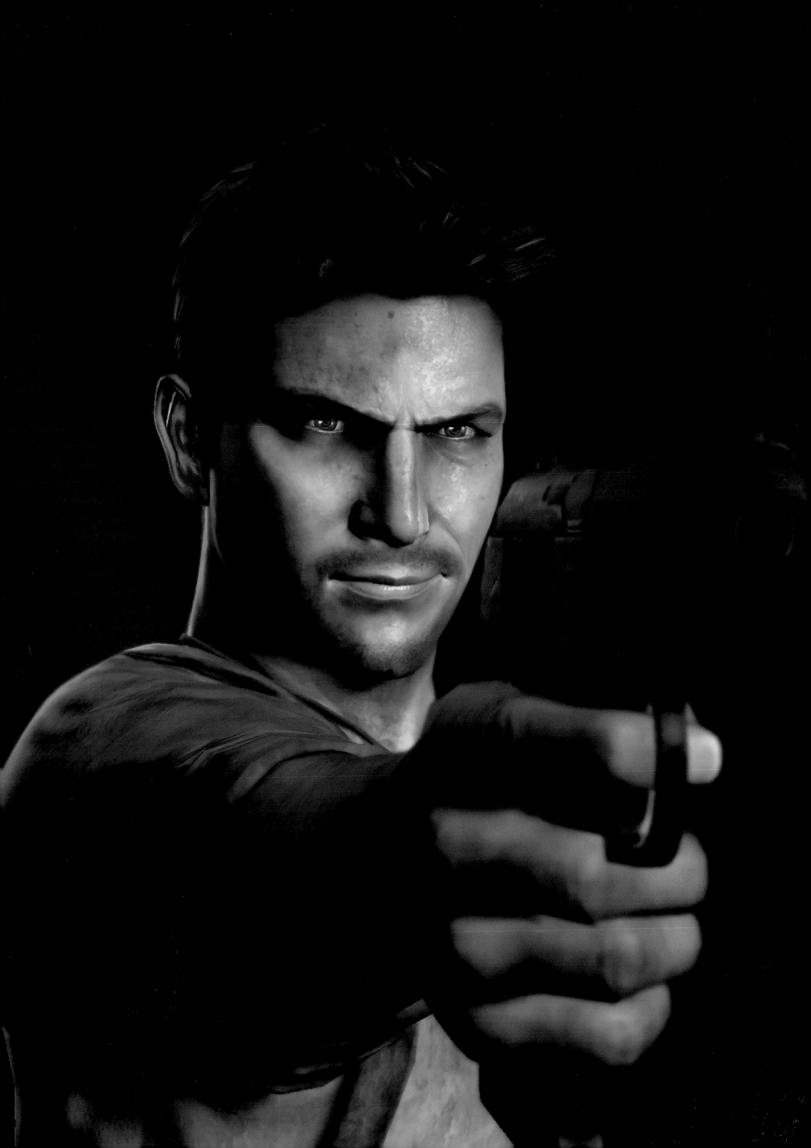

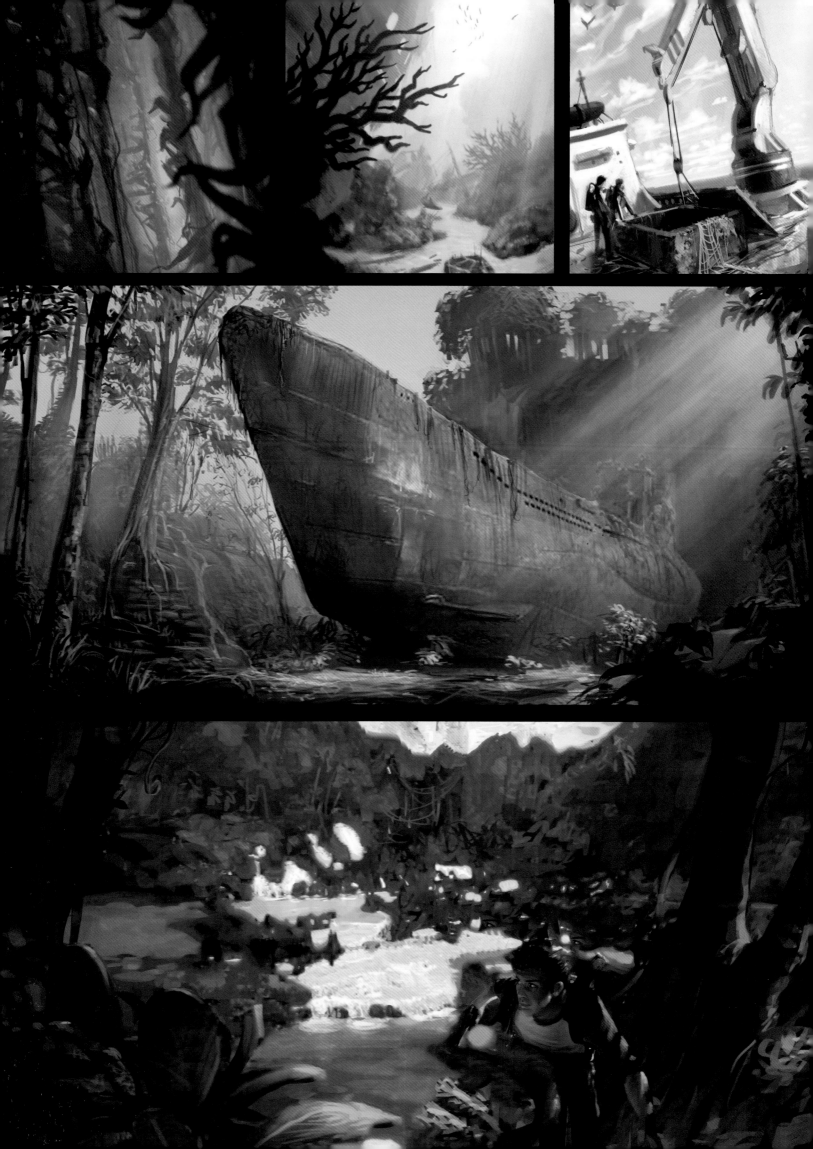

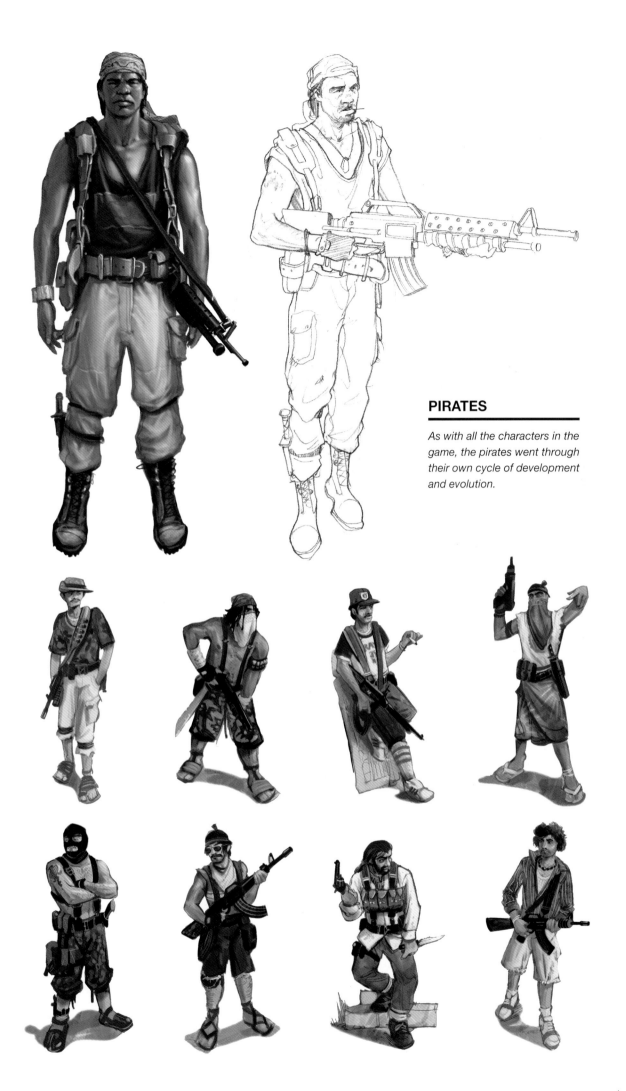

PIRATES

As with all the characters in the game, the pirates went through their own cycle of development and evolution.

PRIMARY ANTAGONISTS

Gabriel Roman, Eddy Raja, and Navarro—these character studies helped define the personality, look, attitude, and wardrobe for the "heavies" and primary antagonists in Uncharted: Drake's Fortune.

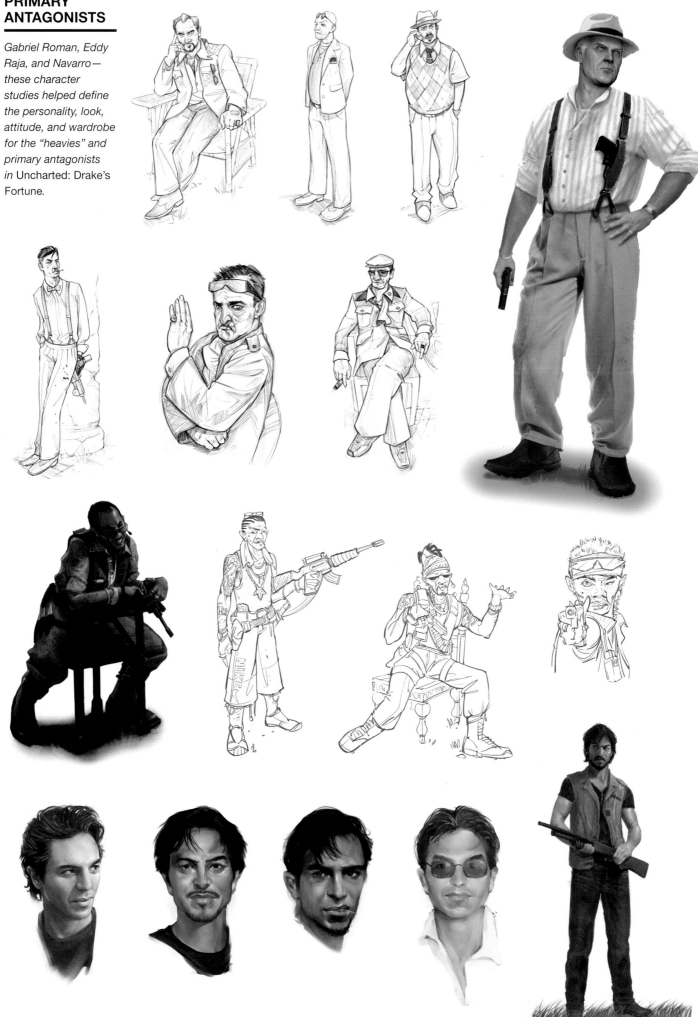

DESCENDANTS

The Descendants, the cursed Spanish colonists that have mutated and devolved, providing that bit of plausible fantasy to the adventure.

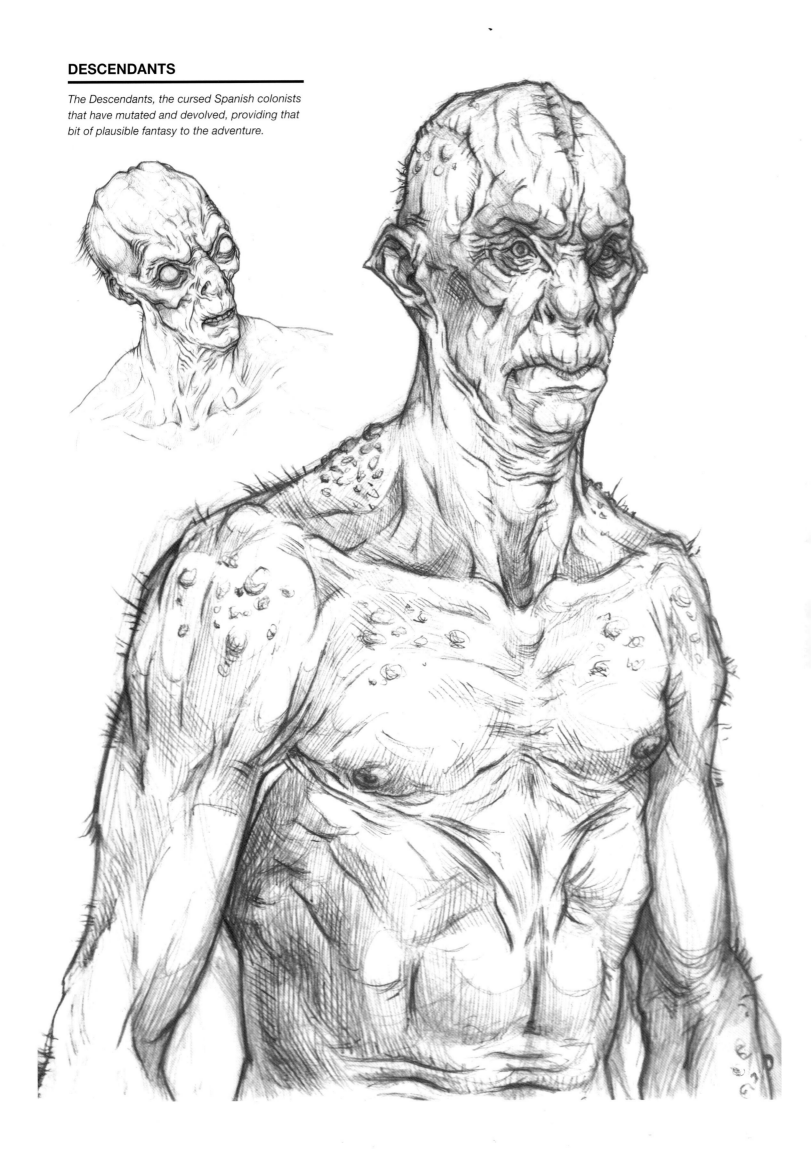

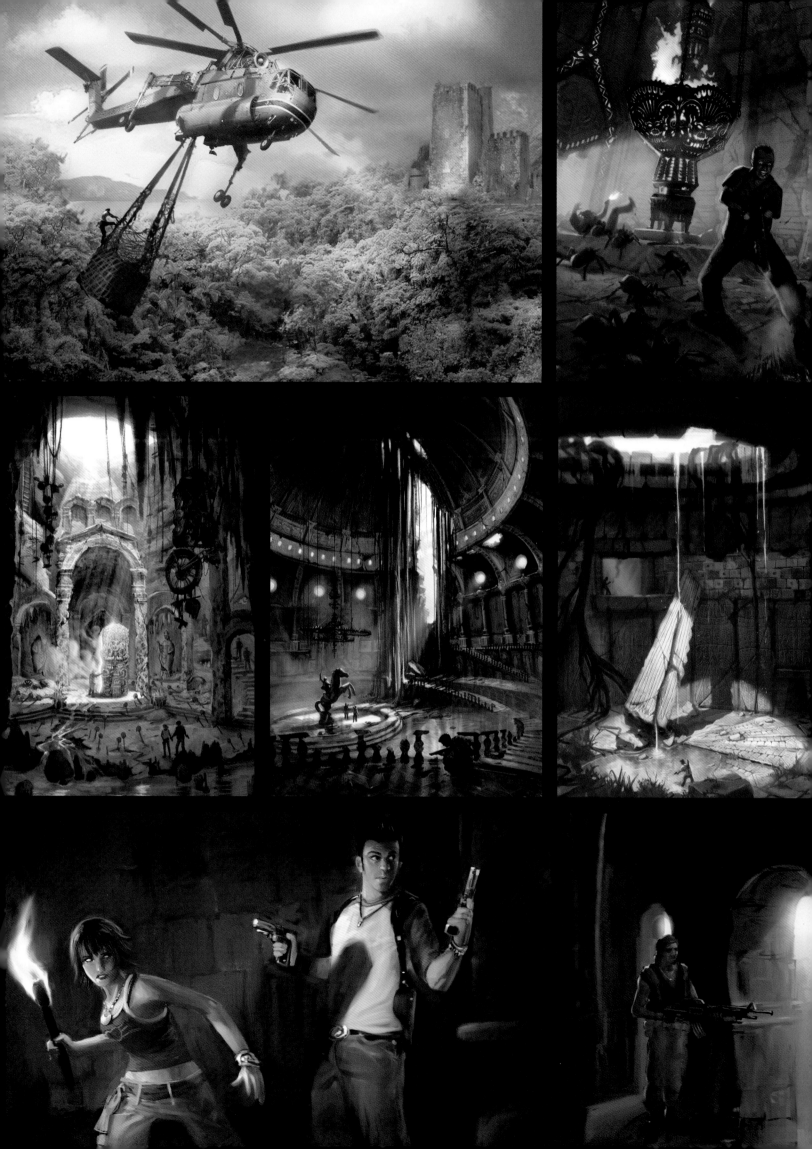

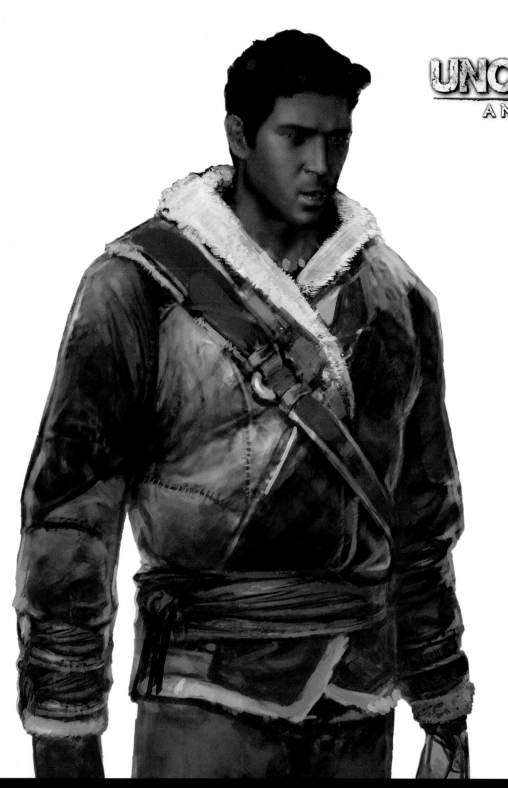

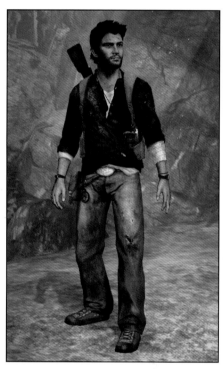

UNCHARTED 2: AMONG THIEVES

With Uncharted 2 *we needed a costume change for our main hero that reflected the slightly darker tone of the new chapter, yet kept Drake grounded and recognizable.*

Chloe plays Drake's occasional love interest and rounds out aspects of Drake's personality.

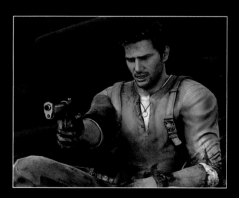

Drake's a daring adventurer but highly vulnerable and human as well.

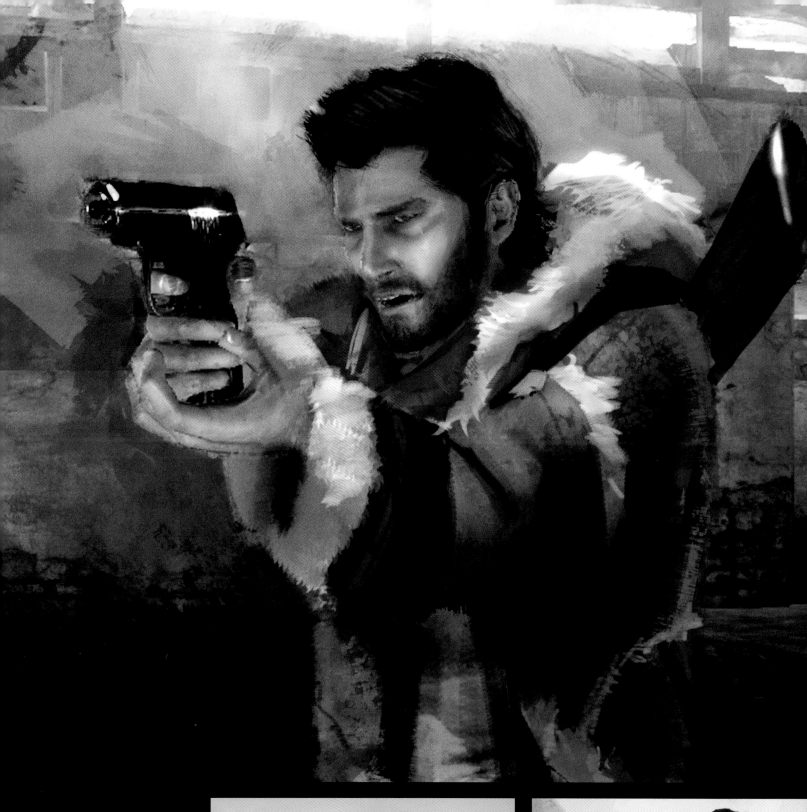

Concept and marketing art that shows Drake's new look.

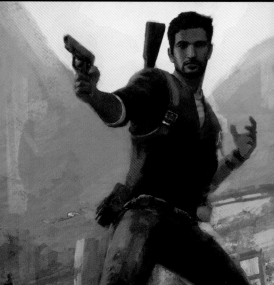

Demon yeti? WTF!

Always Depicted on Fire

Conqueror Bearing the cintamani Stone

crushed skulls of vanquished enemies

THE FACES OF... VICTOR SULLIVAN (goddamn)

① DELIGHT
"EL Goddamn Dorado!"

③ Arousal
"Goddamn, what a woman"

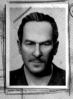
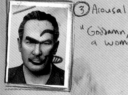

② Compassion
Nate, how did you get stuck in this goddamn shithole!

④ Anger
"Goddammit kid you're gonna get us killed!"

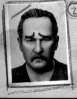

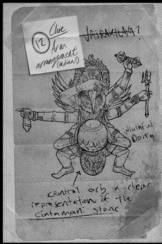

⑫ Clue Aran arrangement (indian) VAJRAKILYA?

Wrathful Deity

central orb a clear representation of the cintamani stone

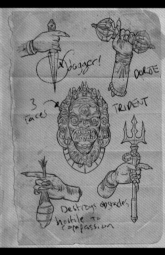

Dagger! DORJE

3 faces TRIDENT

Destroys obstacles hostile to compassion

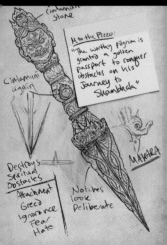

cintamani stone

M to the Pizzo:
"The worthy pilgrim is granted a golden passport to conquer obstacles on his Journey to Shambhala"

Cintamani again

MAKARA

Destroys Spiritual Obstacles
Attachment
Greed
Ignorance
Fear
Hate

Notches look Deliberate

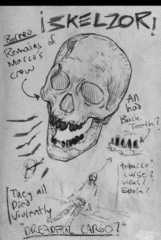

Borneo ¡SKELZOR!
Remains of Marco's crew

All had Back Teeth?

tobacco? curse? virus? Ebola?

They all Died Violently
"DREADFUL CARGO?"

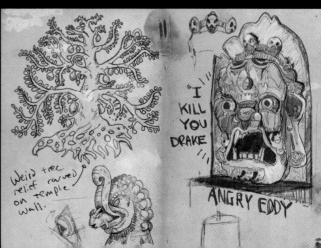

Weird tree relief carved on temple wall.

"I KILL YOU DRAKE"

ANGRY EDDY

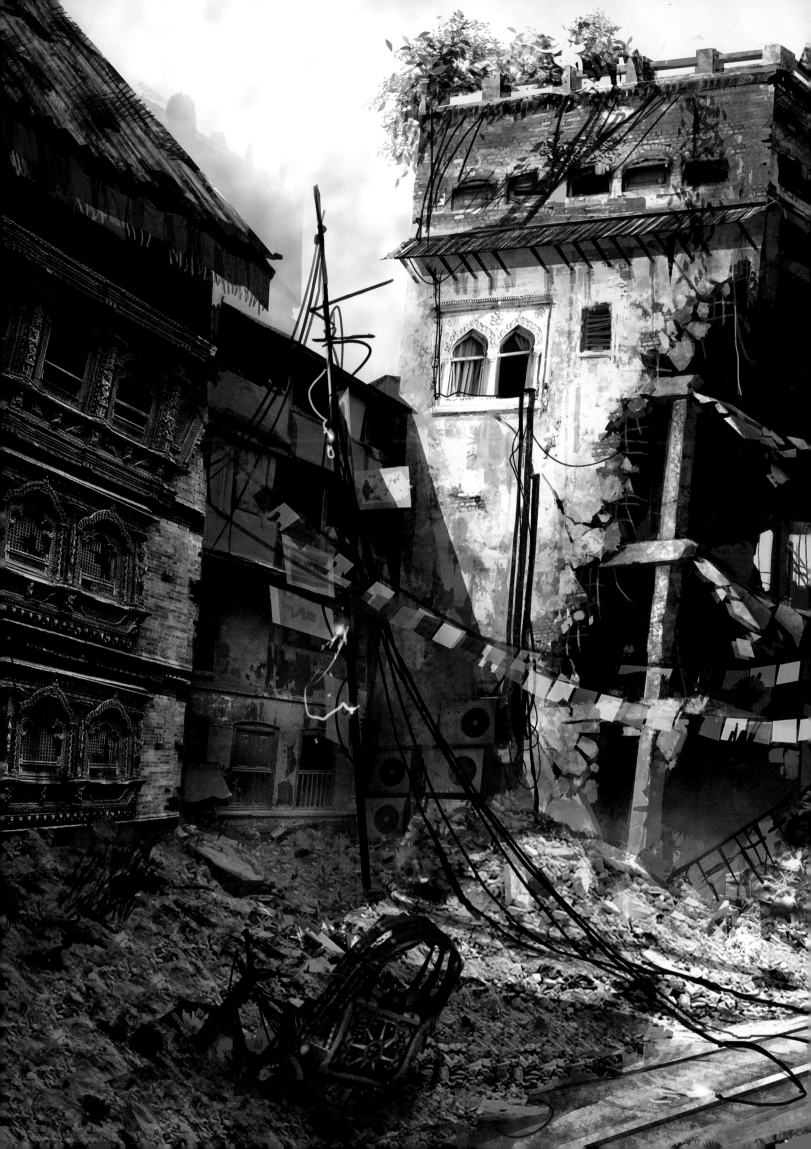

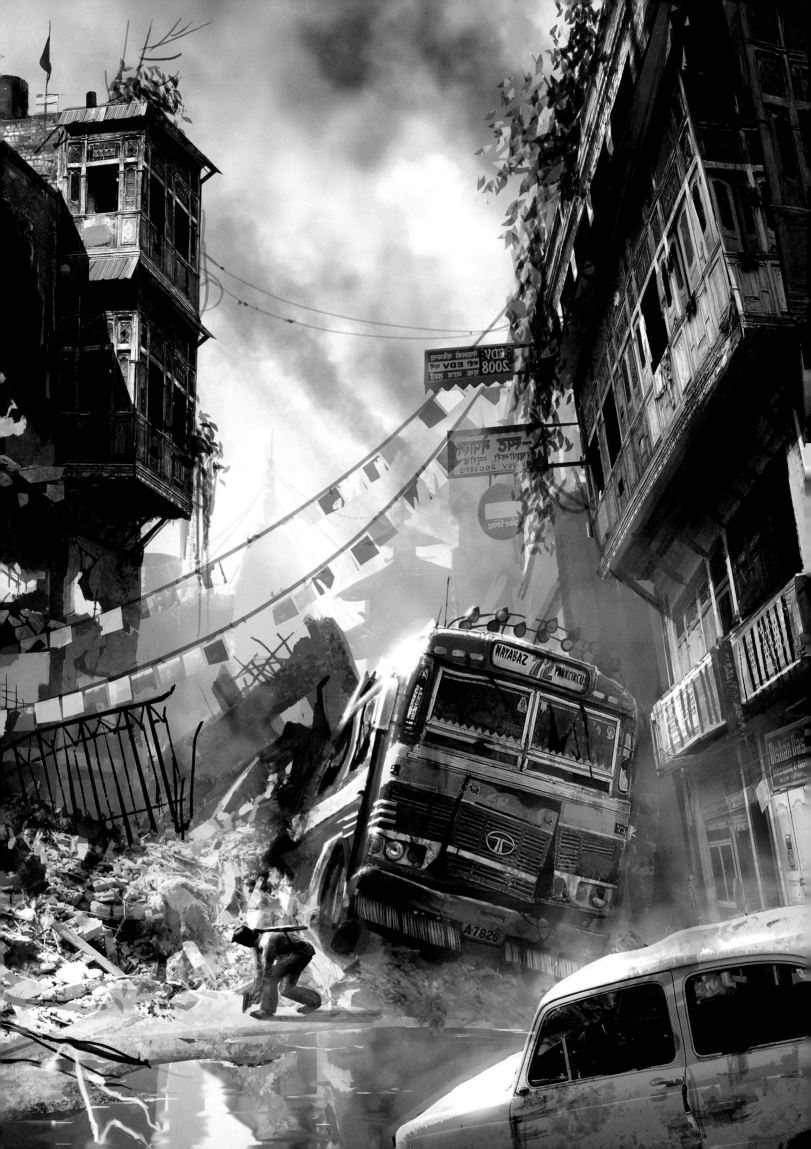

SECONDARY CHARACTERS

Elena, Chloe, Tenzin, and Schäfer concept designs and costume exploration.

Facing page: Concept design for the Guardians and Zoran Lazarevic.

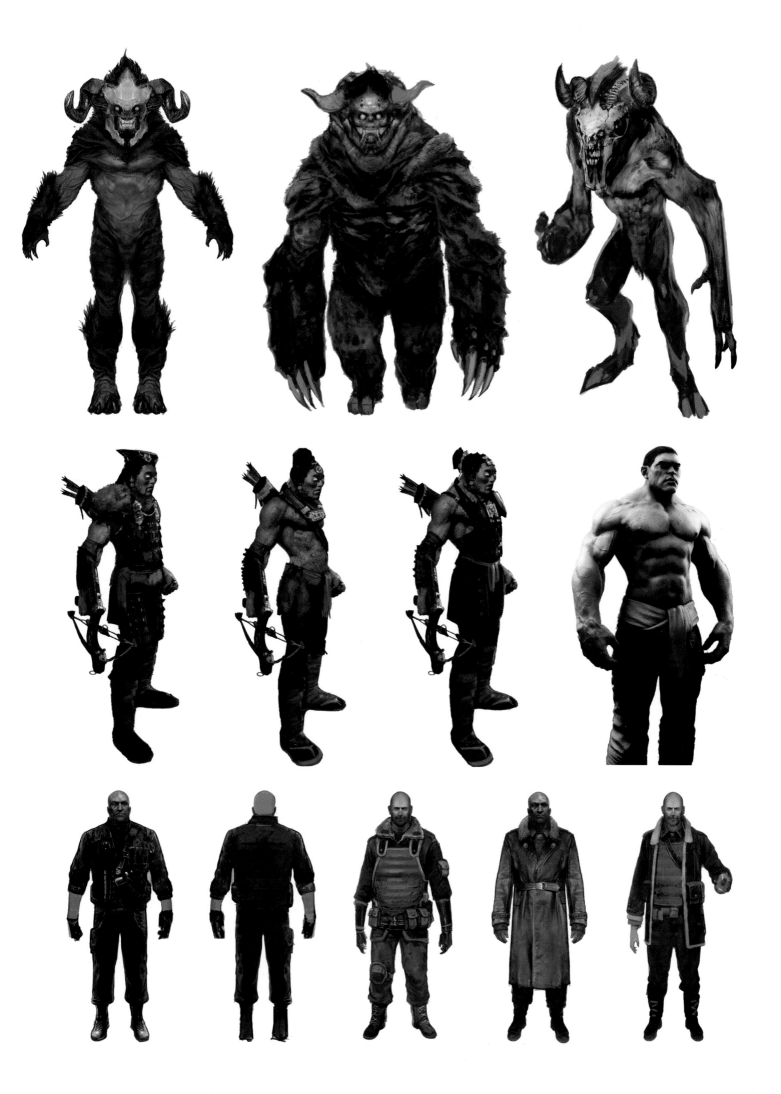

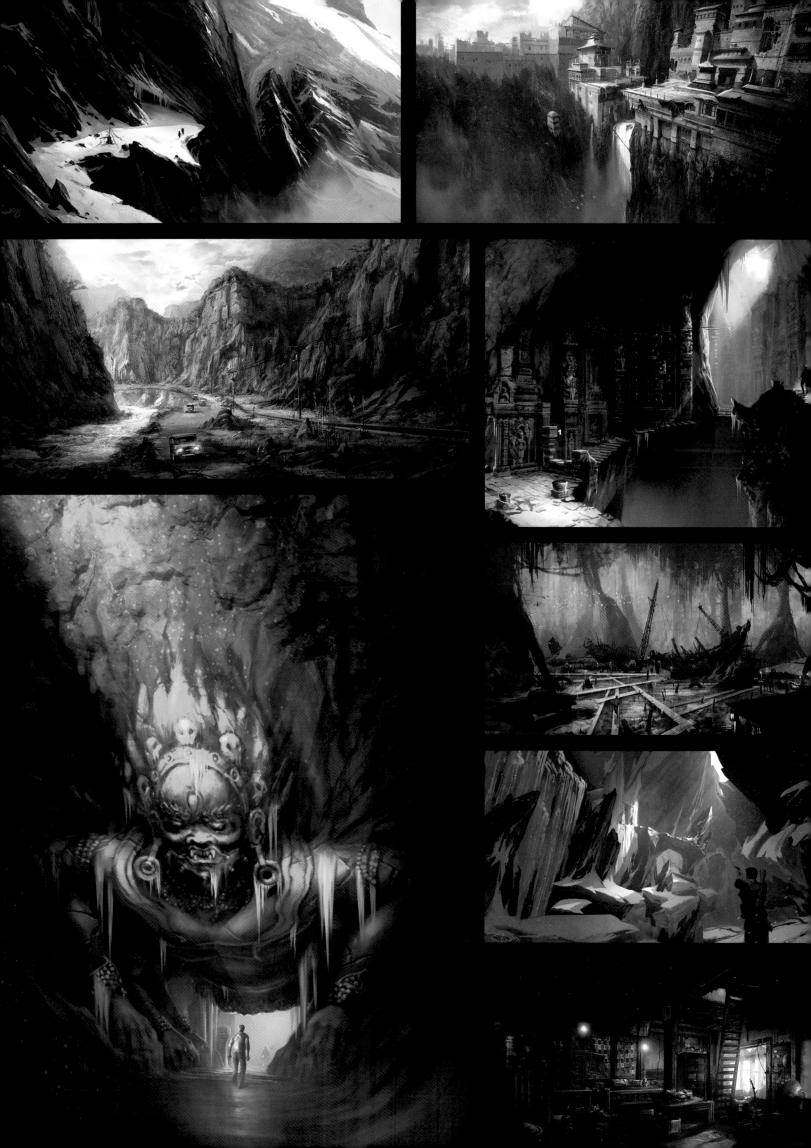

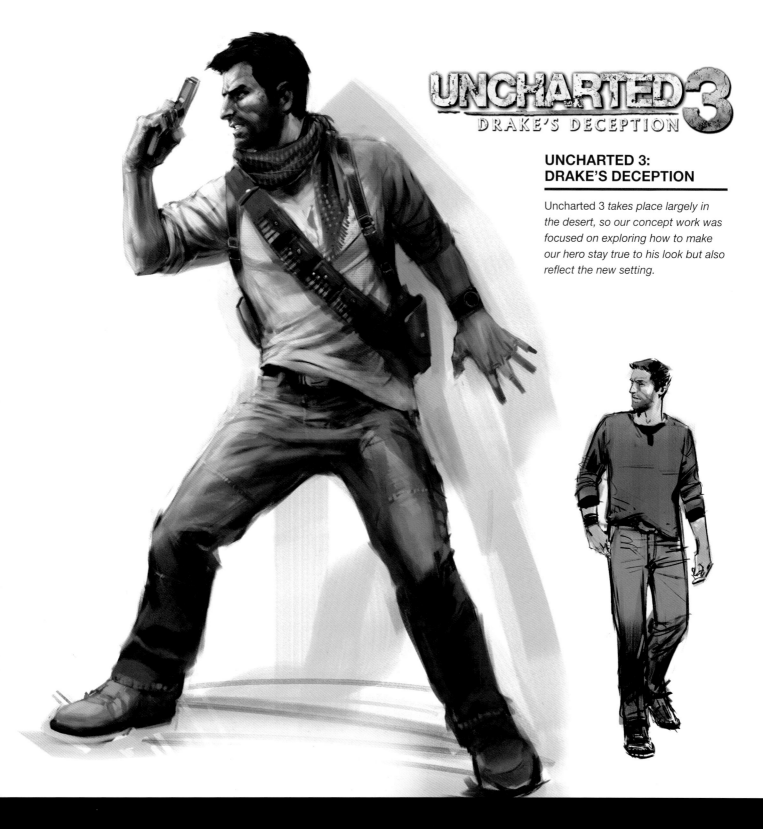

UNCHARTED 3
DRAKE'S DECEPTION

UNCHARTED 3: DRAKE'S DECEPTION

Uncharted 3 *takes place largely in the desert, so our concept work was focused on exploring how to make our hero stay true to his look but also reflect the new setting.*

A chase sequence through a desert canyon was the first time Drake was

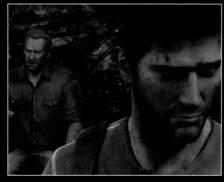

Sully is Drake's mentor and often his voice of reason. His role as father figure is a

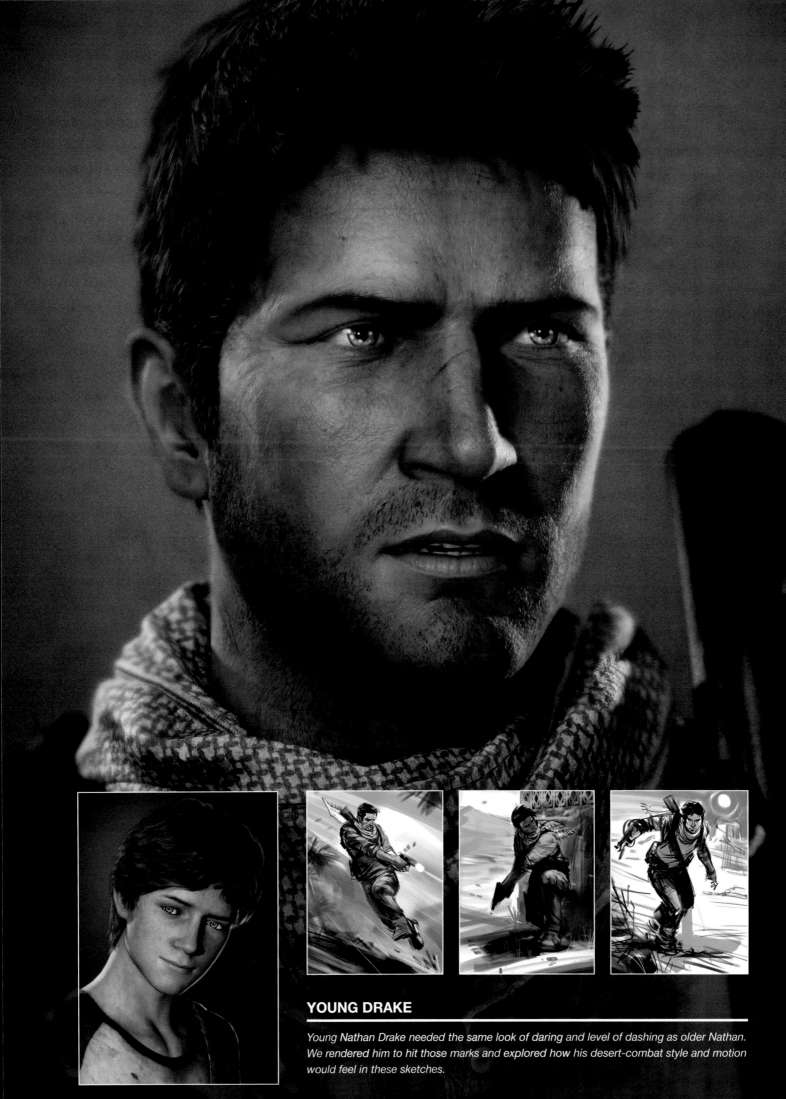

YOUNG DRAKE

Young Nathan Drake needed the same look of daring and level of dashing as older Nathan. We rendered him to hit those marks and explored how his desert-combat style and motion would feel in these sketches.

YOUNG SULLY

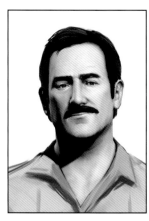

Sully and his younger self. Part of the fun of this installment was coming up with younger versions of our endearing characters. There are also a few ideas of how an injured Sully would look during a skirmish.

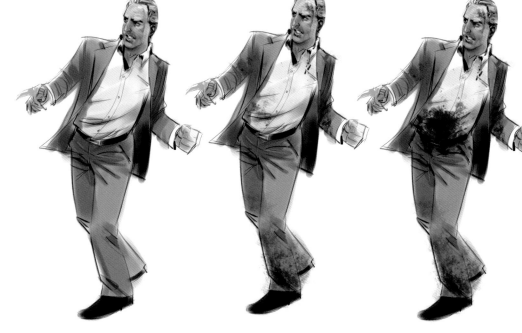

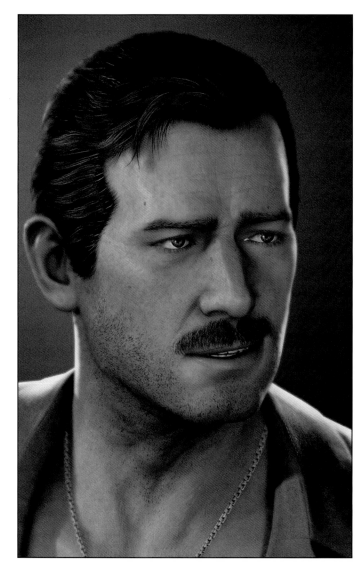

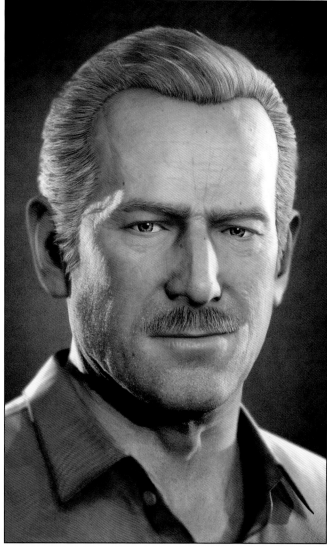

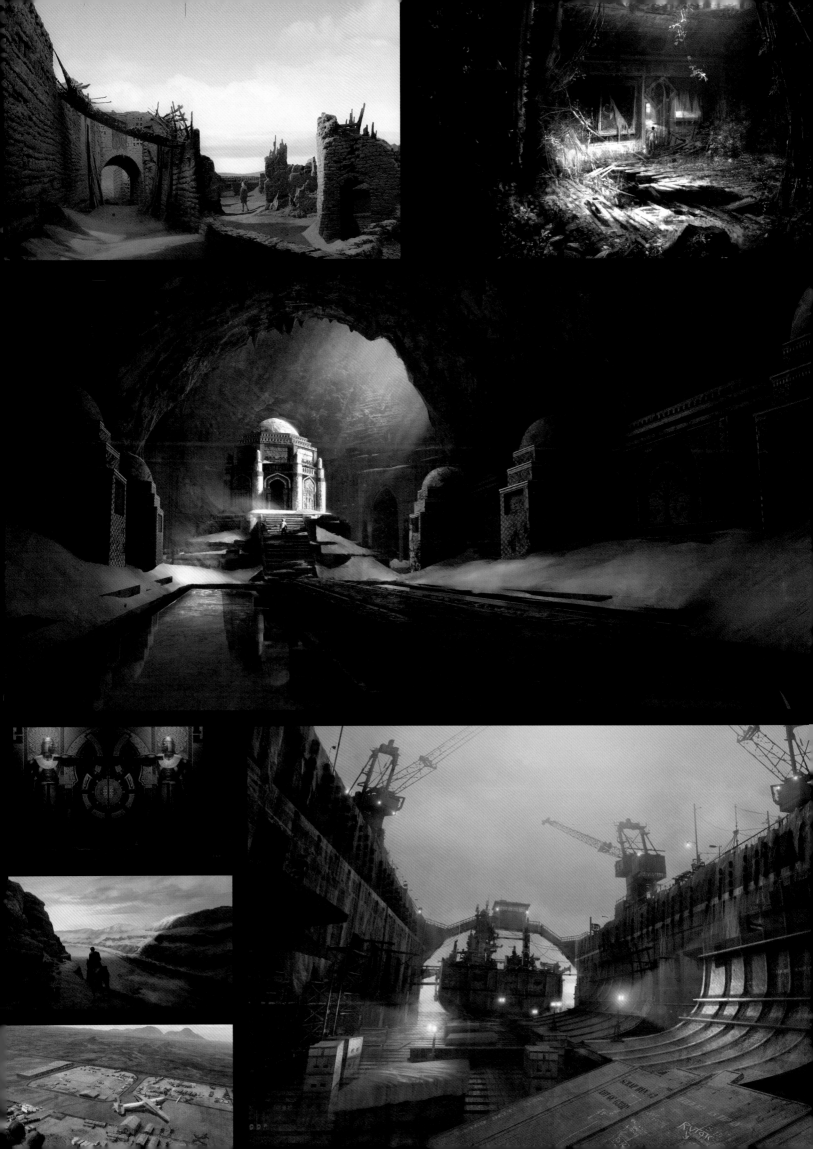

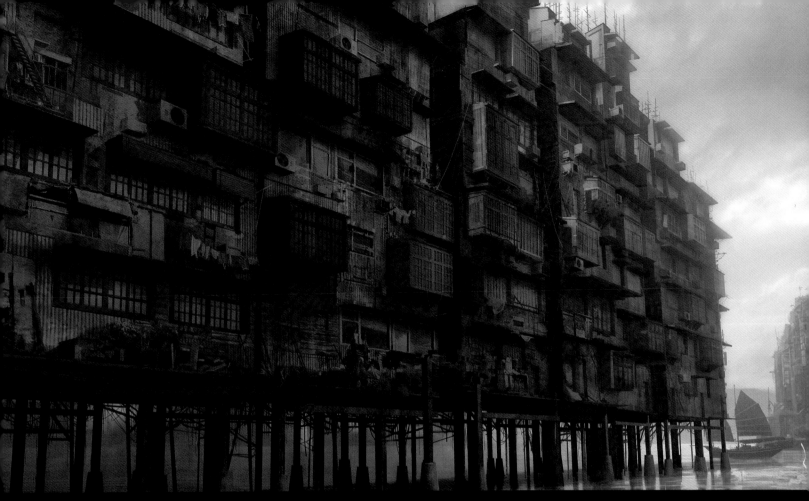

We explored having an area that was set in the middle of the ocean, a floating housing complex modeled on Kowloon City. It was going to have heavy traversal elements and be fairly massive. Ultimately, it didn't pan out.

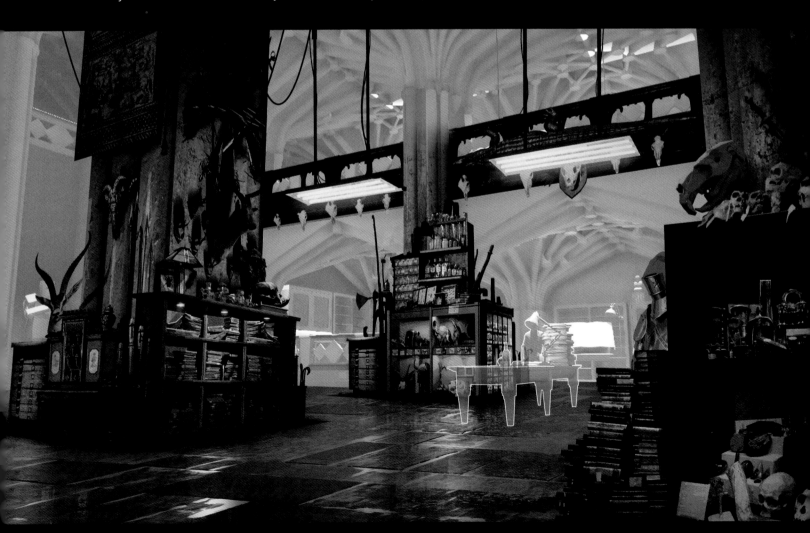

An environmental paint-over that provided the concept for Marlowe's secret vault hidden beneath the tube tracks of London. She and her secret society had collected thousands of artifacts from all over the world and throughout history.

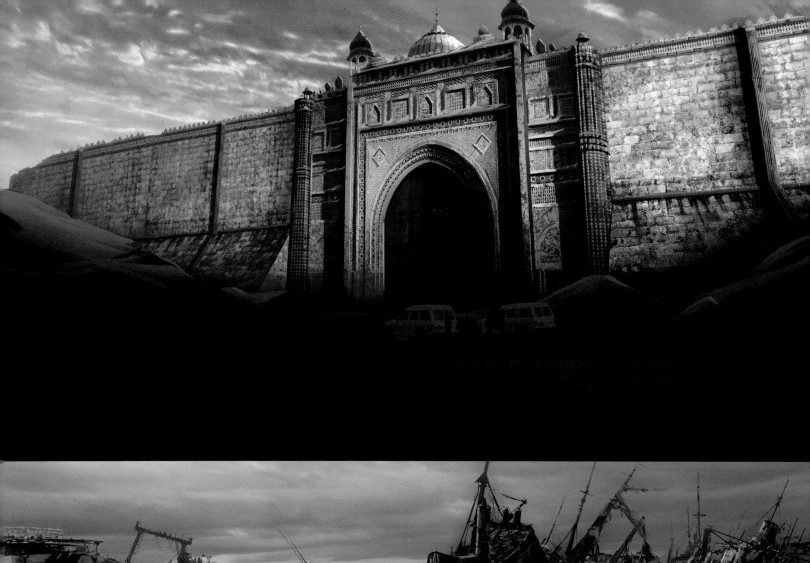

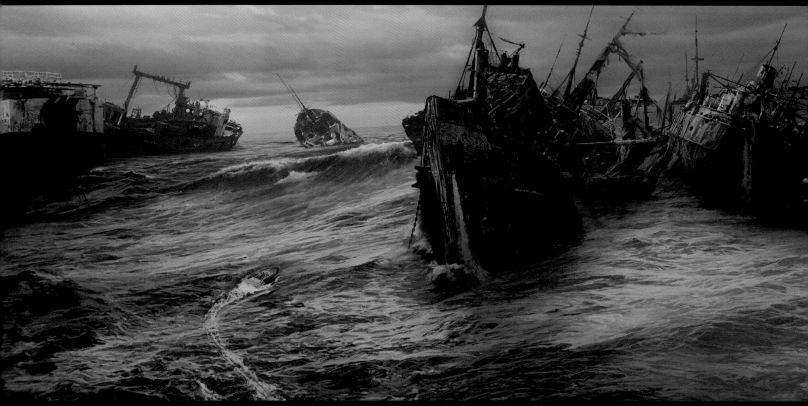

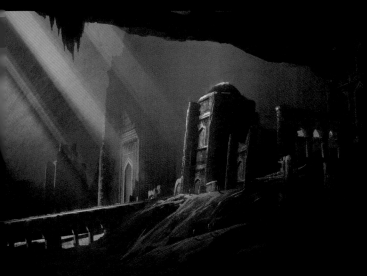
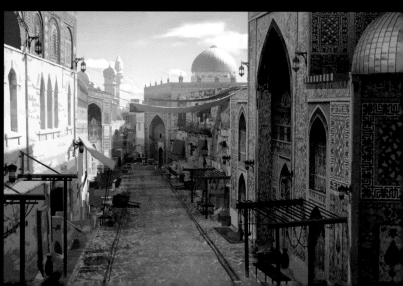

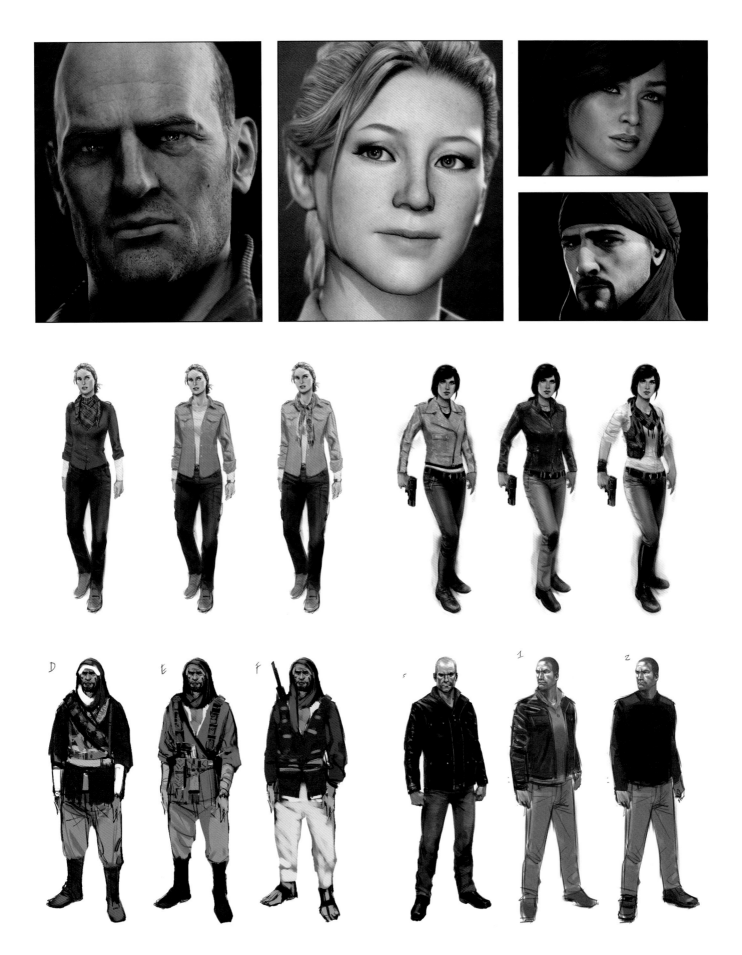

SECONDARY CHARACTERS

Key concepts and wardrobe exploration for Elena, Chloe, Cutter, and Salim. Their looks had to be suited to when Nathan Drake met them in the story.

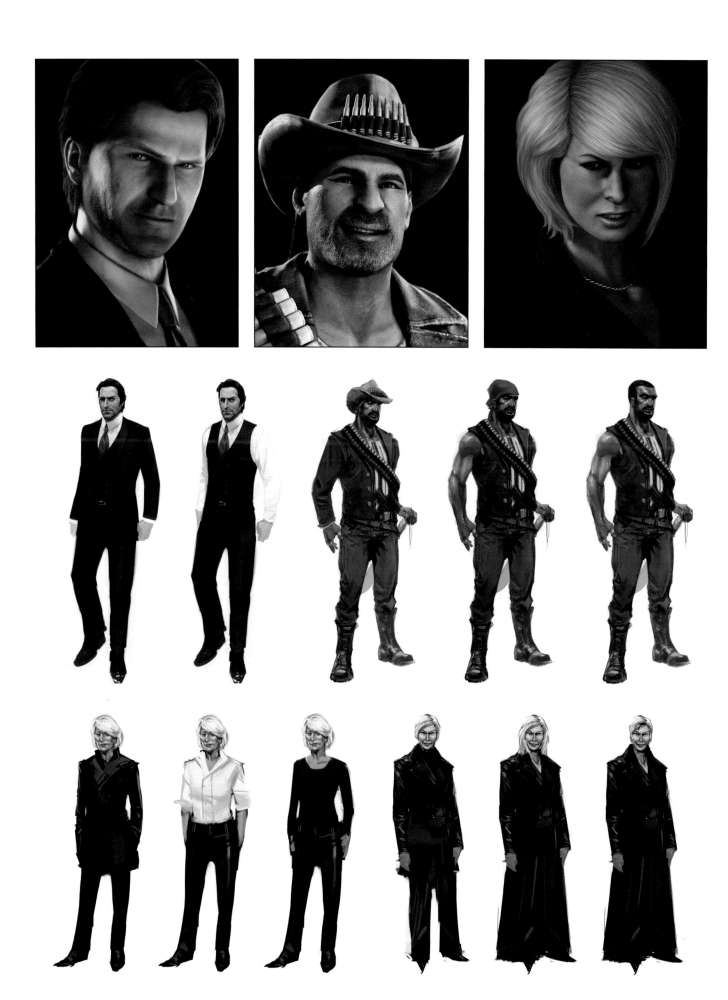

ANTAGONISTS

Talbot, Rameses, and Marlowe's key concepts and wardrobe exploration.

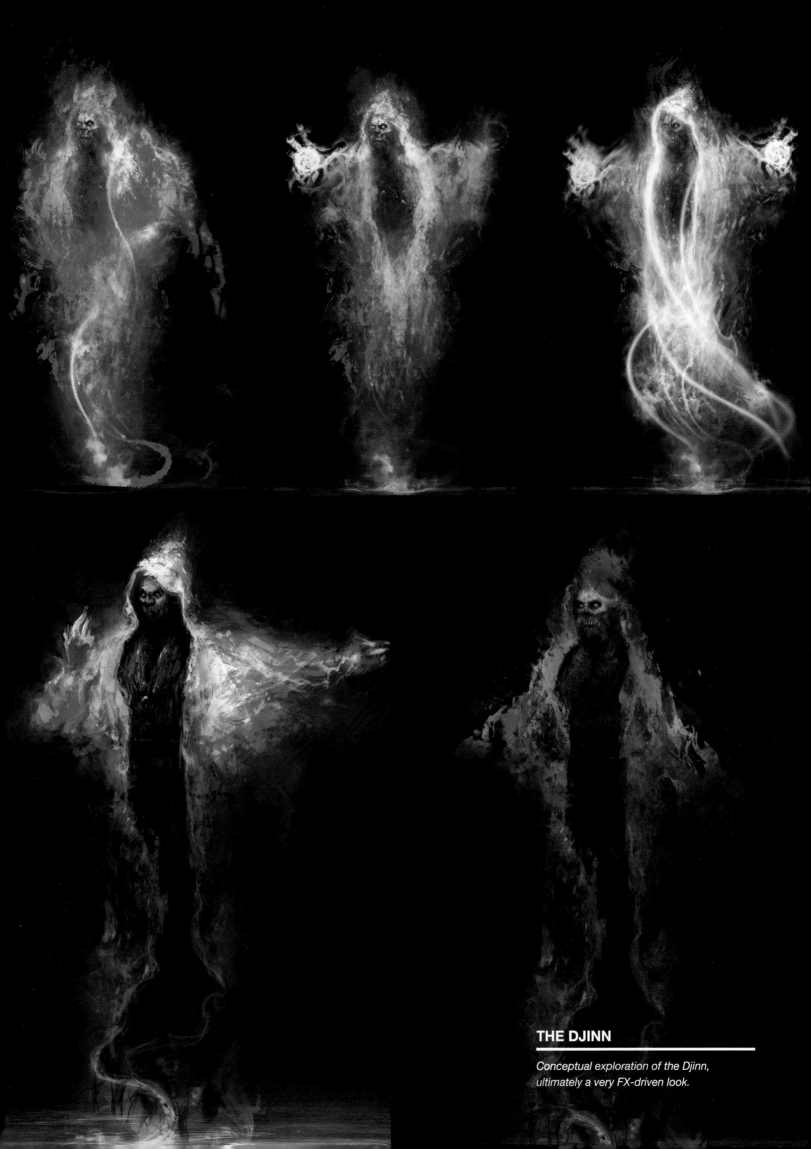

THE DJINN

*Conceptual exploration of the Djinn,
ultimately a very FX-driven look.*

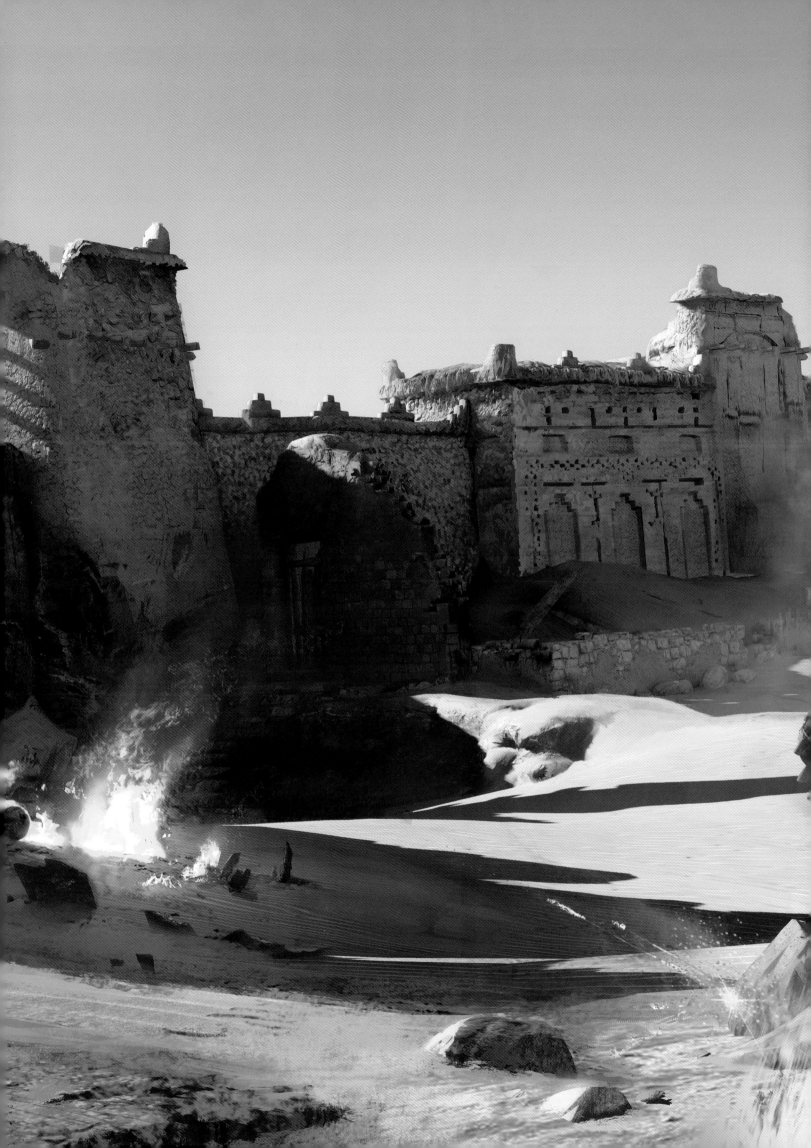

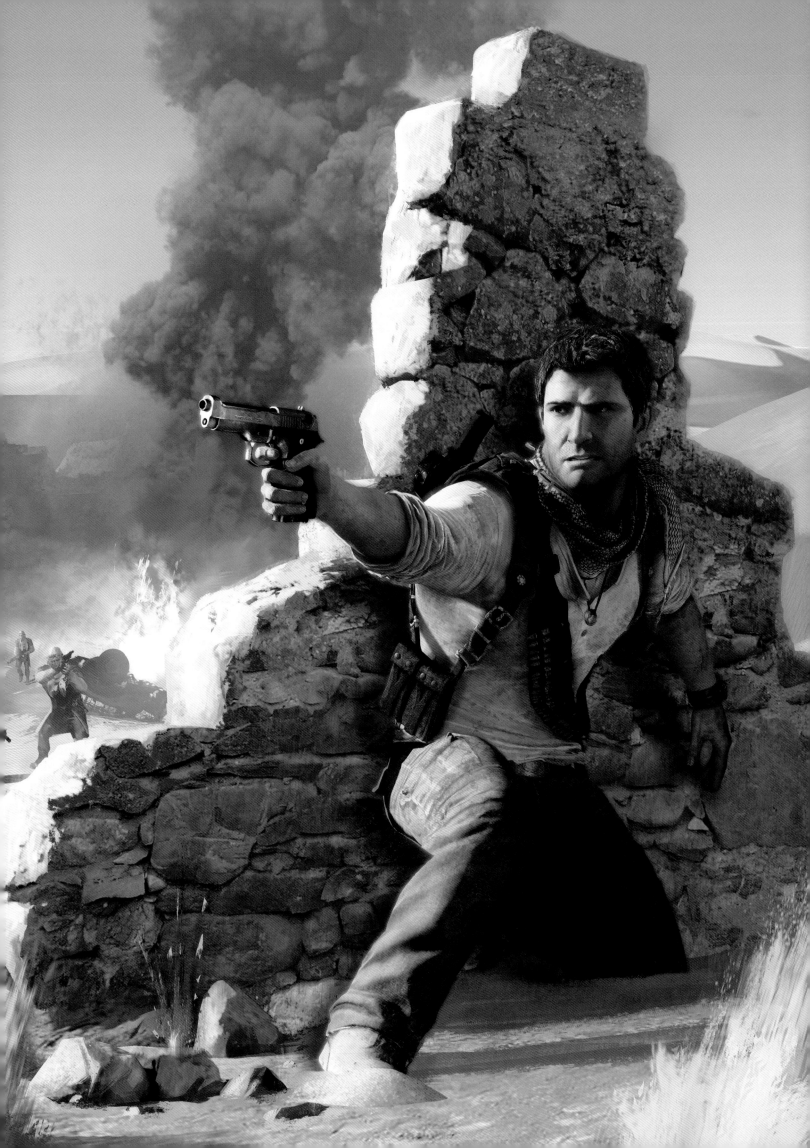

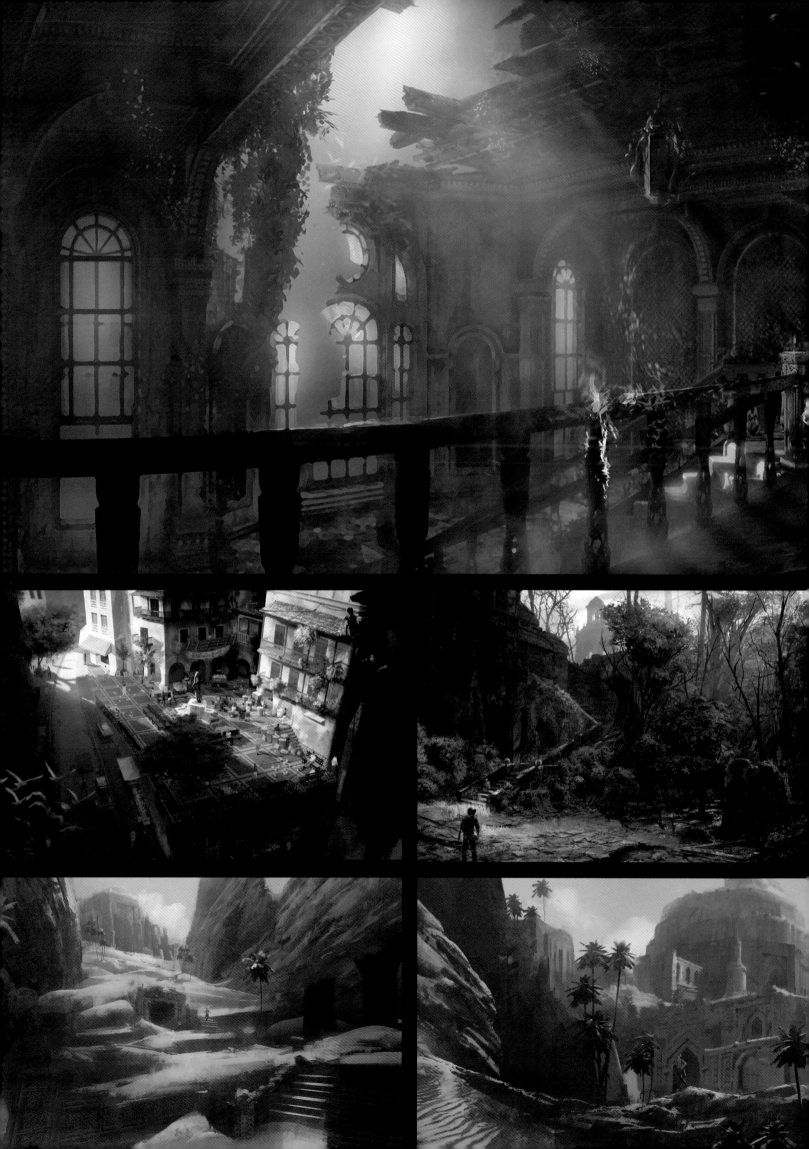

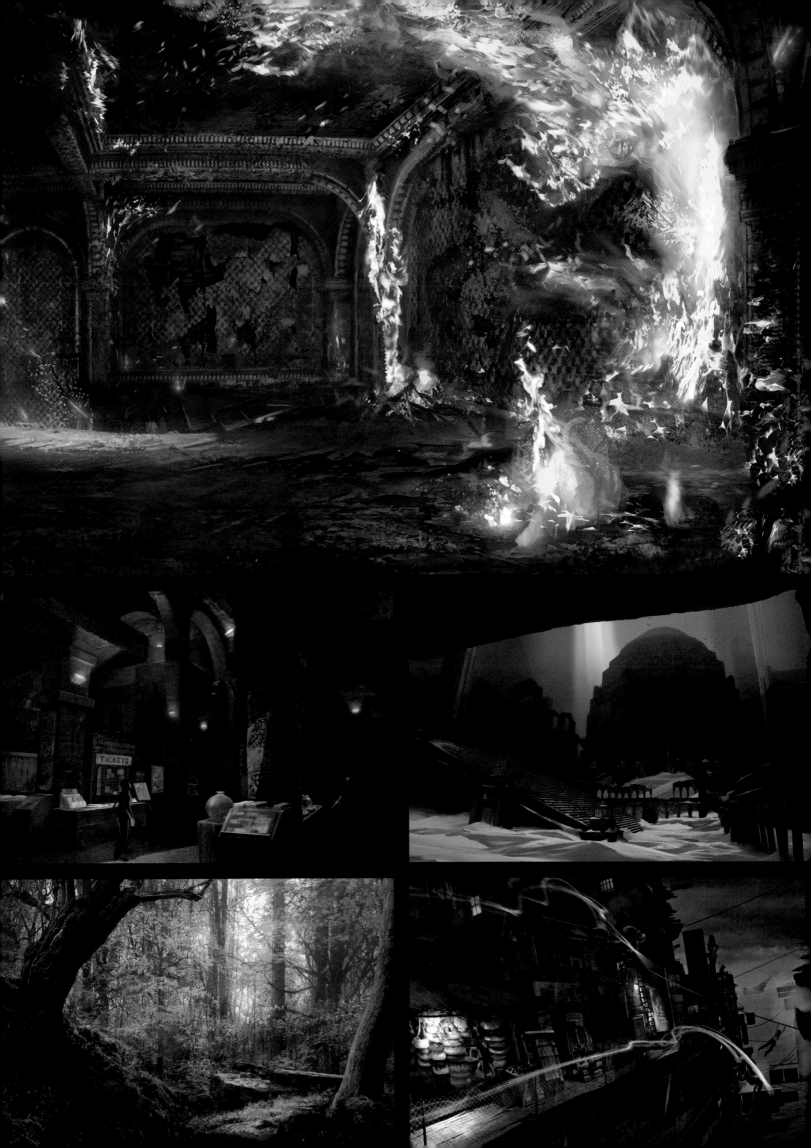

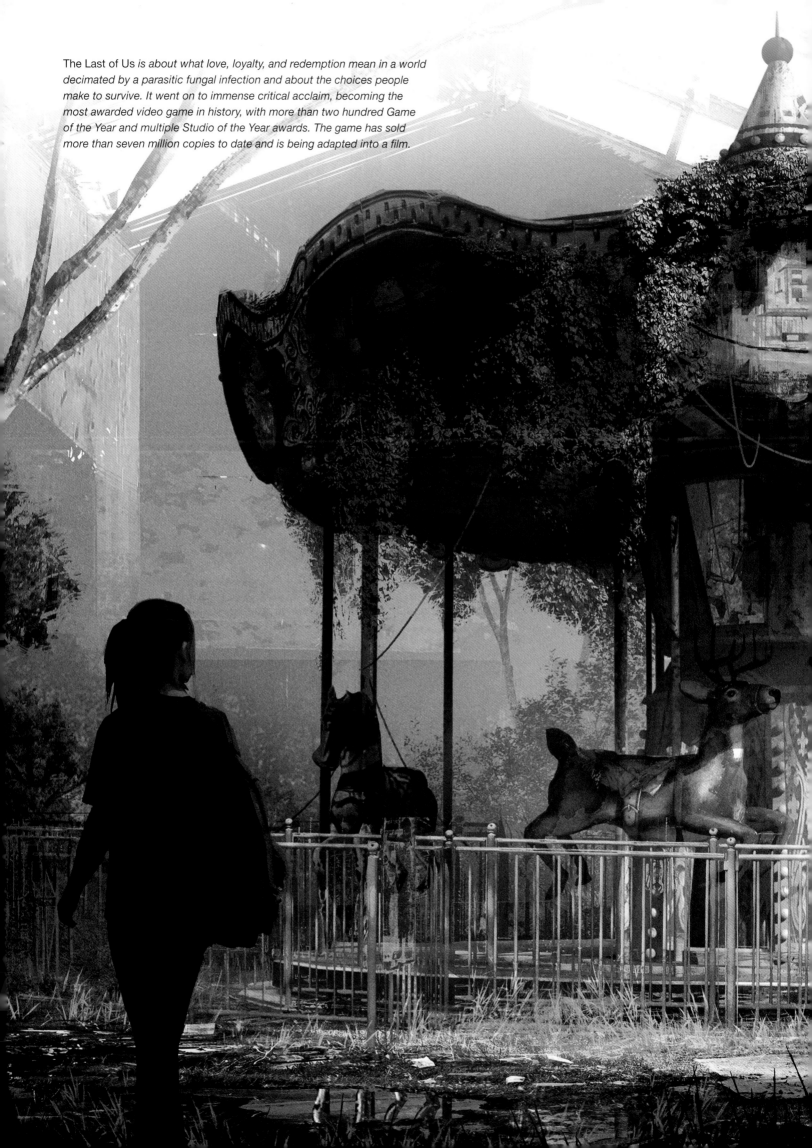

The Last of Us *is about what love, loyalty, and redemption mean in a world decimated by a parasitic fungal infection and about the choices people make to survive. It went on to immense critical acclaim, becoming the most awarded video game in history, with more than two hundred Game of the Year and multiple Studio of the Year awards. The game has sold more than seven million copies to date and is being adapted into a film.*

THE LAST OF US

2013

BY BRUCE STRALEY AND NEIL DRUCKMANN

Well, here we are again—New Franchise Time at Naughty Dog! Once *Uncharted 2* had shipped, we were feeling pretty stable in the studio. We knew what the franchise was, we understood the limits of the PlayStation 3, and our talented team was firing on all cylinders and ecstatic over the success we'd garnered for our hard efforts creating the award-winning *Uncharted 2*—so in true Naughty Dog fashion, we decided to make life more difficult for ourselves! We had tried to split our very talented team into two teams at the end of the PS2/*Jak and Daxter* era, but the timing just wasn't right. Now we were trying to split into two teams again.

It was different this time. We weren't in the middle of the generation jump (the PS3 still had several years of life left in it), and the established team was going to continue to work on a franchise that was already stable. This team already understood the gameplay, art style, and technology, so in theory the challenge would fall squarely on the new franchise's team. (Turns out *Uncharted 3* would push the limits of the PS3 even further and require the team's greatest efforts getting a game out the door to date, but that's the norm here). So we named the new project after a playful joke we made back in the *Jak* days, that the game we're currently working on is going to be the Next Big Thing. We code named *Jak and Daxter* "Next." *Uncharted* was called "Big," which left us with "Thing" for our new project. Project Thing it was, or as we typed a command line to run the game—"T1." But what was it going to be?

As you've probably already learned from reading about the previous games' gestations, making a new franchise is hard. Making a new franchise

that's going to follow up the success of *Crash*, *Jak*, and *Uncharted*, well . . . that's enough to give anyone a few gray hairs, pretty quick. So where to start? We had a fan base that loved *Jak and Daxter*, we loved *Jak and Daxter*, and the idea of working in a cartoony world with the freedom of designing just about anything we wanted became pretty appealing after working in the more grounded reality of the *Uncharted* series—so what if we updated *Jak and Daxter*?

After poking around in the *Jak and Daxter* universe for a while, we started to realize exactly how much we had learned about the integration of story into gameplay, and we felt pretty confident in our desire to explore those challenges more. We were intrigued by two questions: "Could we couple our set-piece moments with our character turns and story beats better?" and "How much more could we get the player to invest in the moment and feel the way our protagonist (or later, protagonists) is feeling in the story?" These were very exciting prospects for us.

We held onto a couple of core ideas from those *Jak and Daxter* brainstorms. Mainly, "What if we created the whole game around the building of a bond between two contrasting characters?" and the theme of survival, which, as a tone and world setting, seemed to provide a lot of great opportunities to explore interesting gameplay and character moments. But we needed something to put the world into a state that required this survivalist backdrop. Then one day, by complete coincidence, we stumbled onto the BBC series *Planet Earth*, in which David Attenbourough eloquently describes a species of fungus that can take over the motor functions of an insect's brain. Basically he was describing what we started referring to as "zombie ants"! This was our jumping-off point—our "what if" moment. "What if this *Cordyceps* fungus were to jump to humans?" AHA!

So we had the start of our setting. An outbreak of this extremely virulent *Cordyceps* fungus would catch the world by surprise, infecting innumerable humans, who would in turn kill off millions more. This would lead to the inevitable collapse of our infrastructure, pitting humans against the infected, and eventually humans against other surviving humans. Sounds juicy! We had an apocalyptic backdrop, but we didn't like the connotation of that word. From what we'd seen in other games and movies of this genre, *apocalyptic* was synonymous with drab, gray, and dreary. But from our research we'd learned if an event like this were to actually happen, the world would become verdant, vibrant, and lush. A place where nature wouldn't be cut back, pruned, and maintained—because there was no one around to maintain it anymore. The lack of human-devised pollutants would make

the skies bluer and the sunsets richer. Years of seasonal change would bring with them the detritus and compost of falling leaves, and storms would create an accumulation of debris. This would allow grasses, weeds, and trees to root into every crack and crevice they could find. This was certainly going to be a beautiful world, full of nature and life, but what intrigued us most was that all of this lushness would be contrasted with loneliness and the abandonment of our familiar world, the fallen world of humankind.

A theme or general guideline started to form within these early concept and story days, and that was the theme of *contrast*. The juxtaposition of two differing elements was giving us an intriguing tone. This touchstone helped us greatly throughout production.

But who were our protagonists? We knew that if we were going to strengthen the bond between them, they would have to start from two opposing perspectives, and we wanted them to grow to understand, respect, and eventually love one another over the course of their journey. We started to gravitate to the idea of there being an older man, born before the outbreak, and a younger girl born after. He had struggled to learn how to survive in this new world, and she was born in the protection of one of the last standing quarantine zones. This gave us an interesting basis for their different viewpoints, and specifically gave us great material where we could start generating our concepts.

We realized we were starting to create what was essentially a road story—a journey these characters would go on that would forever change them. This meant there would be ups and downs in their relationship, moments where they would be in complete sync and others where they would have a falling-out. This also helped drive some of our early concept work on showcasing the range of emotions we wanted them to express. This led us to realize how important it was to always show the two of them together. They really became one entity over time—two halves of a whole. So over the next few months we pushed and pulled at these core ideas, and we kept coming back to one basic concept—that we would be building towards a father-daughter relationship between the two. These characters would eventually be called Joel and Ellie, and the story would be about how the relationship they formed would forever change them.

Our goals were becoming clearer and clearer. We wanted to build the most grounded and personal experience Naughty Dog had ever created. It became a summation of all we had learned making games at Naughty Dog so far—the Next Big Thing.

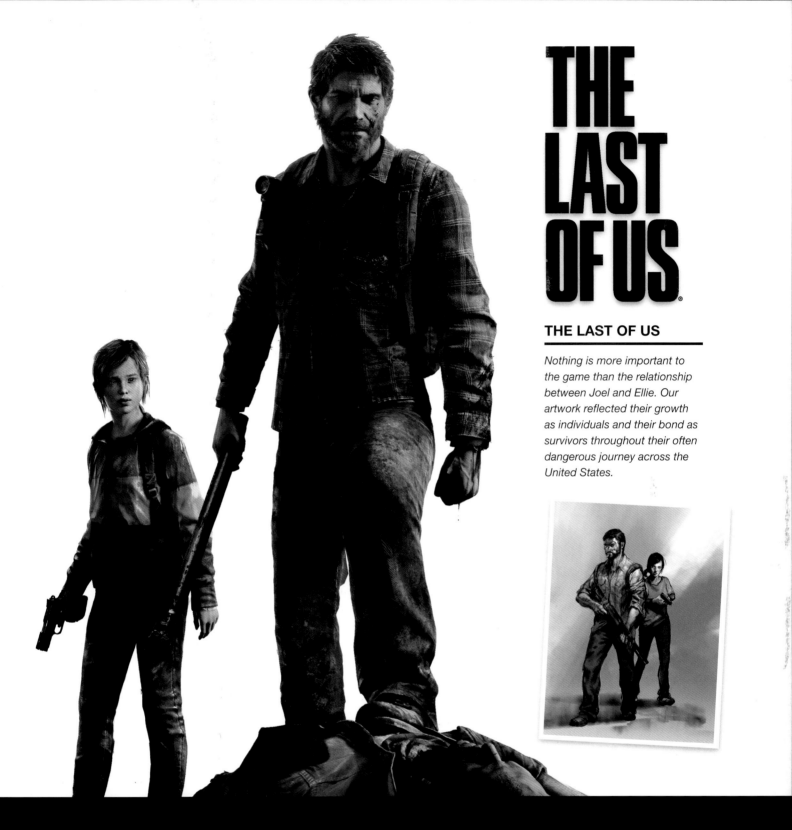

THE LAST OF US

THE LAST OF US

Nothing is more important to the game than the relationship between Joel and Ellie. Our artwork reflected their growth as individuals and their bond as survivors throughout their often dangerous journey across the United States.

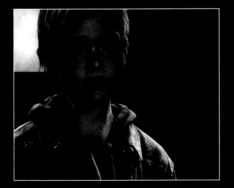

Creating realistic characters with emotional complexity is paramount. This scene exemplifies how Naughty Dog delivers emotional beats through performance capture and detailed character models.

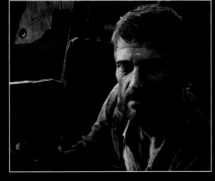

In the brutal world of *The Last of Us*, Joel instructs Ellie to make every shot count.

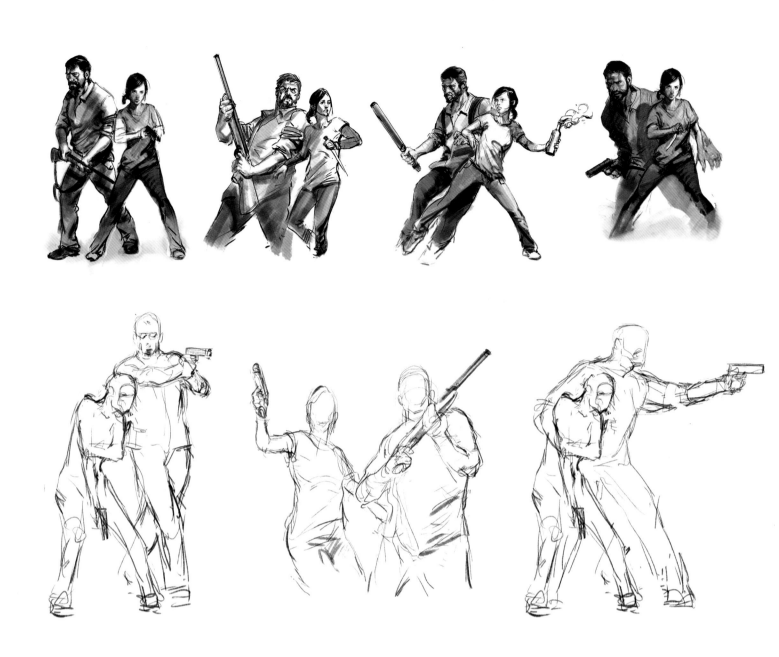

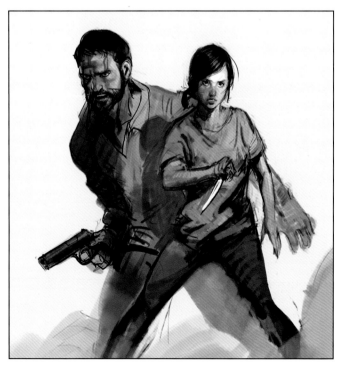

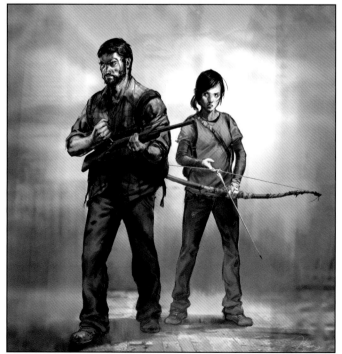

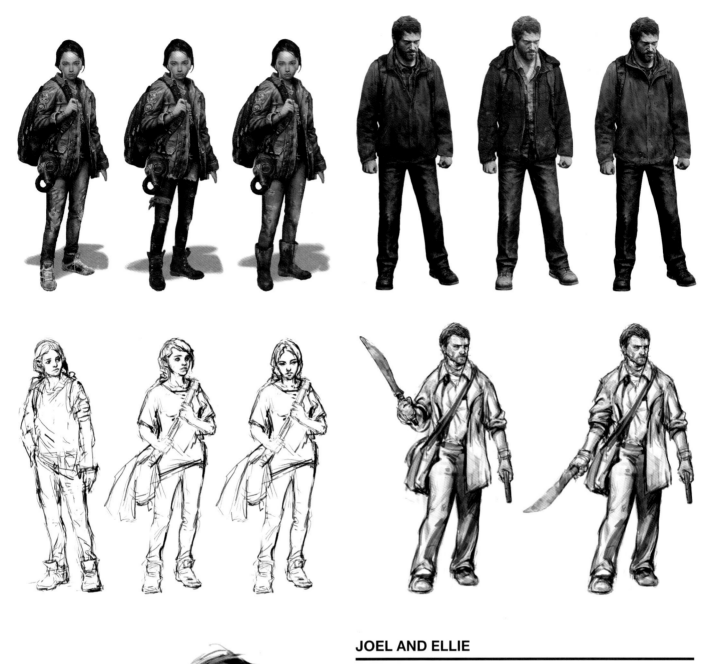

JOEL AND ELLIE

The look for Joel and Ellie was always intended to be plain and practical, but it was crucial to perfect each element of their character design. In a world where resources are scarce, people resort to scavenging for clothes and supplies, and their look had to reflect that.

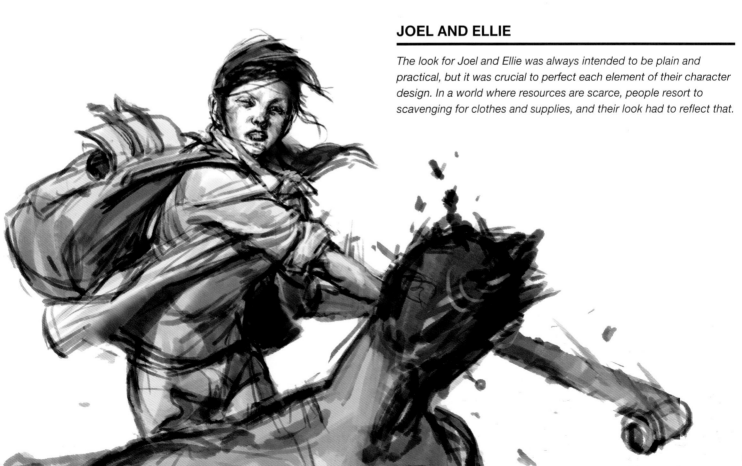

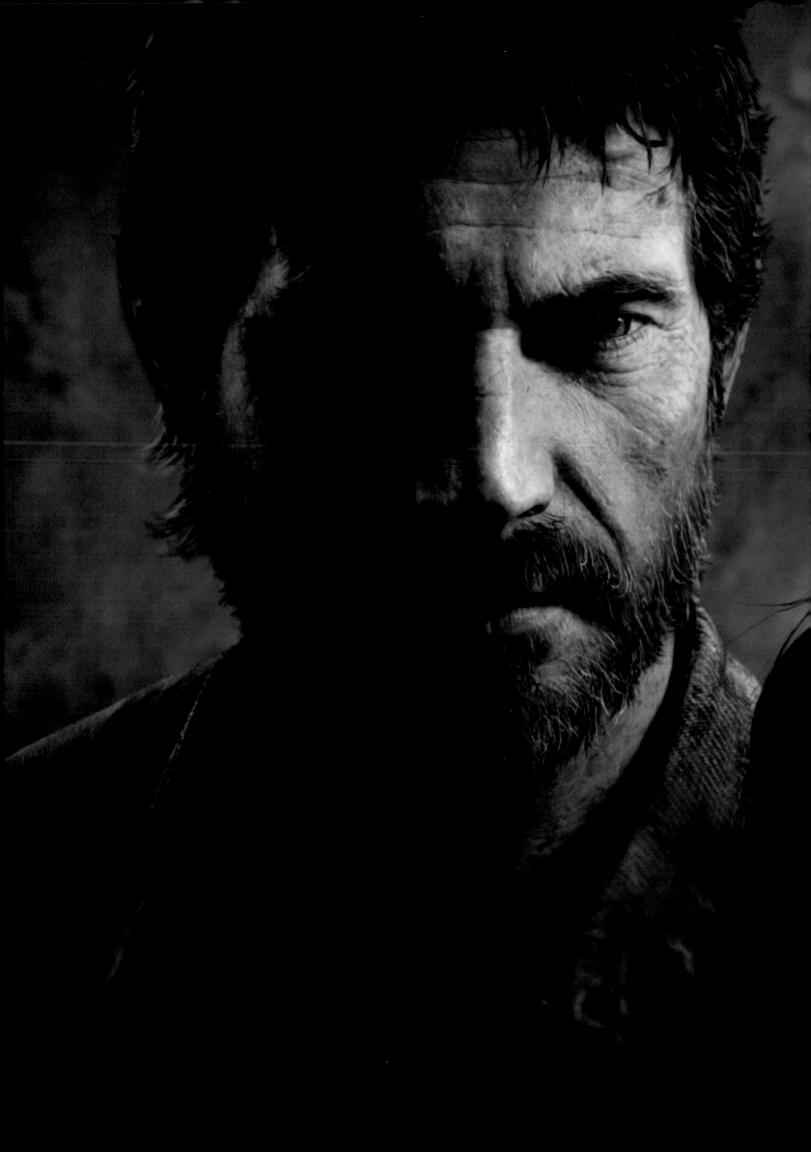

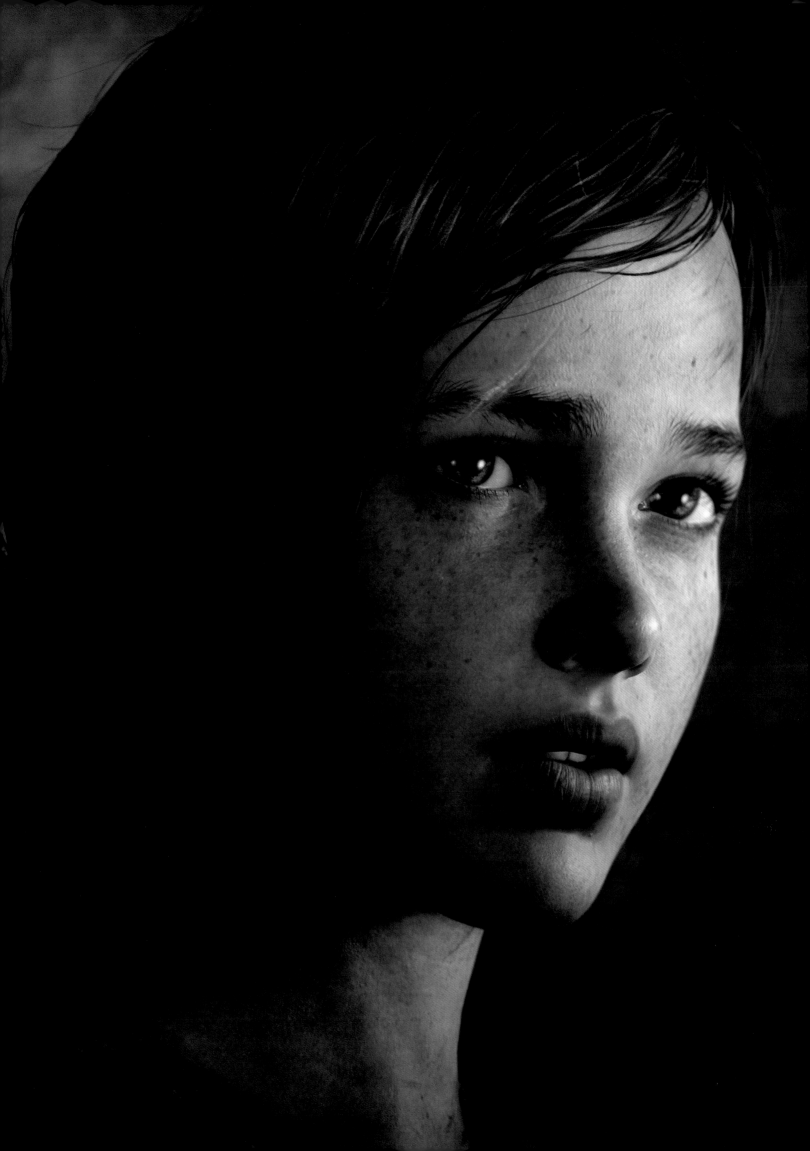

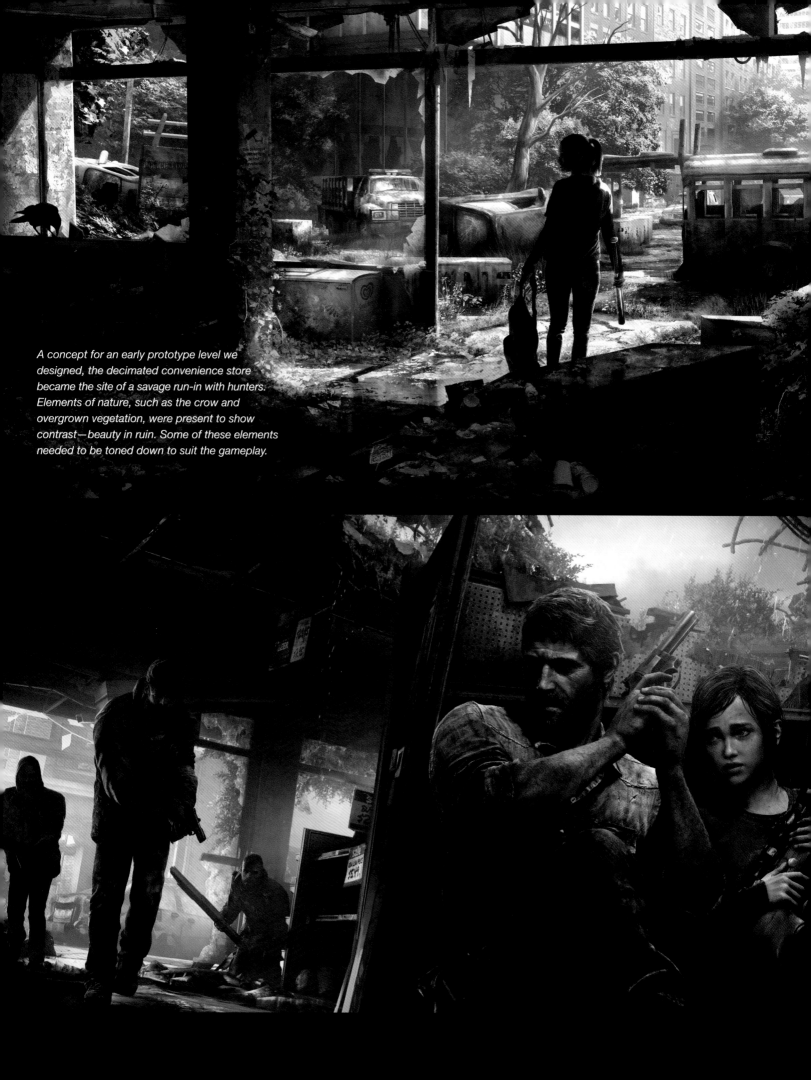

A concept for an early prototype level we designed, the decimated convenience store became the site of a savage run-in with hunters. Elements of nature, such as the crow and overgrown vegetation, were present to show contrast—beauty in ruin. Some of these elements needed to be toned down to suit the gameplay.

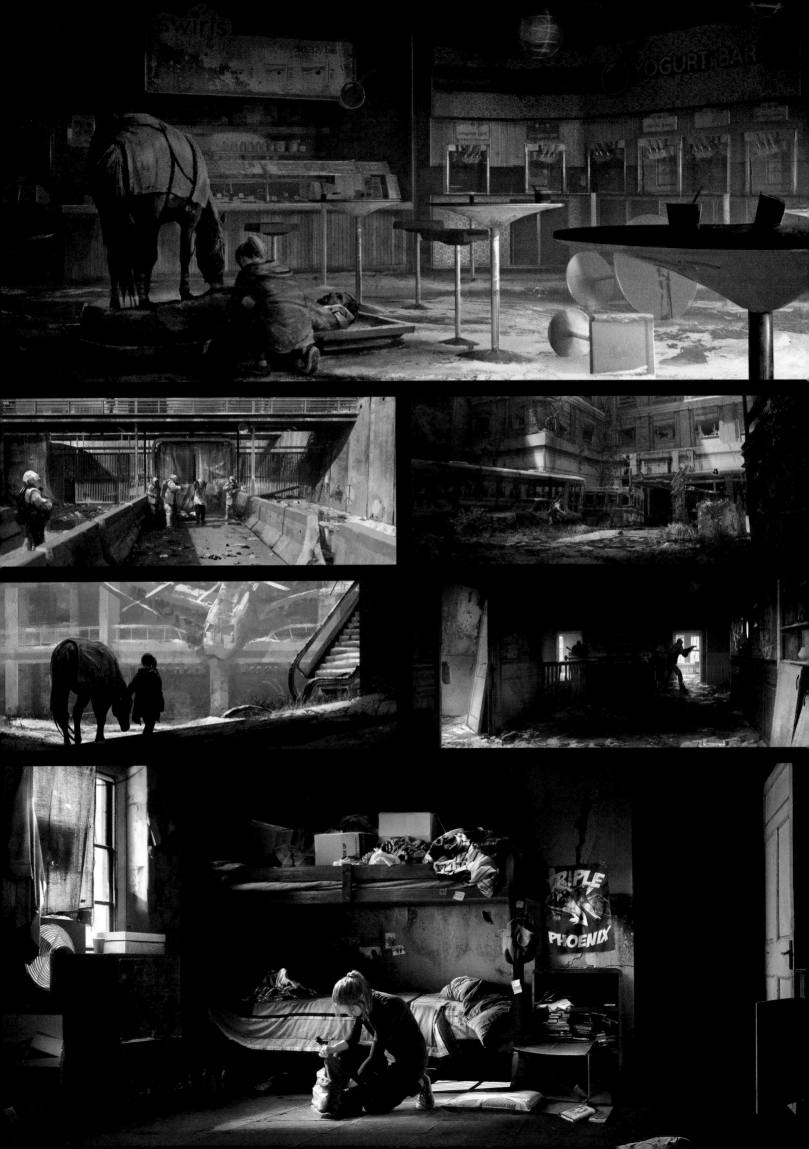

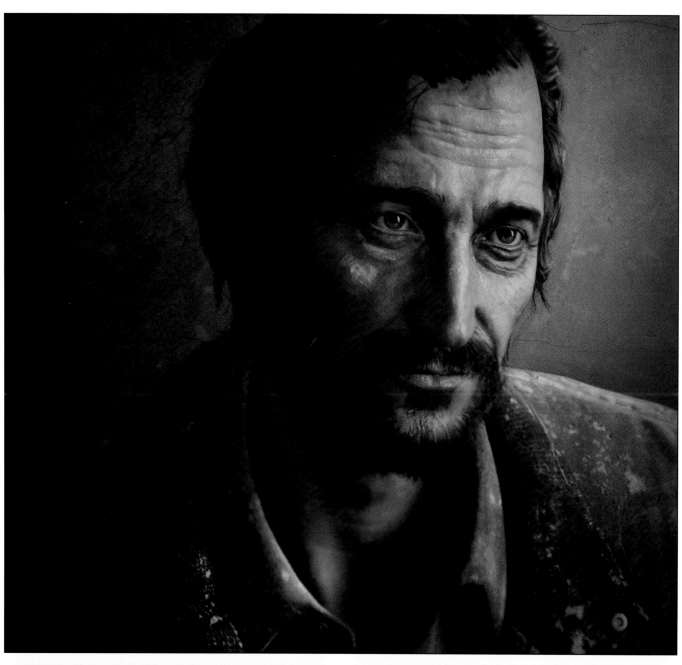

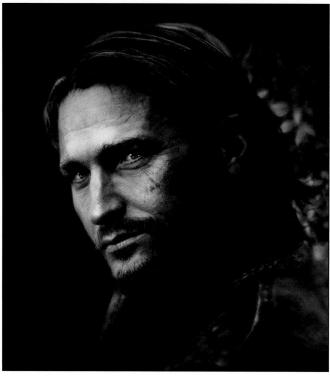

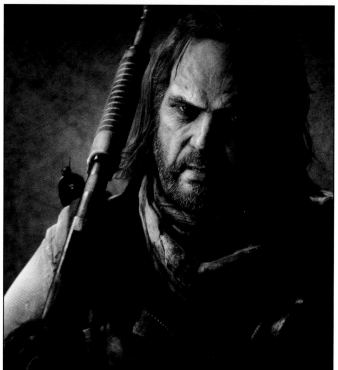

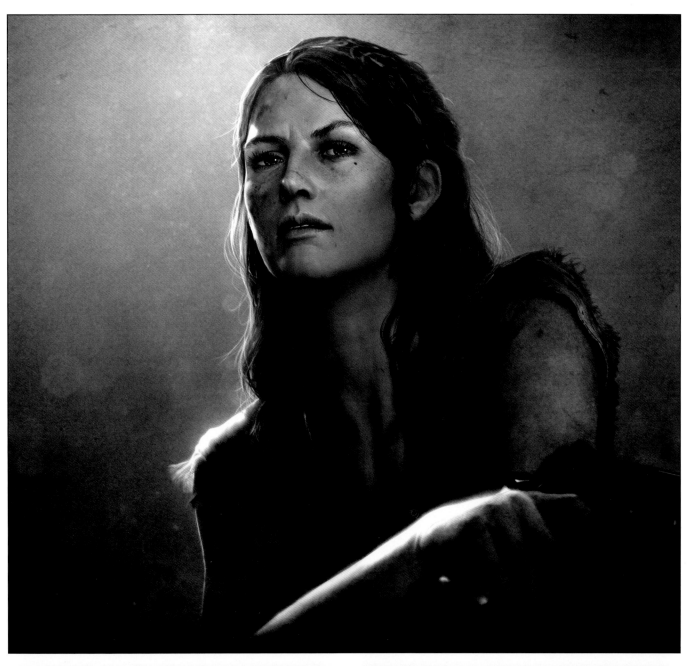

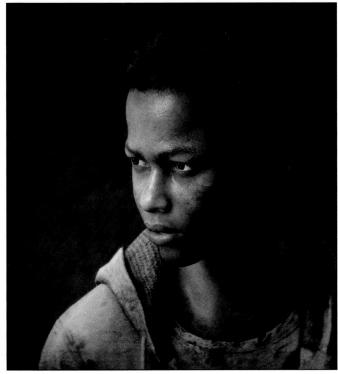

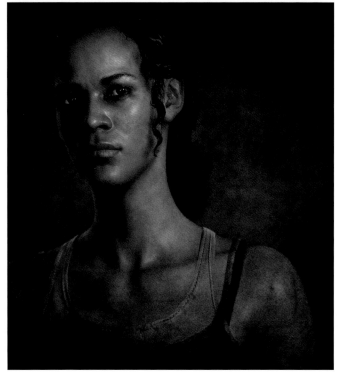

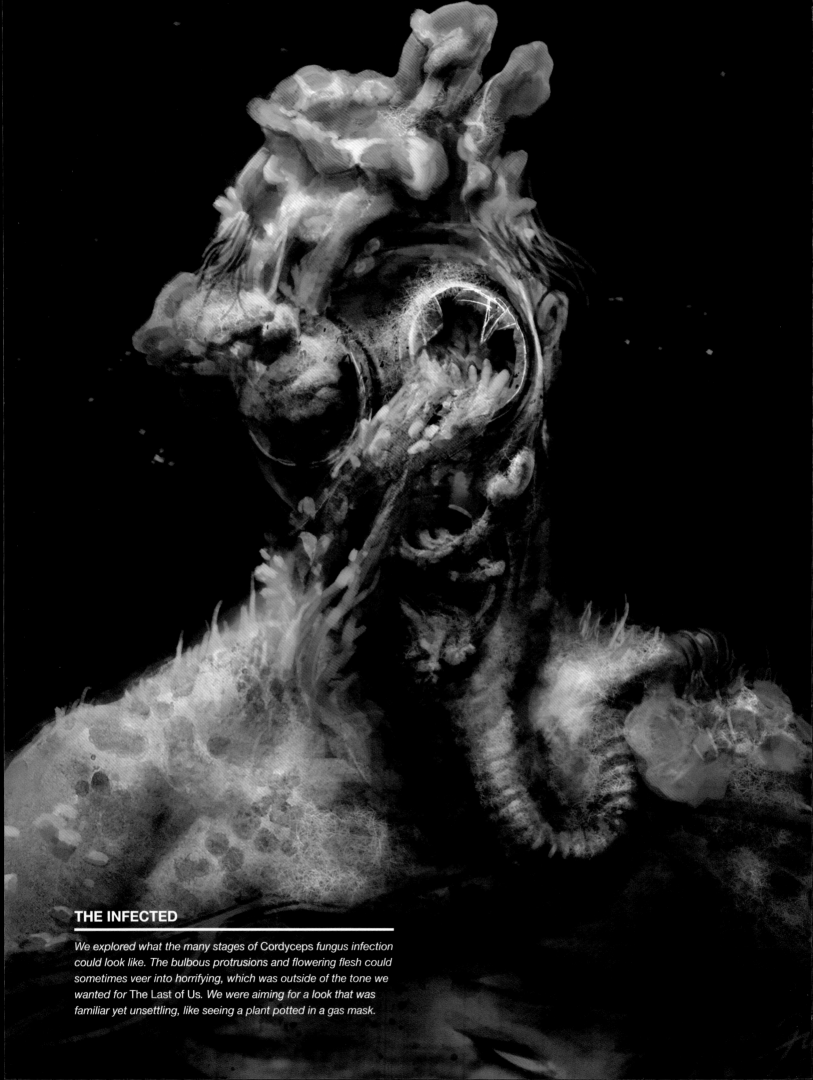

THE INFECTED

We explored what the many stages of Cordyceps fungus infection could look like. The bulbous protrusions and flowering flesh could sometimes veer into horrifying, which was outside of the tone we wanted for The Last of Us. We were aiming for a look that was familiar yet unsettling, like seeing a plant potted in a gas mask.

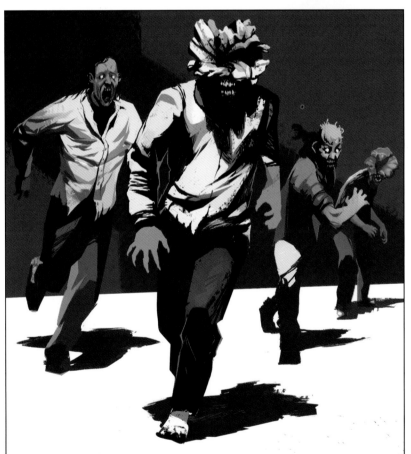
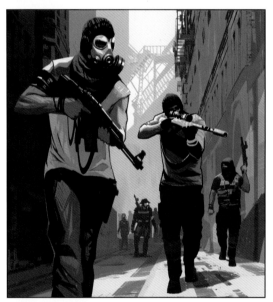

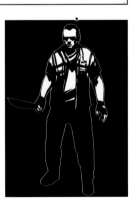
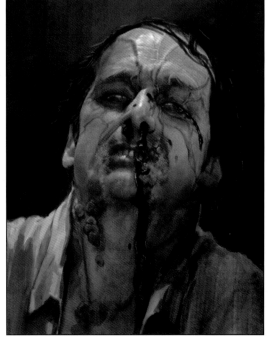

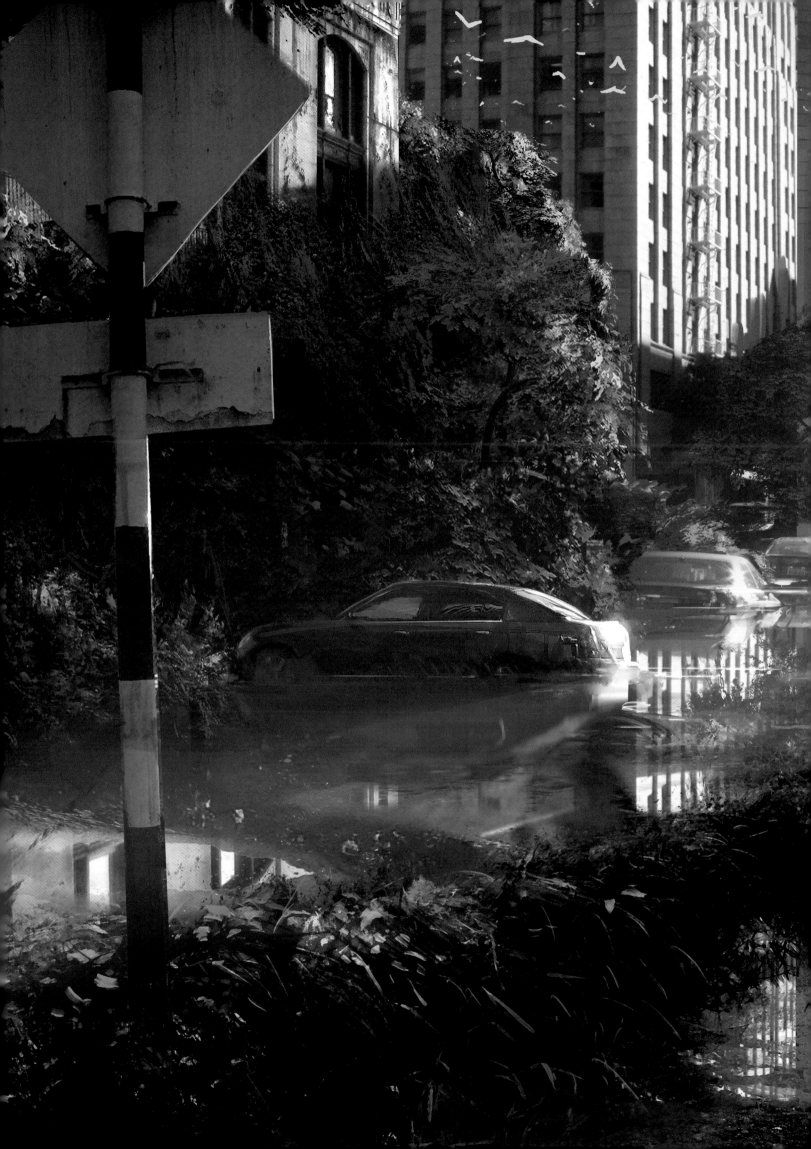

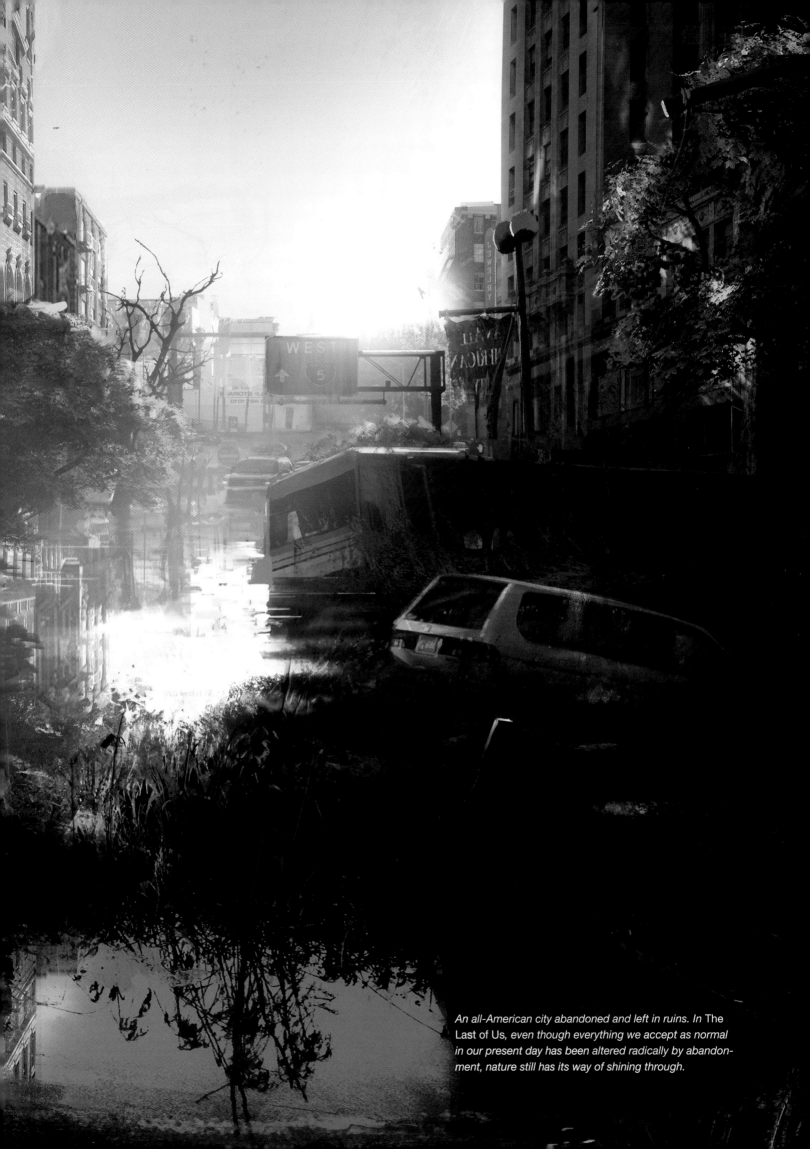

An all-American city abandoned and left in ruins. In The Last of Us, *even though everything we accept as normal in our present day has been altered radically by abandonment, nature still has its way of shining through.*

THE LAST OF US.
LEFT BEHIND

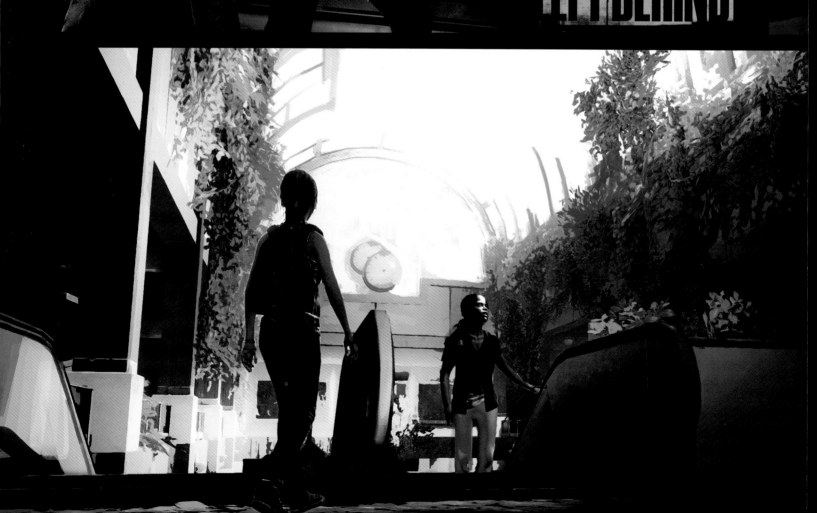

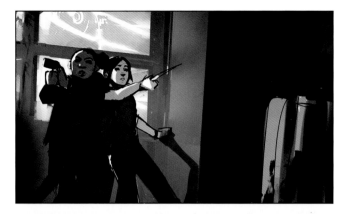

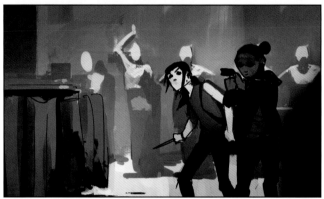

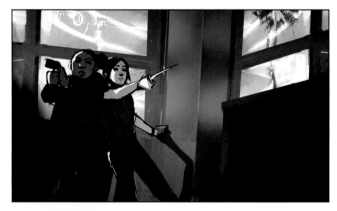

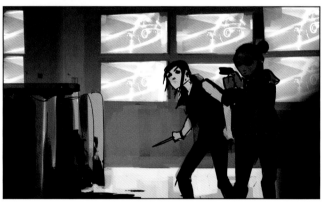

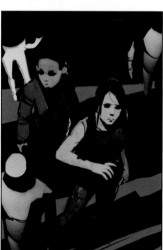

ELLIE AND RILEY

Key art exploration always involves many stages. These are a few of the directions we pursued before settling on the color image on the opposite page. In a pose that relayed both toughness and friendship, Ellie and Riley leaning on one another made for an obvious choice.

THE LAST OF US: LEFT BEHIND DLC

The world of Left Behind *had to feel familiar—a place two teenage girls could explore—but different from the main game in order to complement the specific story we were telling. These logos populated the Boston and Colorado malls. Naughty Dog employee pets are featured in the pet store ad.*

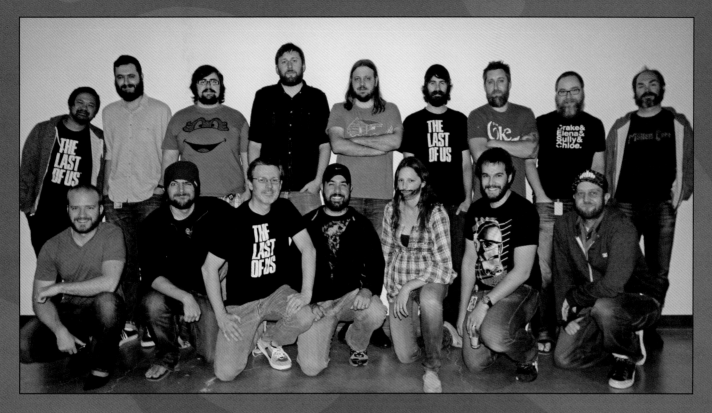

STUDIO EXPANSION

Naughty Dog expanded to over 13,000 square feet of office space in February 2013. Also, we're pretty well known for being able to grow some impressive beards.

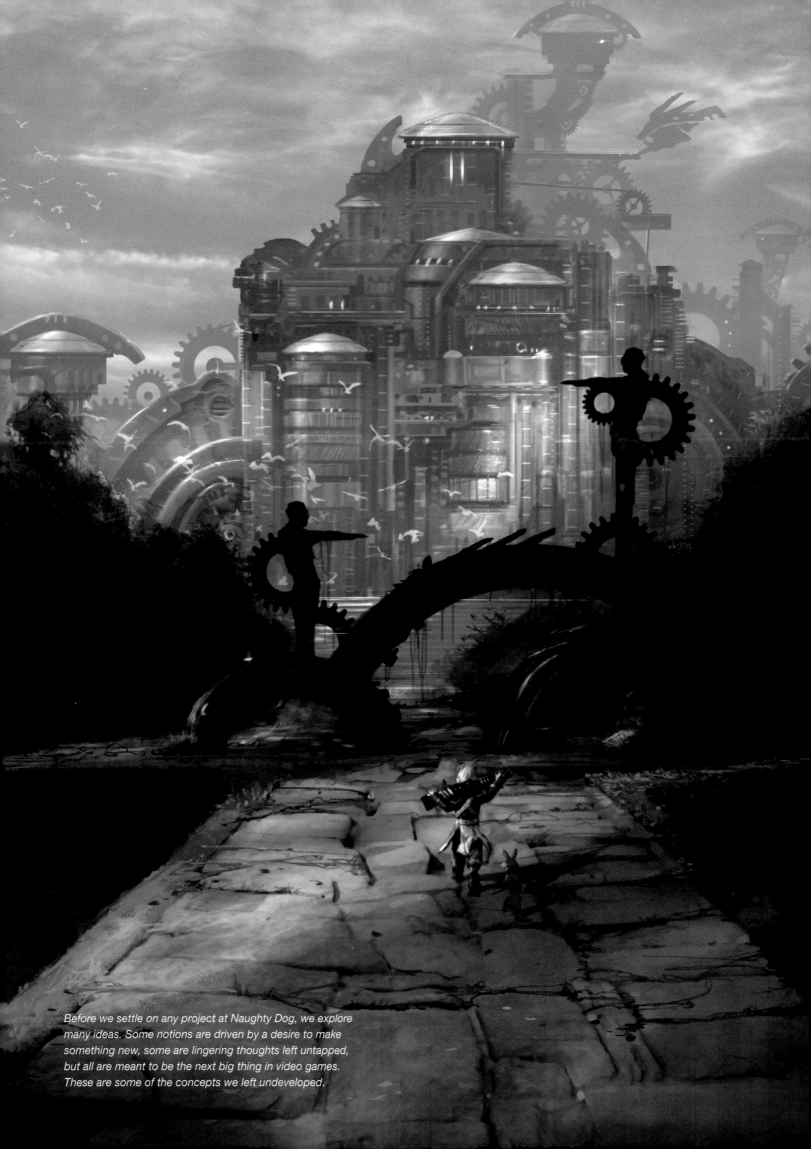

Before we settle on any project at Naughty Dog, we explore
many ideas. Some notions are driven by a desire to make
something new, some are lingering thoughts left untapped,
but all are meant to be the next big thing in video games.
These are some of the concepts we left undeveloped.

UNDEVELOPED PROJECTS

BY EVAN WELLS, BRUCE STRALEY, AND CHRISTOPHE BALESTRA

As we were preparing to transition from the PlayStation 2 to the PlayStation 3, we were kicking around a ton of ideas. The only thing we knew for sure was that we wanted to continue to make games that were in our wheelhouse—third-person, story-based action-adventure games. But outside of that, we were open to exploring anything and everything.

Some of the very earliest brainstorms were even happening right after we completed *Jak II*. It was about that time that PlayStation started sharing information with us about the PS3 hardware. We anticipated that it might be out in 2005 so we thought we needed to get going on preproduction as soon as possible. It didn't take long before we realized that the hardware wouldn't be ready until 2006. We did not intend on being a launch title so we had even more time—meaning we could explore lots of ideas since we just had a few people ideating, while the rest of the team was working on our last two *Jak* games.

All of the art that you'll see in this section came from us working with a number of outsourced concept artists, along with a rotating group of concept artists on our internal team. Nothing ever went as far as becoming a full-fledged game that could be pitched for greenlight, but there were two

The first was going to build on the direction that *Jak II* and *Jak 3* had started to take us in—exploring the open-world genre. You'll see a bunch of concepts with futuristic buildings and vehicles. We never got as far as defining our hero, or what role he might play in the city, but we did create a bunch of concepts of what he might look like, along with other civilians populating the world.

The second idea that we explored is probably what ultimately led us to *Uncharted*. We got away from the open-world city, and started focusing on a more linear storytelling approach. We thought it would be cool to be trapped in an underwater facility. There were lots of ideas about what the facility could be, but a prison was something we kept revisiting. For the sake of visual variety, we thought that part of the adventure would lead players out of the hidden facility and to the nearby uncharted tropical island. I think this is where we started to realize that we were much more interested in making a game that allowed us to explore lush, beautiful, natural environments, instead of hard and drab human-made ones.

Finally, you'll see some of the concepts and ideas we had for a return to the world of *Jak and Daxter*. This exploration happened right before the story foundation for *The Last of Us* came along. The aim was to make a more realistic, more contemporary *Jak and Daxter* game, as you'll see in many of the sketches. There were already so many firmly established relationships, character personalities, and character motivations—it became tougher and tougher to feel engaged by the prospect of making a new *Jak and Daxter*. So we had a dilemma: If we stuck to the constraints of the already established world, would we be happy with the type of game we were about to make? But if we diverged too greatly from those constraints to tell the type of story we wanted to tell, were we actually making *Jak and Daxter* anymore? Ultimately our exploration didn't pan out, as it felt like too much of a departure for the fans that wanted the game the most, but it was a treat to revisit that world.

Even though these ideas never formulated into a game that went into production, the exploration was very helpful for us as a team to find our footing as we transitioned from the heavy stylization of our previous franchises. It was great to get to go back and look at all of this artwork and see how it influenced the decisions we made for our games on the PlayStation 3. We've never shared this art before in an official way. We hope you have fun seeing part of our ideation process.

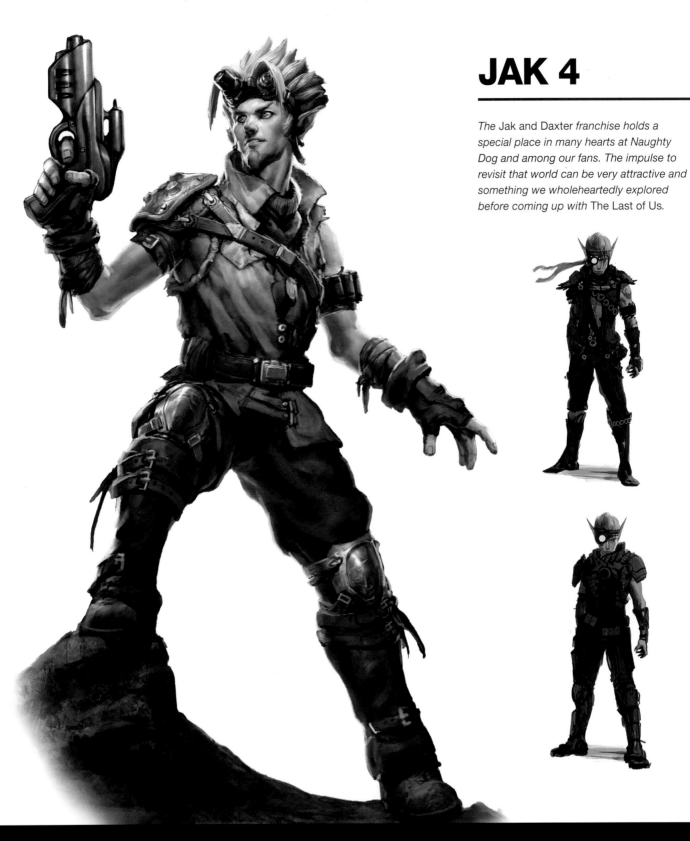

JAK 4

The Jak and Daxter franchise holds a special place in many hearts at Naughty Dog and among our fans. The impulse to revisit that world can be very attractive and something we wholeheartedly explored before coming up with The Last of Us.

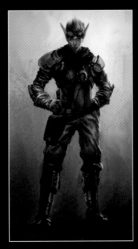

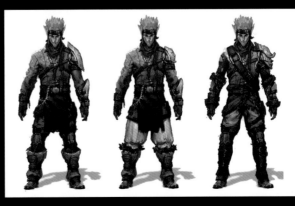

What would a realistic, distinctly noncartoony Jak look like? We struggled with that idea for many months before realizing it might not work out.

DAXTER

As a wisecracking, anthropo-morphic ottsel (half otter, half weasel), a realistic Daxter needed to have all the adorableness of a puppy but the edge of a foxy jokester. Exaggerated hands and a bushy, playful tail were absolutely necessary.

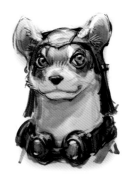
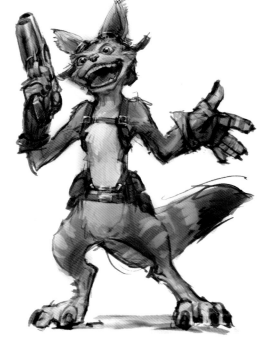
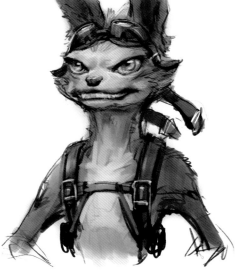

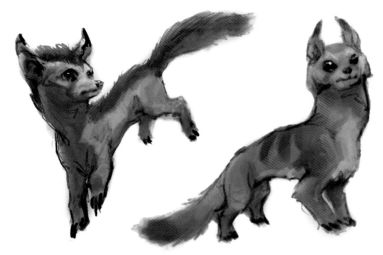
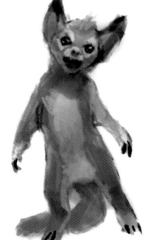
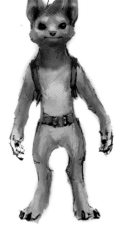

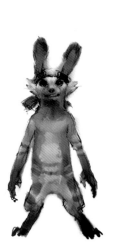
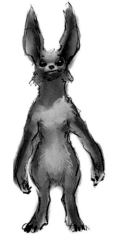
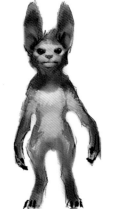
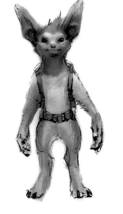
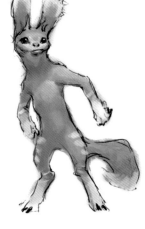

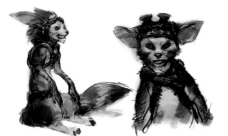
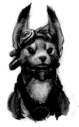
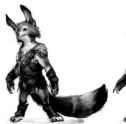

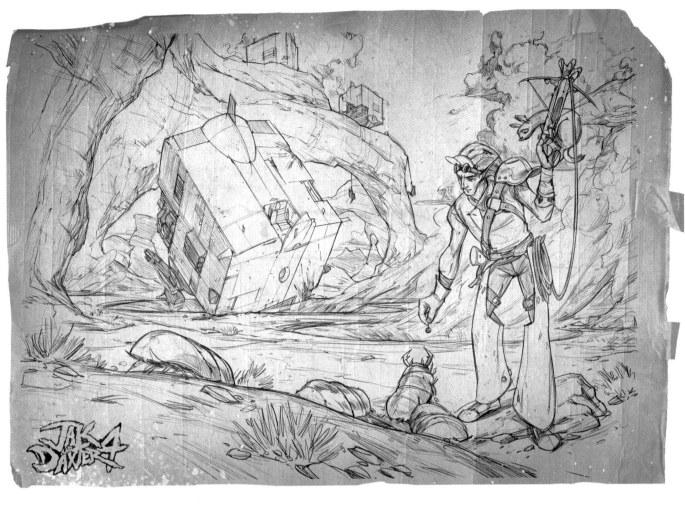

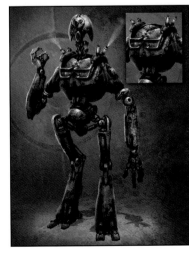

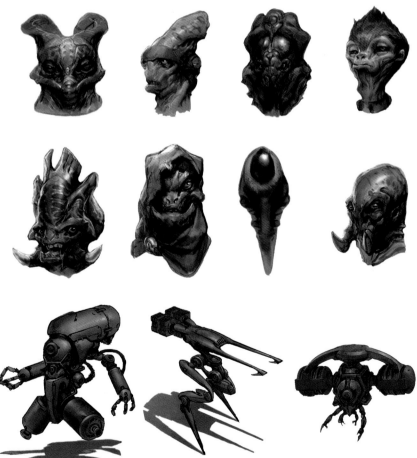

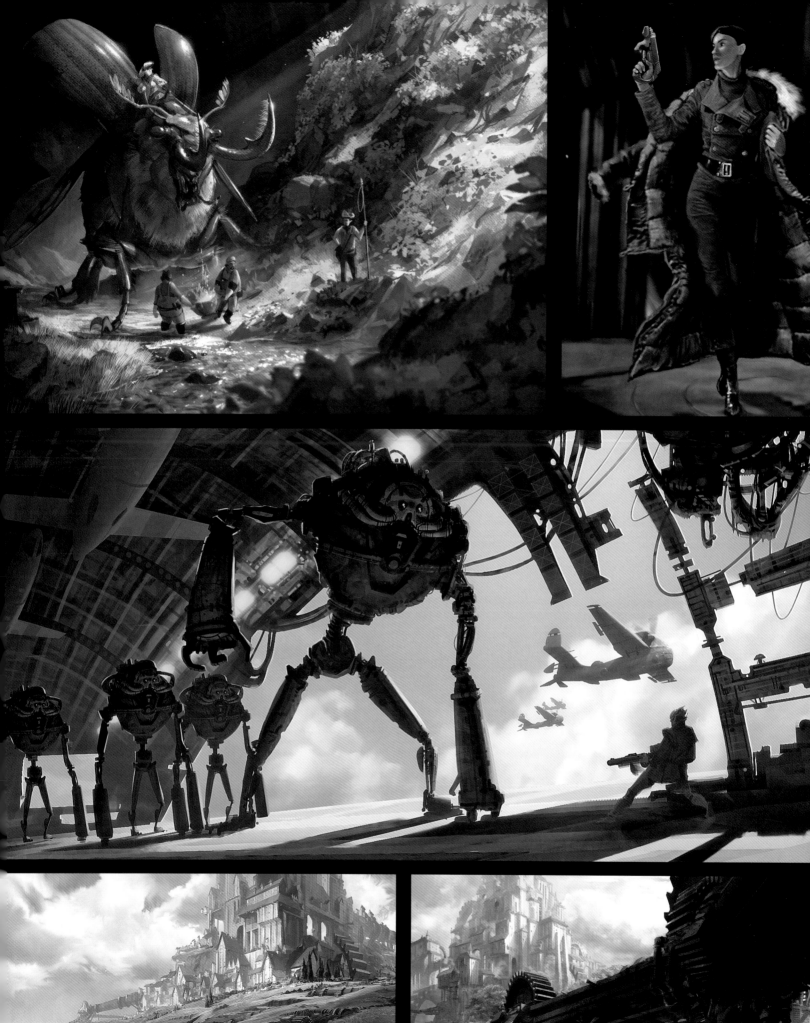
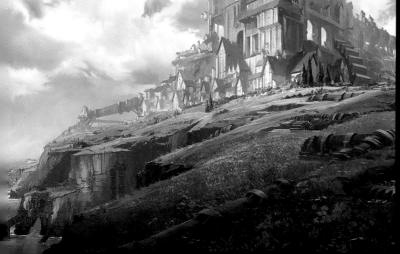
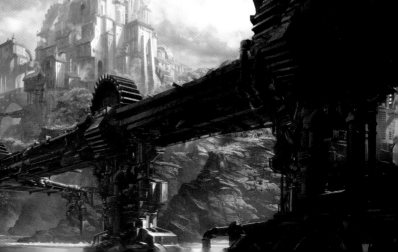

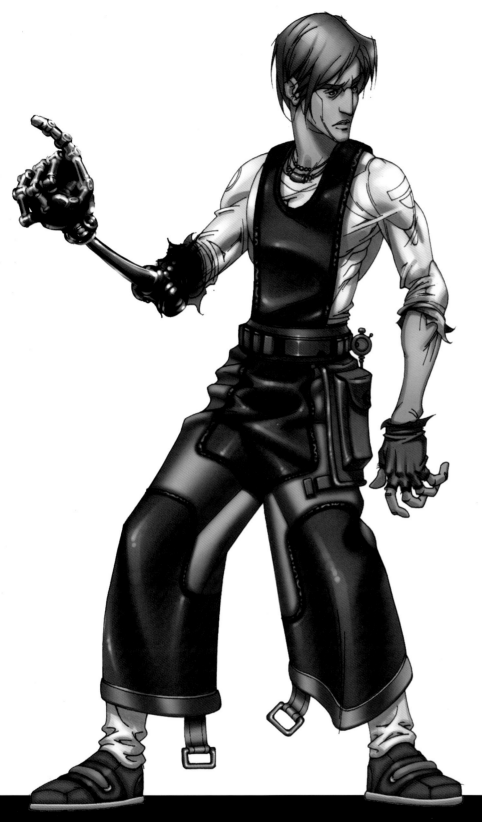

UNDEVELOPED SCIENCE FICTION GAME

We explored the idea of doing a science fiction game following the Jak and Daxter *franchise*, complete with androids, robots, and futuristic weapons.

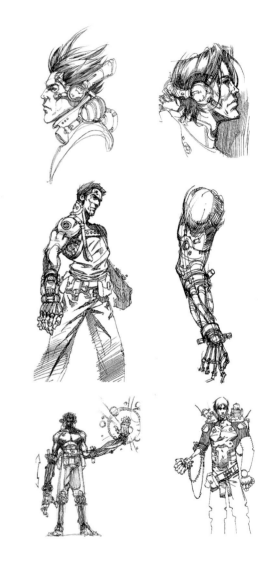

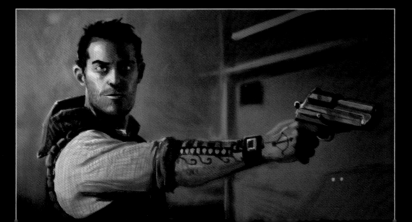

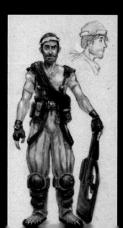

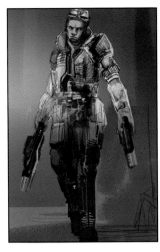
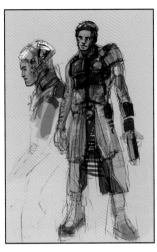
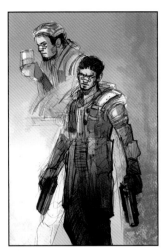
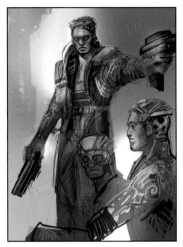
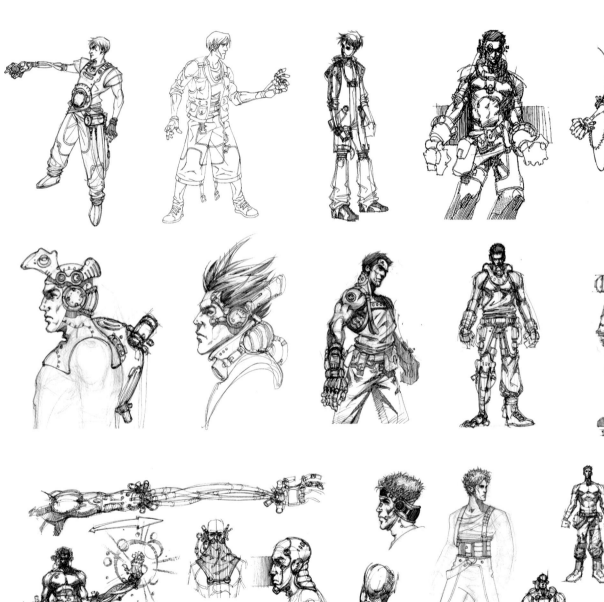

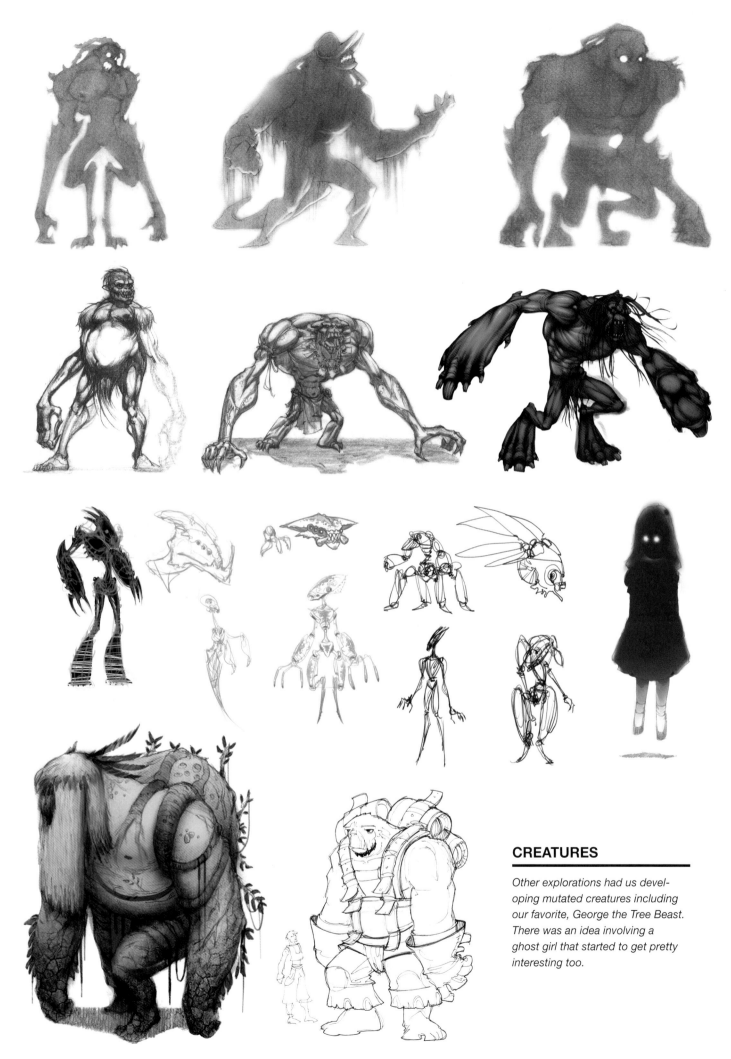

CREATURES

Other explorations had us developing mutated creatures including our favorite, George the Tree Beast. There was an idea involving a ghost girl that started to get pretty interesting too.

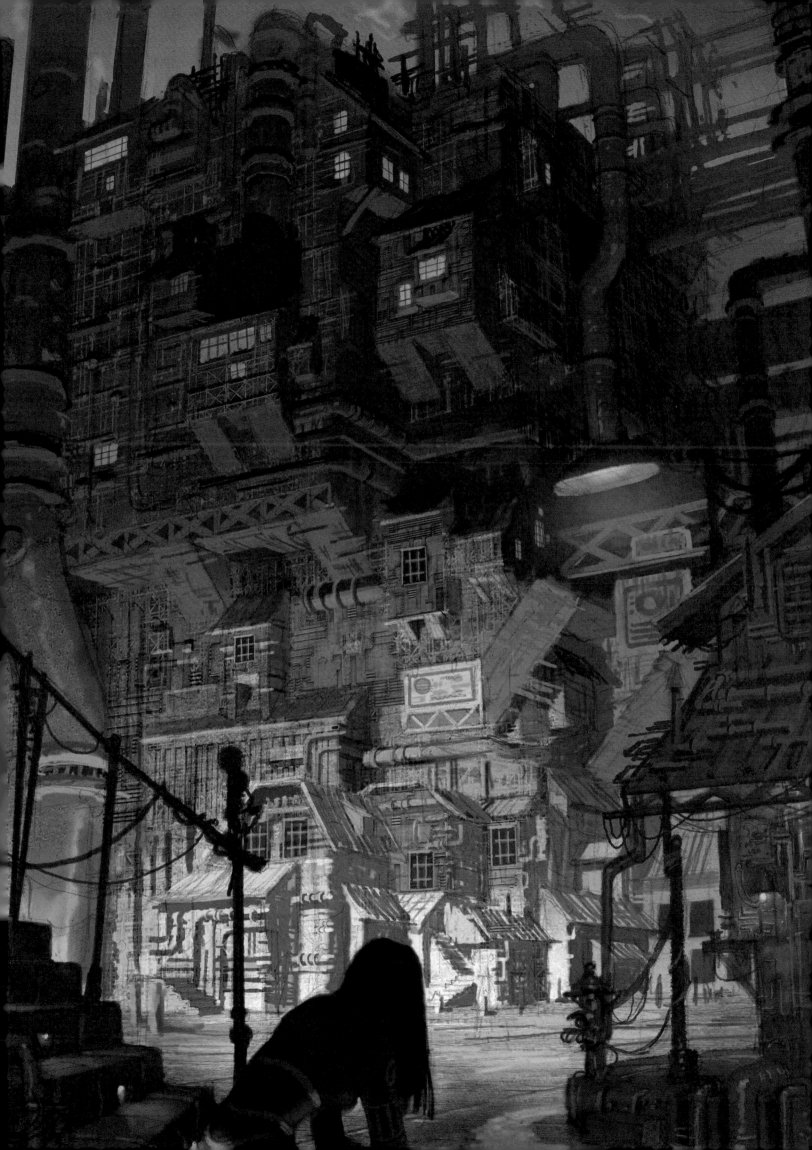

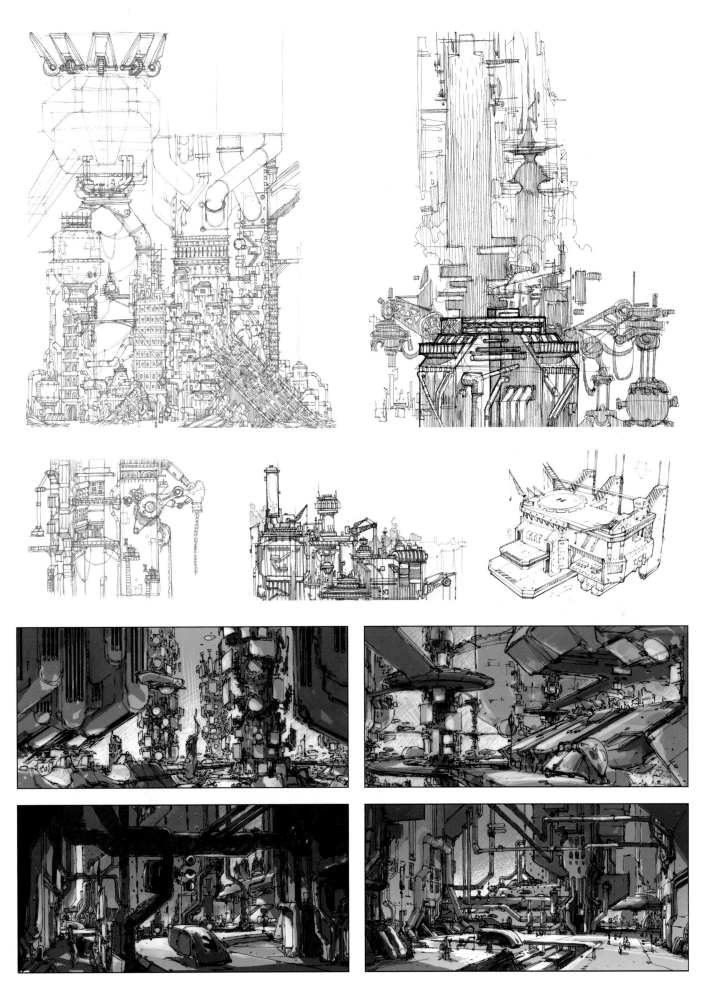

THE CITY

The sci-fi game was going to be centered around a city that had been built up around a giant hole in the ground. No one knew exactly what created the hole, but the adventure would have the player exploring its depths.

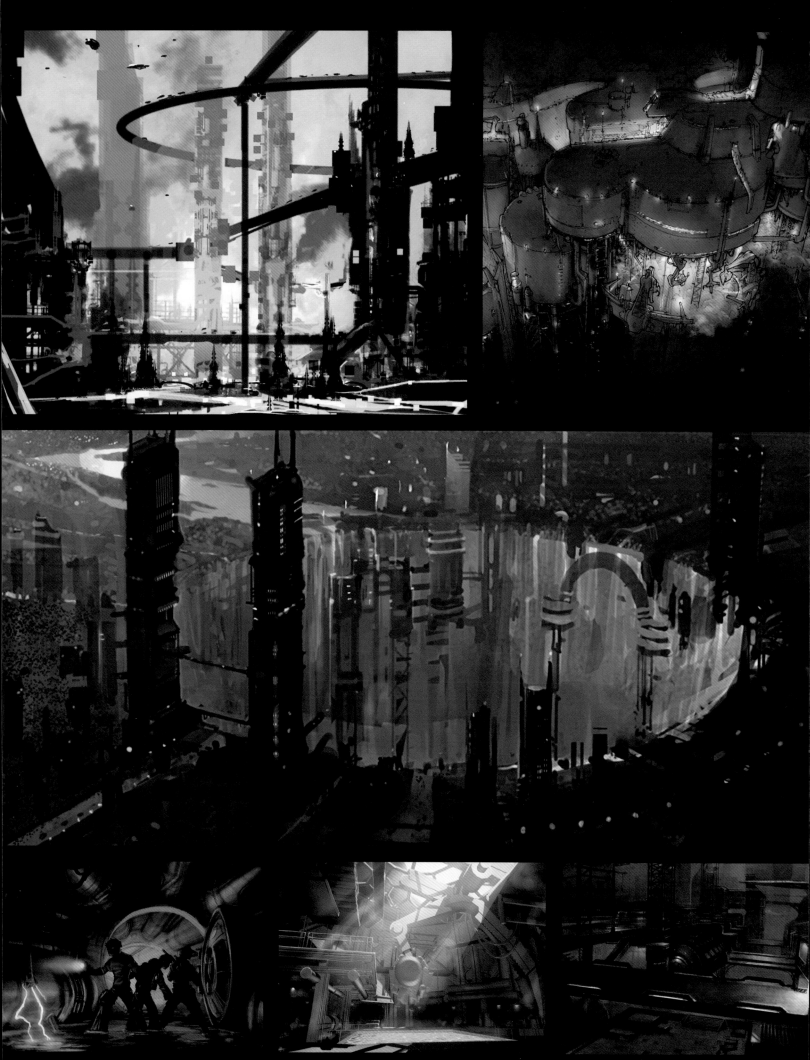

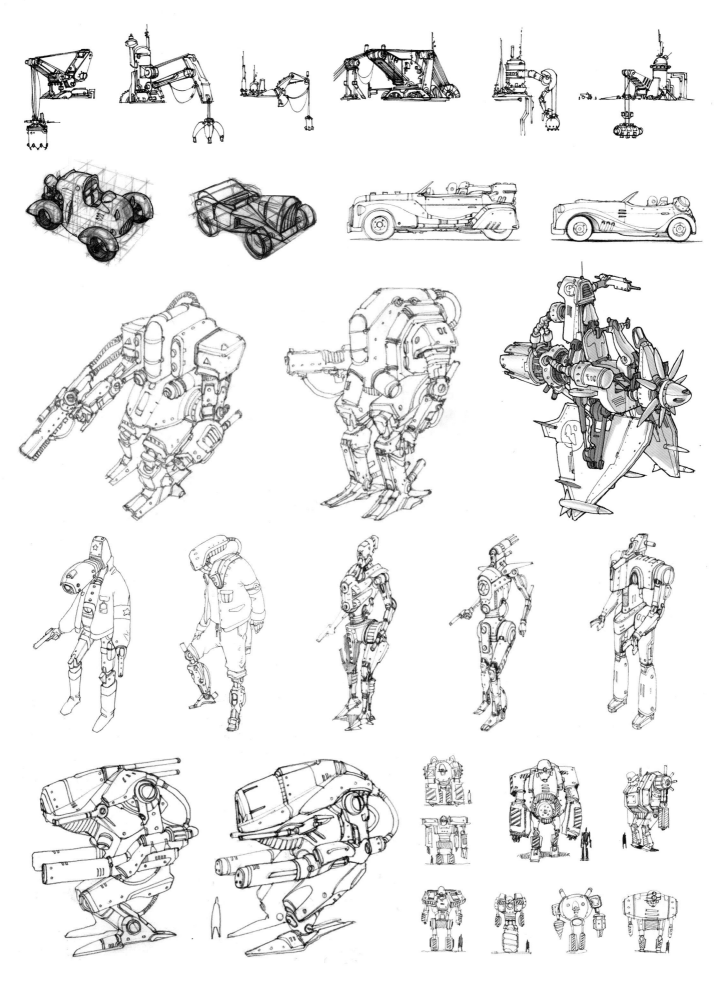

ROBOTS

Various explorations for robots, mechs, and machines in the sci-fi world. Notice the scale of these creations in the images with the humans.

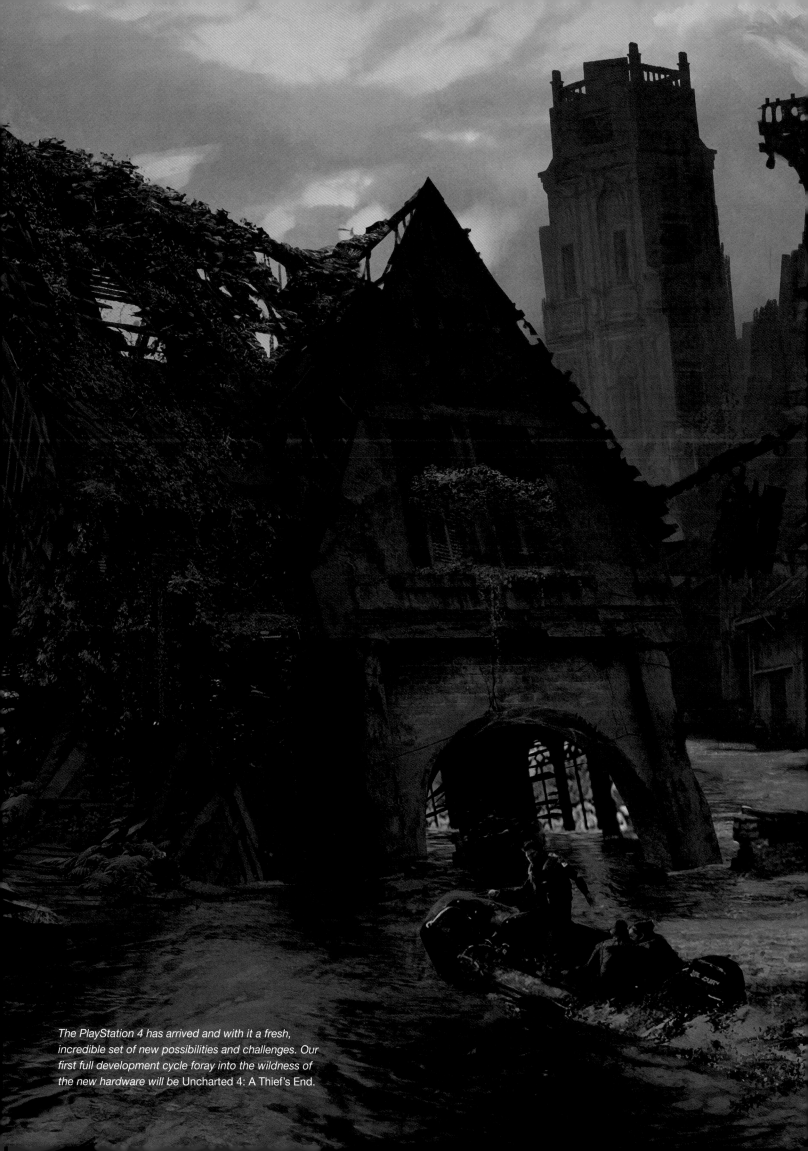

The PlayStation 4 has arrived and with it a fresh, incredible set of new possibilities and challenges. Our first full development cycle foray into the wildness of the new hardware will be Uncharted 4: A Thief's End.

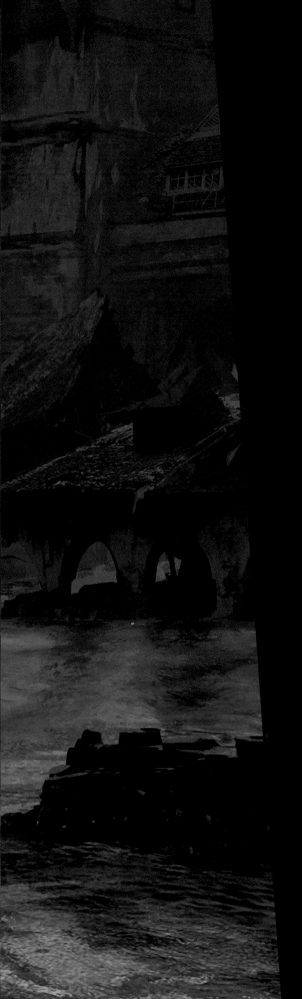

FUTURE PROJECTS

BY EVAN WELLS AND CHRISTOPHE BALESTRA

While one can never predict the future, we do know what our next project is going to be: *Uncharted 4: A Thief's End*. We haven't revealed a great deal about the game just yet, but in the following pages we are sharing some never-before-released pieces of concept art from Drake's upcoming adventure. We're not going to spoil it for you, but rest assured: he and his companions will be traveling the globe again discovering secrets lost to history—and you might even discover some secrets about Drake himself.

Uncharted 4 will be our first dedicated effort for the PlayStation 4. And while we have thirty years of history, technology, and experience to build off of, tackling a game on a new piece of hardware is always a huge challenge. Our fans have come to expect us to raise the bar in terms of graphics and storytelling, which is a huge amount of pressure to live up to. But we've always said—and it's truer today than ever—that the pressure that we feel from our teammates far exceeds any expectations set externally.

So, how are we going to do it? We never know. Every day we come to the studio and try what we think is going to work—and nine times out of ten, we fail. What we've come to realize is that we've got to figure out how to fail faster! With each of those failures we get closer to the best solution, and there's no amount of planning that can help us shortcut that process. Thankfully we have a team that understands that this is how we manage to not accept "good enough." There is no secret formula, no silver bullet—it just takes hard work, determination, and faith in your team.

It doesn't end there. We wouldn't have the privilege to keep doing what we love if it weren't for our fans. We want to thank everyone who has supported Naughty Dog over the years. Thanks for playing our games, giving us the feedback (good and bad), and helping us celebrate our thirtieth anniversary. Here's to another thirty years—let's keep playing!

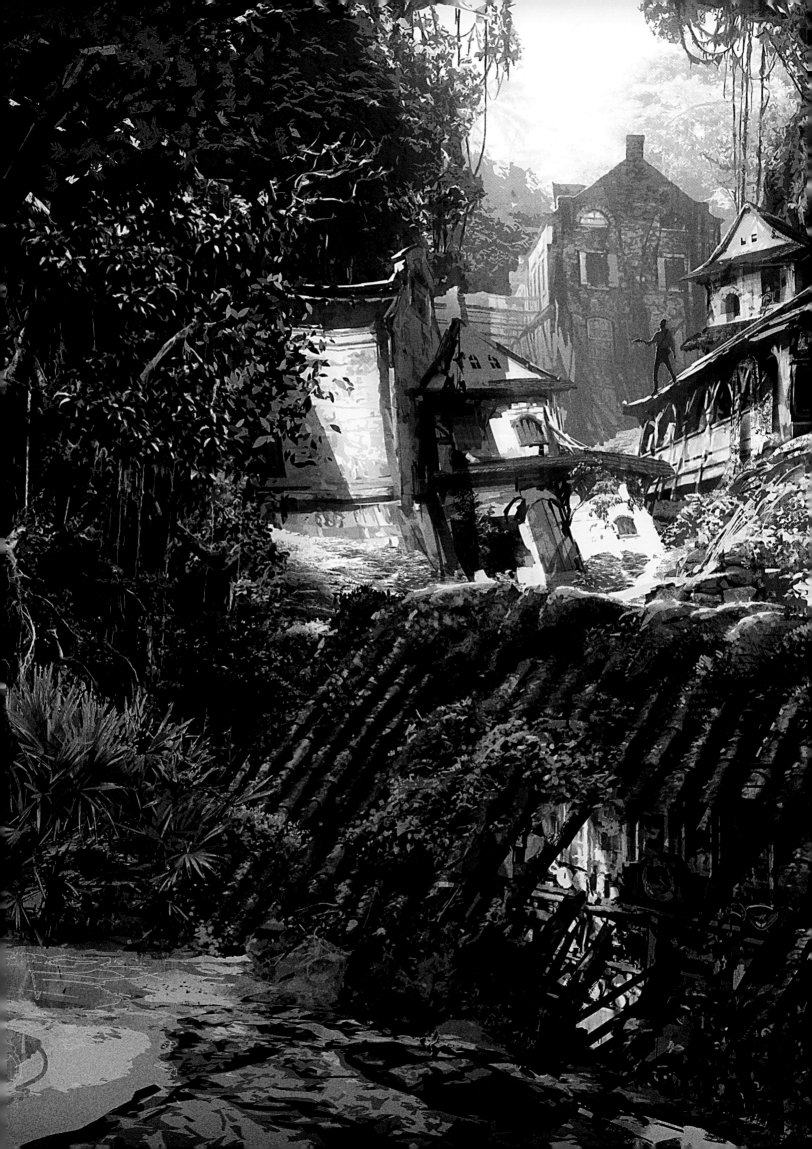

UNCHARTED 4

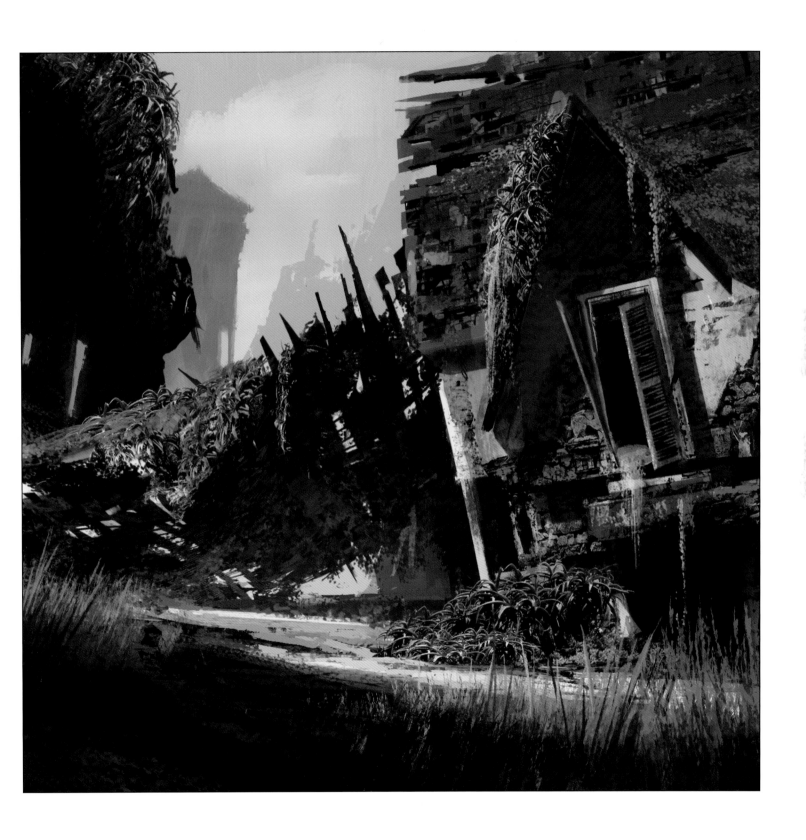

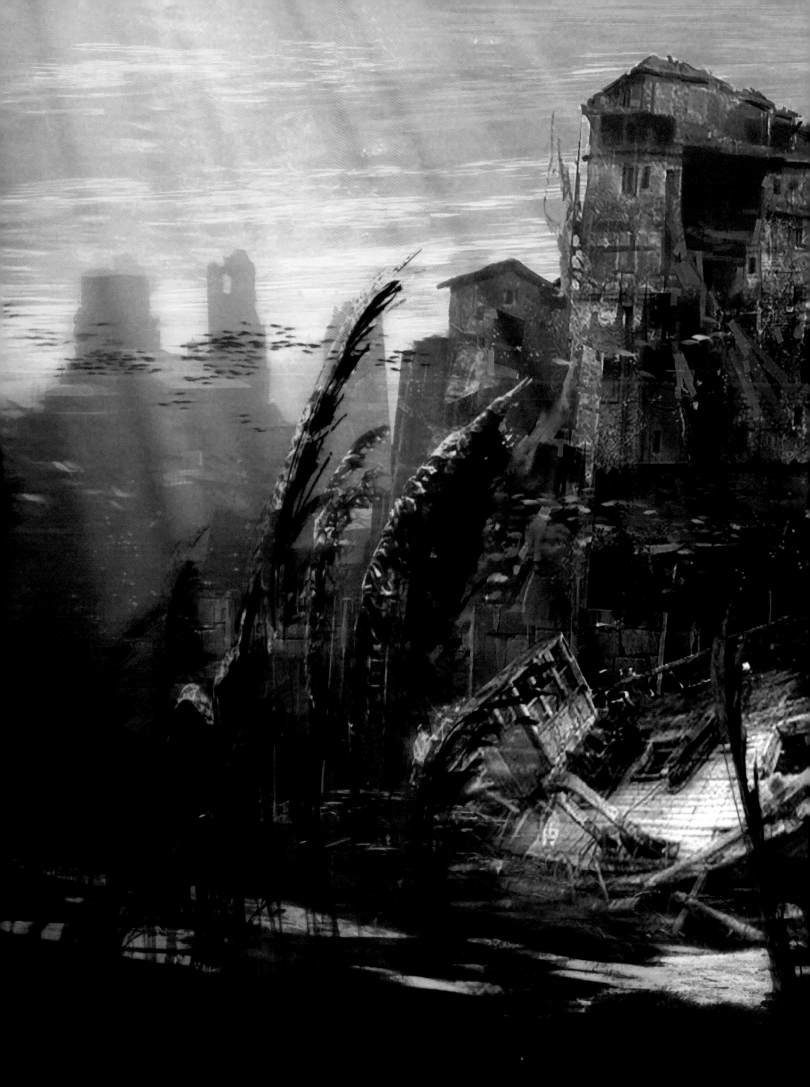

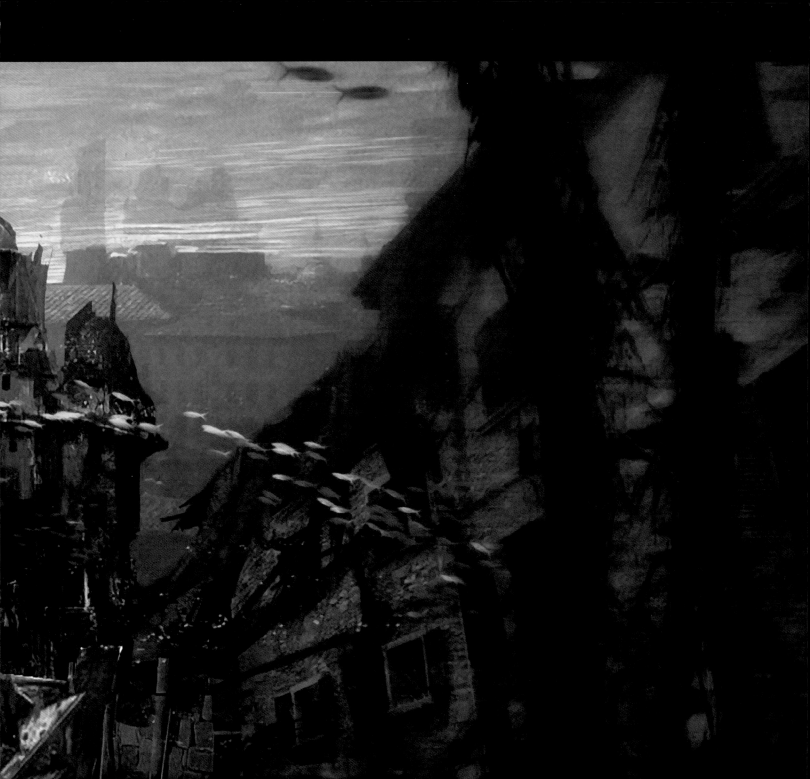

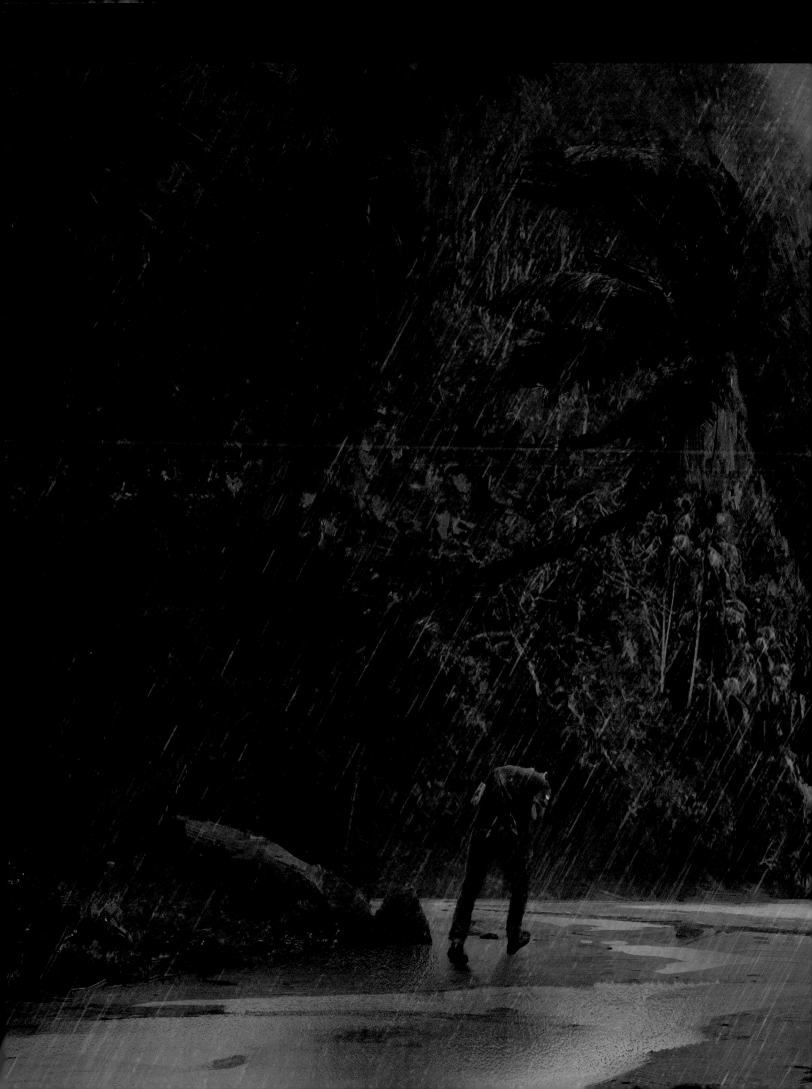

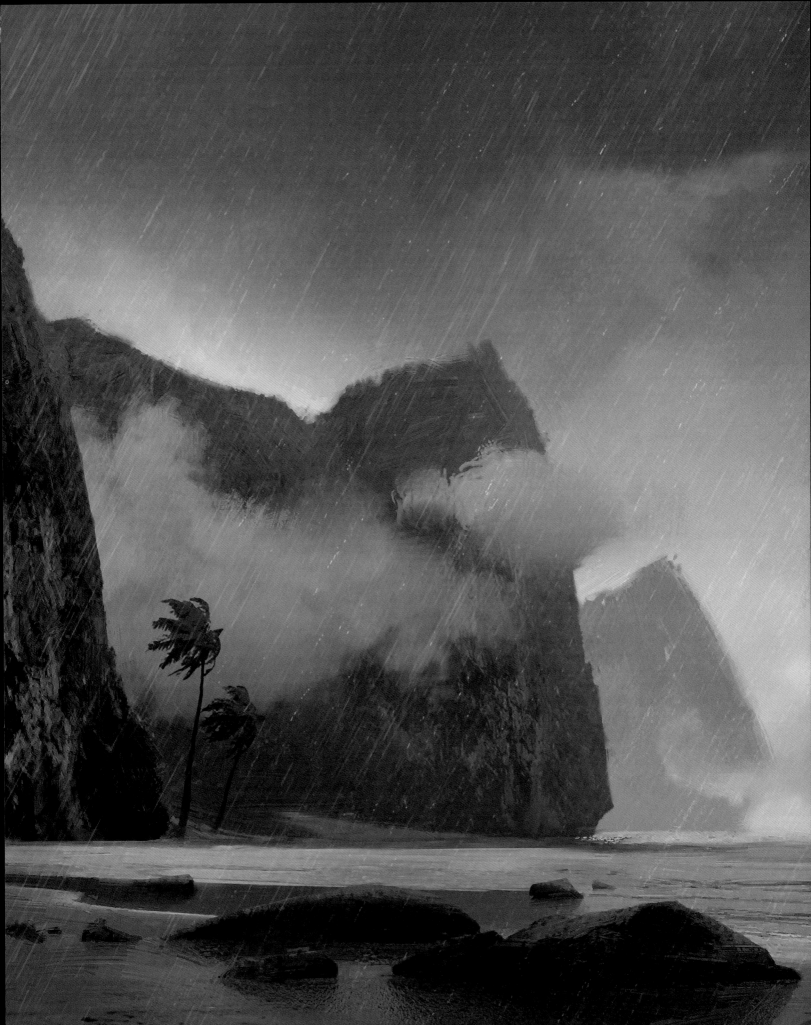

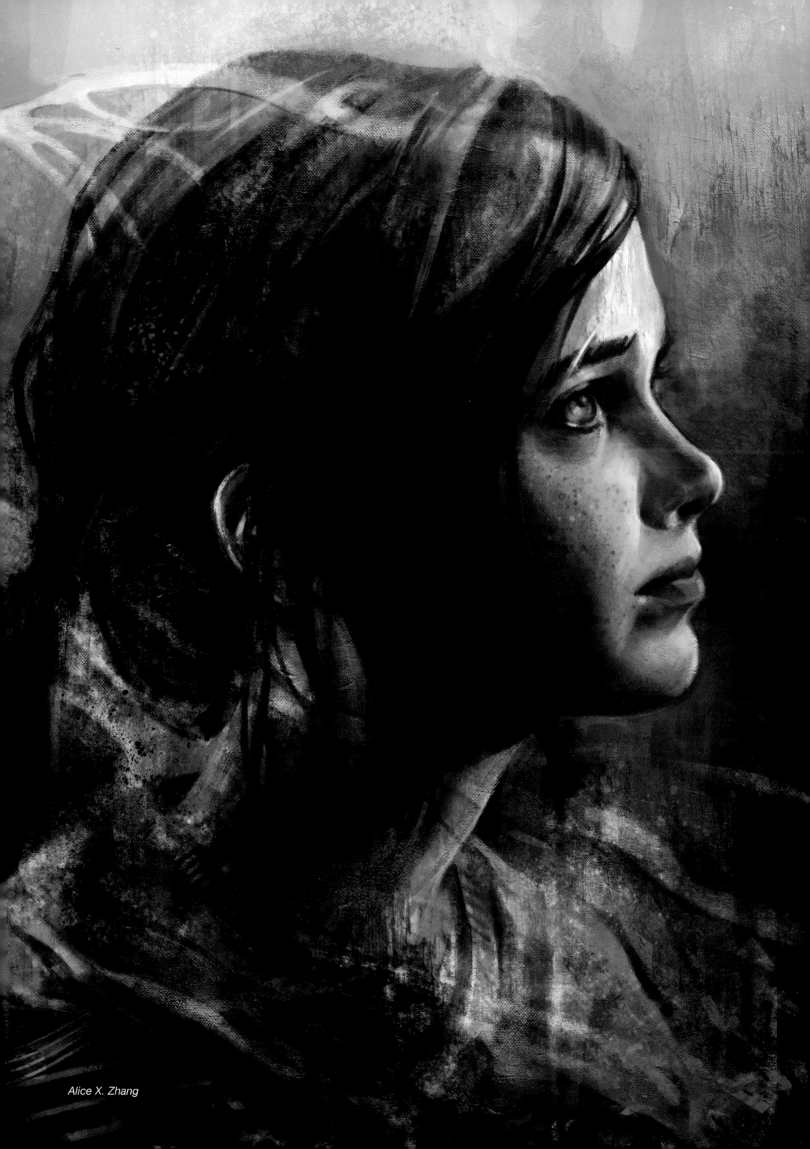

Alice X. Zhang

FAN ART

BY ARNE MEYER AND ERIC MONACELLI

Existing for thirty years and having a good run of successful franchises earns you some incredibly talented fans along the way. The inspired work we've seen from the community that forms around our games is astonishing. Our community often lets us know when a fan has created something really special, and sometimes that creation even finds its way into our studio to be hung on our walls or put in our display cases.

We looked at those walls and display cases and combed the Internet and our e-mail archives to find some of the most remarkable and ingenious pieces out there. It was a staggering and humbling search. This is just a small sampling of the incredible body of fan art that exists online and on paper. If we devoted an entire book to just this kind of art we likely still wouldn't have the pages to honor each of the pieces worthy of recognition.

We've met many of the artists on these pages and even hired some to do work for us. It's truly amazing to witness our characters and worlds reimagined and redrawn in ways we couldn't even dream up ourselves. The creativity on these pages is a fitting tribute to our work, as well as something that's given us inspiration, happiness, and a sense of pride. Thank you to everyone who's ever scrawled a line, a shape, or a dot that resembles anything our studio has created. You are what keeps us going

ARTISTS

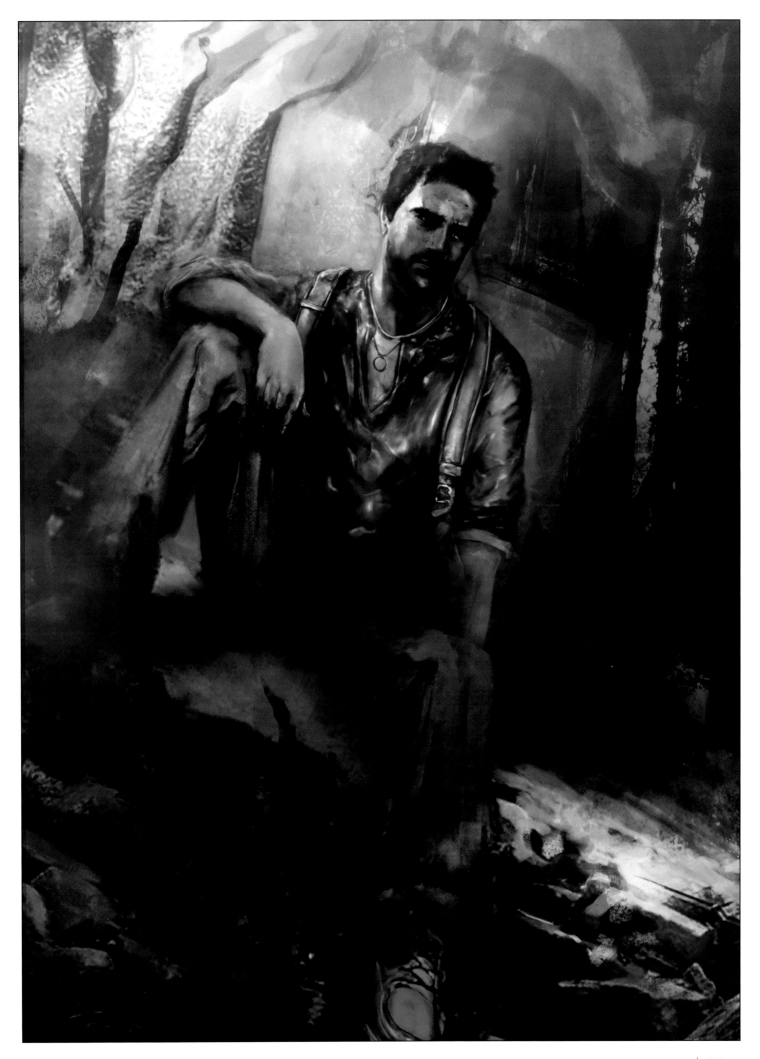

Bruce Straley

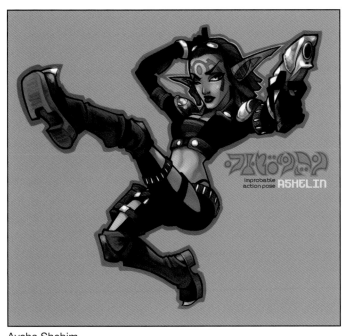

Aysha Shehim

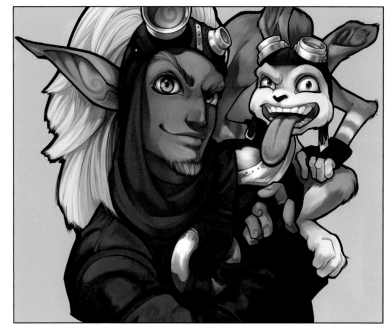

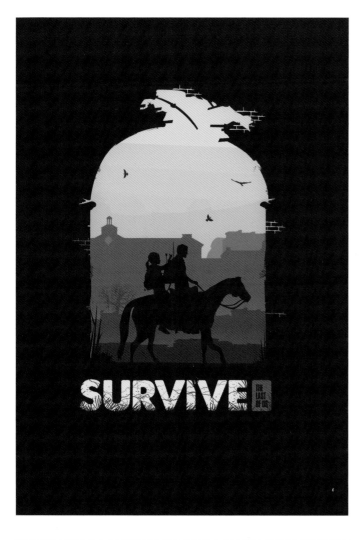

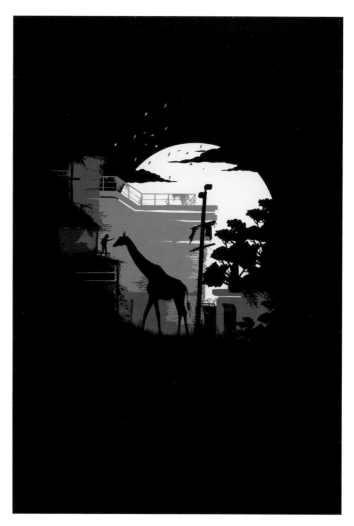

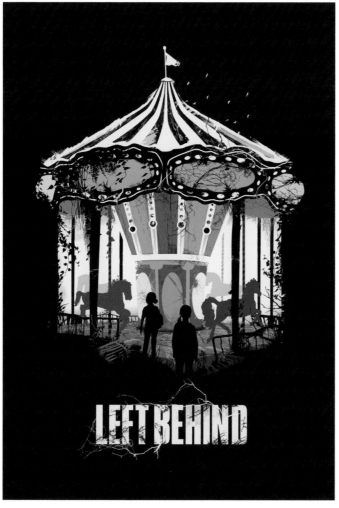

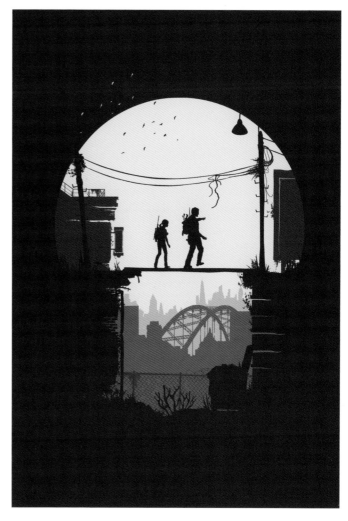

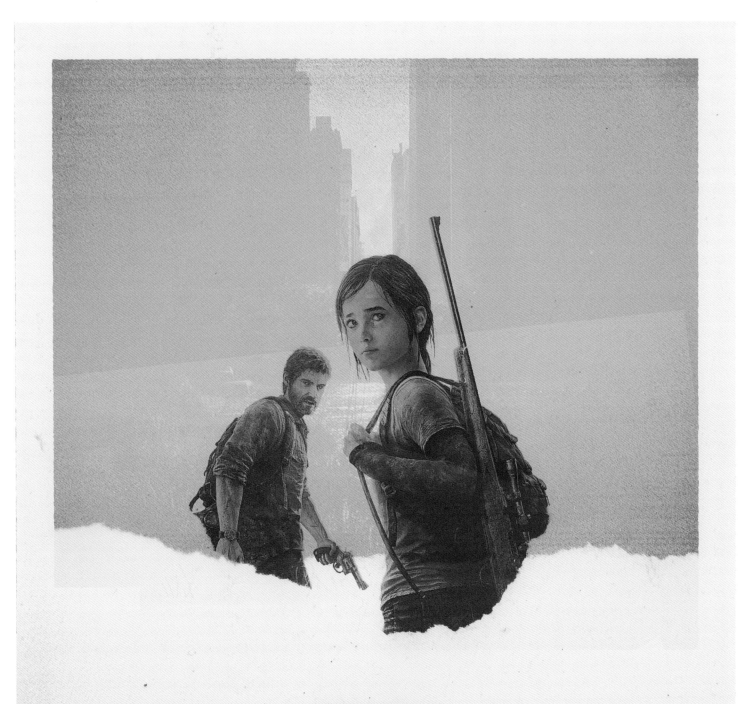

After all we've been through.
Everything that I've done.
It can't be for nothing.

THE LAST OF US

2013 (PlayStation 3)
2014 (PlayStation 4)

Developed by Naughty Dog
Published by Sony Computer Entertainment

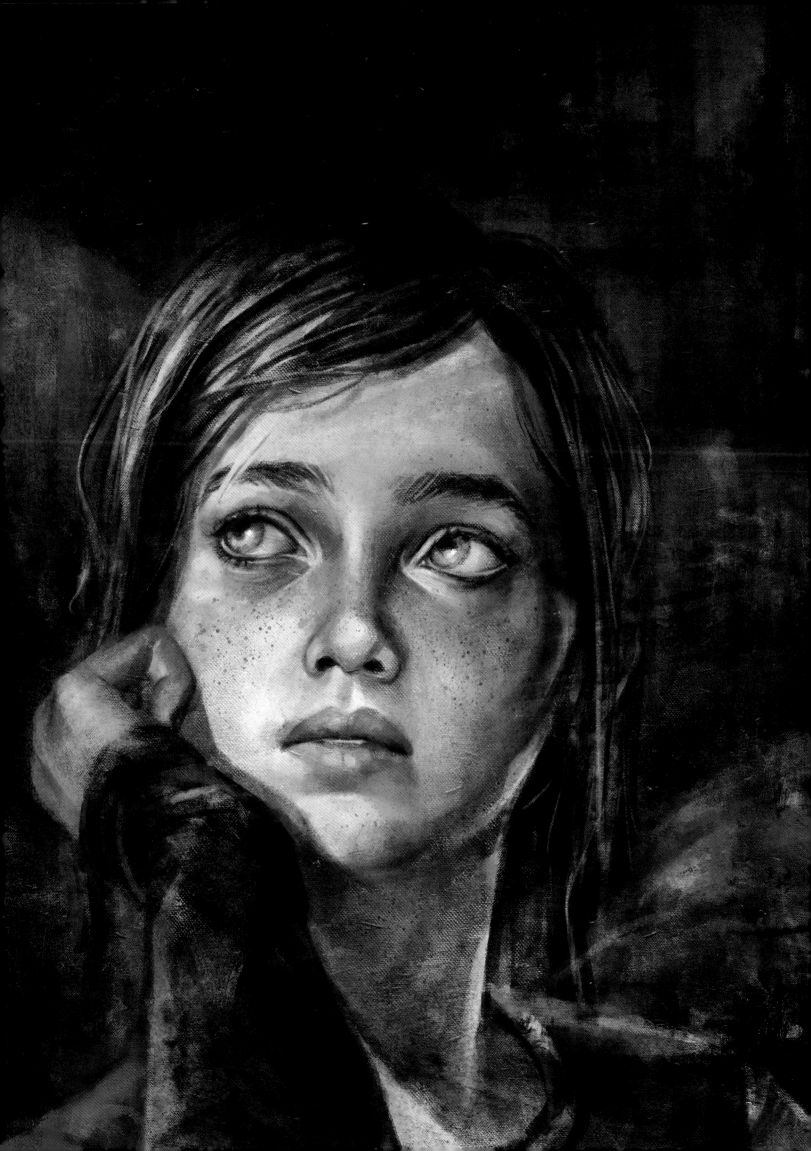

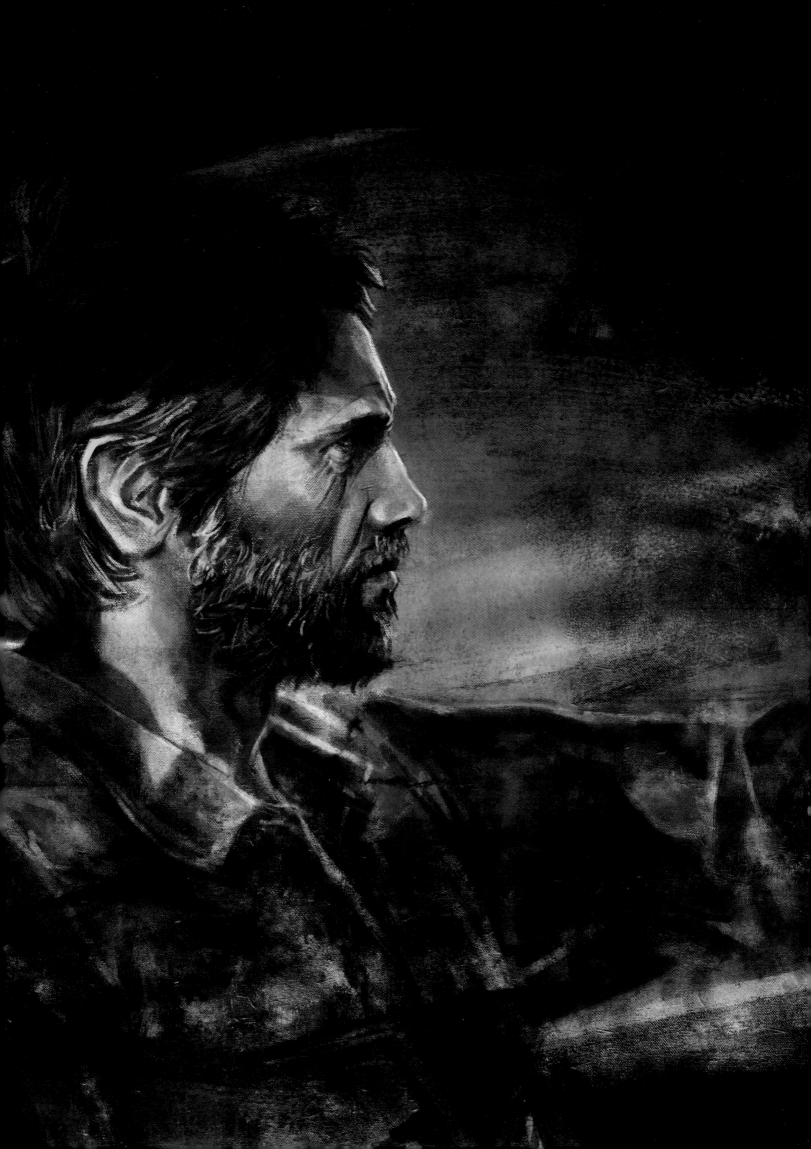

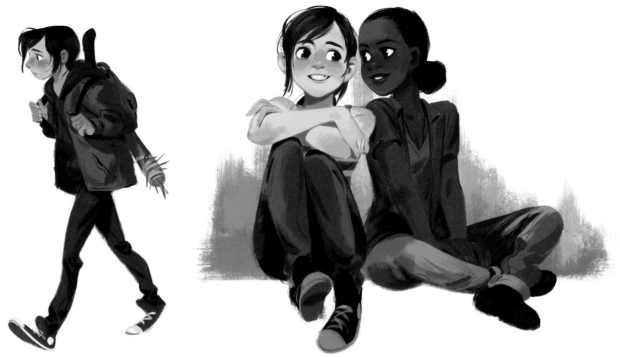

Mingjue Chen

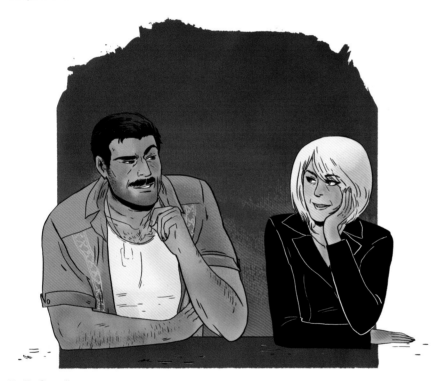

Emily Carroll

i kept your tears in a jar.

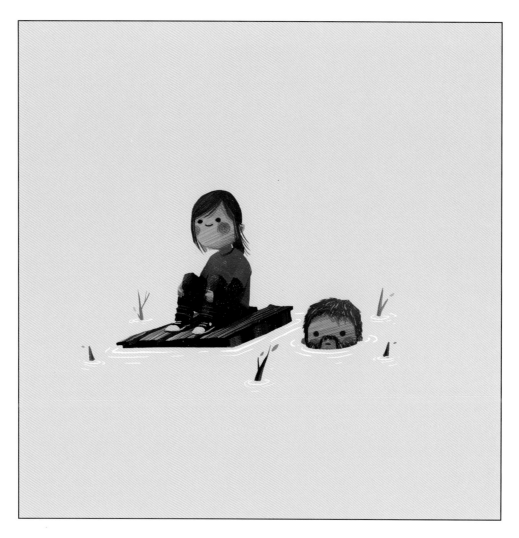

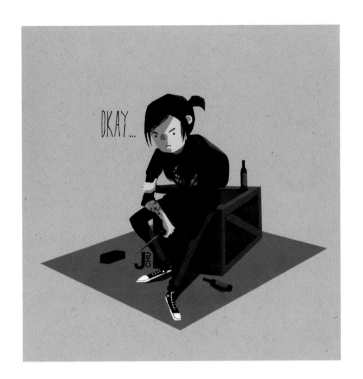

OKAY...

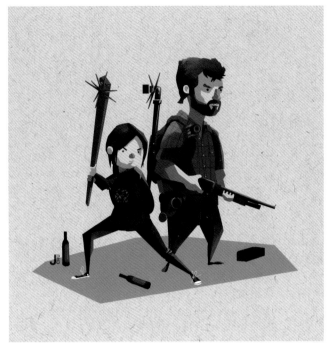

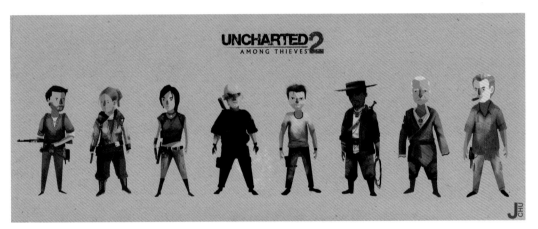

UNCHARTED 2
AMONG THIEVES

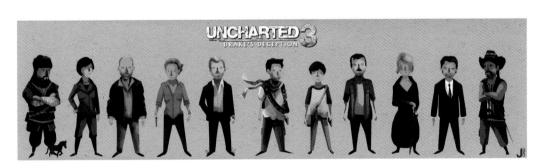

UNCHARTED 3
DRAKE'S DECEPTION

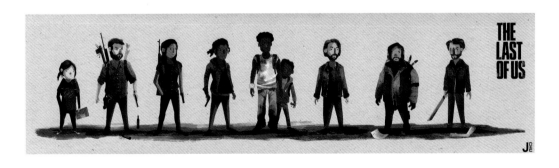

THE LAST OF US

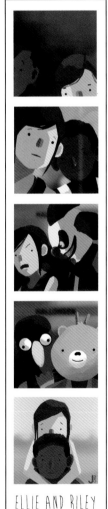

ELLIE AND RILEY

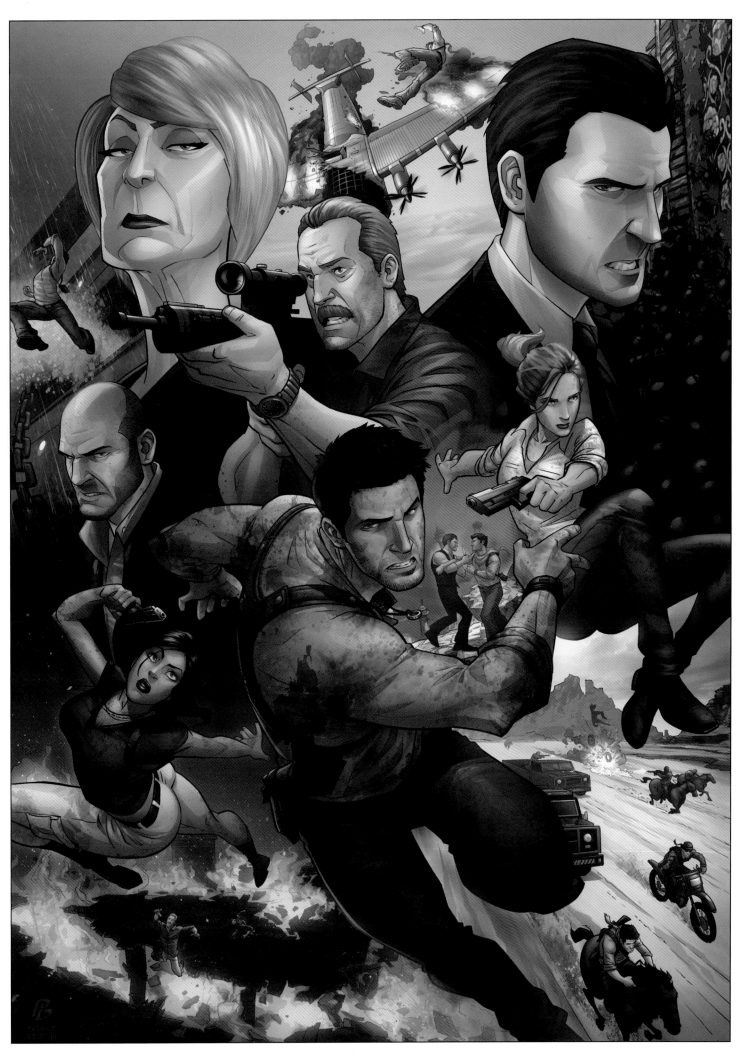

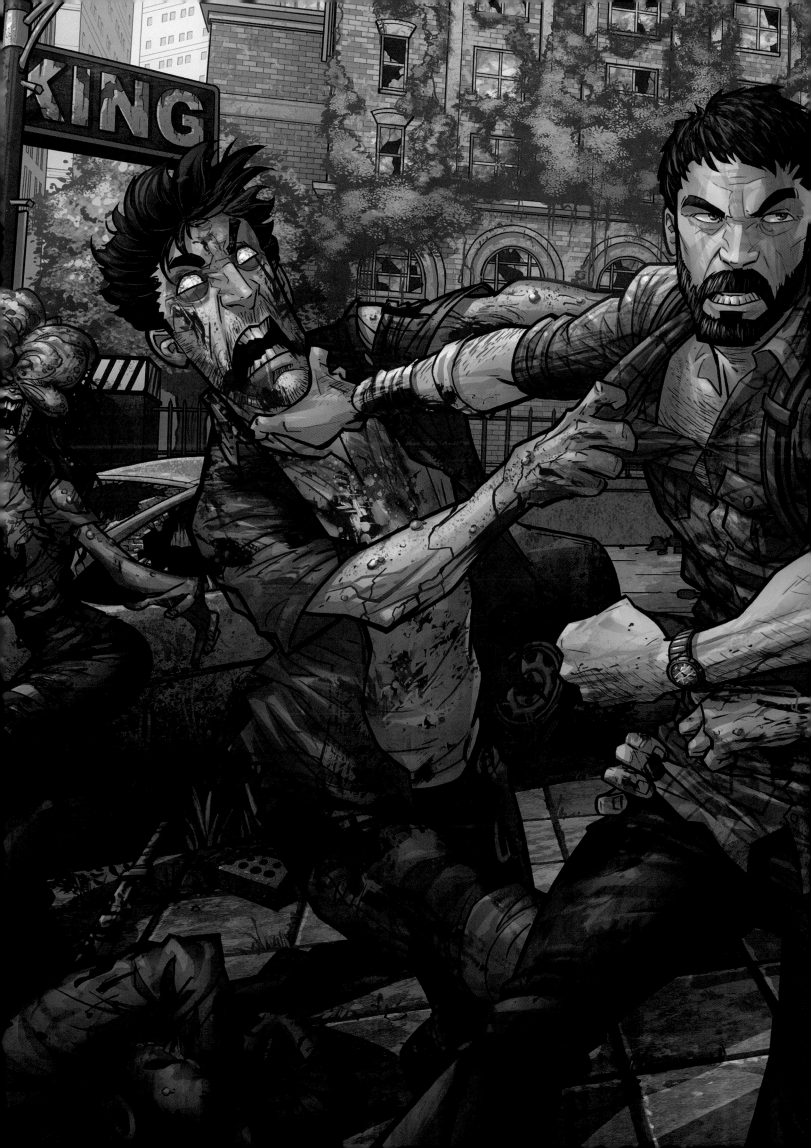

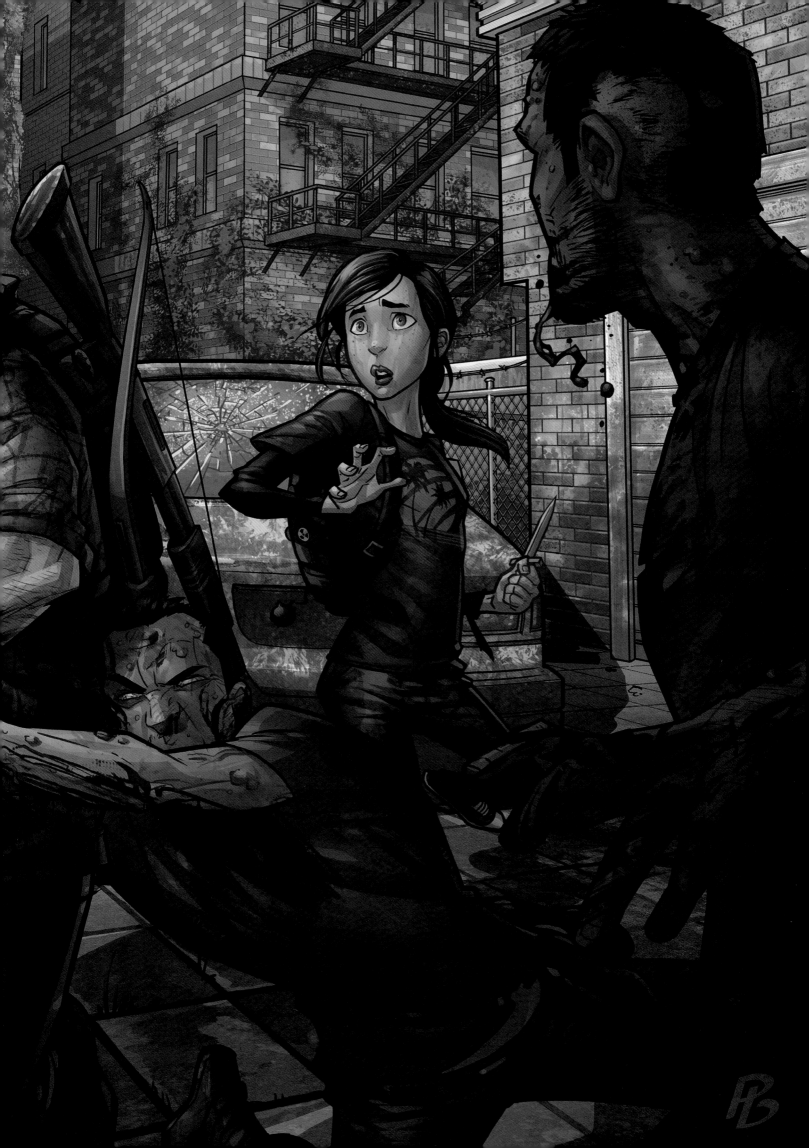

ALSO FROM NAUGHTY DOG AND DARK HORSE:

THE ART OF THE LAST OF US

Featuring concept art, character designs, and astonishing settings and landscapes, *The Art of The Last of Us* provides a unique look at one of the gaming world's most celebrated titles.

ISBN 978-1-61655-164-3 | $39.99

THE LAST OF US: AMERICAN DREAMS

Neil Druckmann, Faith Erin Hicks

In the years before the game, thirteen-year-old Ellie's disrespect for the military authority running her boarding school earns her new enemies, a new friend in fellow rebel Riley, and her first trip into the outside world.

ISBN 978-1-61655-212-1 | $16.99

THE ART OF THE UNCHARTED TRILOGY

Encompassing *Drake's Fortune*, *Among Thieves*, and *Drake's Deception*, this epic volume offers a look at the creation of one of the most exciting game series of this generation, along with insightful commentary from the games' creators.

ISBN 978-1-61655-487-3 | $39.99

COMING APRIL 2015

THE ART OF NAUGHTY DOG

Crash Bandicoot. Jak and Daxter. Uncharted. The Last of Us. One studio has been responsible for the most iconic video game experiences of this generation. This thirty-year retrospective tour recounts Naughty Dog's ascension to its place as one of the most influential production studios in the world.

ISBN 978-1-61655-477-4 | $39.99